Unequal opportunities
The case of women and the media

Unequal opportunities

The case of women and the media

Margaret Gallagher

Unesco

First published in 1981 by the United Nations
Educational, Scientific and Cultural Organization
7 place de Fontenoy, 75700 Paris
Printed by Presses Universitaires de France, Vendôme

Second impression 1983

ISBN 92-3-101897-3

© Unesco 1981
Printed in France

Preface

The year 1980 marked the mid-point of the United Nations Decade for Women. It was also the year in which a review of progress since International Women's Year was conducted, in the context of the World Conference of the Decade, held in Copenhagen in July. As part of this review, relationships between women and communication media were also examined.

Early in 1980, Unesco commissioned a book on the portrayal and participation of women in the media, based upon an international research survey undertaken over a two-year period. Later in the same year, a United Nations/Unesco seminar in New York looked specifically at this issue, with the forum of Copenhagen in mind. There were parallel activities in a number of countries and regions, and by the end of this period of concentrated discussion and research, a number of new experiences had come to light. At the moment they are fugitive, scattered in many places, and the purpose of this book is to bring them together, so as to address a series of basic questions. The questions are these: What are the issues? What do we know already? What has been done so far? What remains to be done?

The book, therefore, attempts to relate the findings of research to the needs and possibilities for action. Its author carried out the original Unesco study on the portrayal and participation of women in the media and participated in most of the major encounters of 1980, including the Copenhagen conference. In these pages, she has consolidated her work, to make it available to a wider audience, and has compiled a valuable reference bibliography. The opinions expressed are, however, her own; they have been formulated in the light of her experience, and do not necessarily reflect the views of Unesco or of other agencies within the international system.

Acknowledgements

I am grateful to the Swedish Broadcasting Corporation for permission to reproduce: *Schema for Programme Analysis—Sex Roles in Television Fiction*—developed for the 'Equality Project' 1978; and to Unesco for permission to adapt material from *The Portrayal and Participation of Women in the Media* (CC.79/WS/130); *Women and the Cultural Industries* (CC.80/CONF.629/Col.9); *Images of Women in the Mass Media* (International Commission for the Study of Communication Problems); *Women, Communication and Development: the Unesco/UNFPA Features Services on Women and Population* (SS.80/WS/18).

Two Open University colleagues helped in the early stages of the project on which this book is based. Moira Griffiths carried out extensive and careful bibliographic searches. Nicola Durbridge's abilities in languages and skills in criticism gave me ready access to materials in Dutch, German, Danish, Norwegian and Swedish. The Unesco Secretariat provided considerable help in terms of contacts, documentation and general moral support. Literally hundreds of people around the world supplied me with information and material for the survey which preceded the book. I am immensely grateful to all of them.

Contents

Part I	*What are the main issues?*	9
Chapter 1	A question through history	11
2	The status of women and the socio-economic system	13
3	Culture, communication and the production of meanings	16
4	Specific characteristics of women's relationship to the communication media	19
5	Patterns of distribution and access	22
6	Women and media: some implications	28

Part II	*What do we already know?*	31
	Introduction	33
Chapter 1	The portrayal of women in the mass media	35
2	Participation of women in the mass media industries	79
3	Portrayal and participation: effects and relationships	105

Part III	*What has been done so far?*	113
	Introduction	115
Chapter 1	Using mass media for women in development	118
2	Media and the social reality of women	125
3	Alternative strategies for media change	137
4	Mainstream media and alternative distribution channels: case-study of a women's communication network	145

Part IV	*What remains to be done?*	157
Chapter 1	Setting the agenda: some lessons in politics	159
2	Redefinition and revitalization of the issue	164
3	Developing new structures	170

Appendices	Sources of reference	177
1	Feminist publications	179
2	Directories and guidebooks	184
3	Seminar proceedings and reports	185
4	Catalogues of women's media	187
5	Groups and organizations	188
6	Format for media analysis	193

References 207

Part I

What are the main issues?

'God adapted women's nature to indoor and man's to outdoor work.... As nature has entrusted woman with guarding the household supplies, and a timid nature is no disadvantage in such a job, it has endowed woman with more fear than man.... If anyone goes against the nature given him by God and leaves his appointed post ... he will be punished.'

Xenophon (*c.* 430—355 B.C.) *The Economist*, I, 42 ff.

Part I

What are the main issues?

Chapter 1

A question through history

The 'woman question' has been a perennial question throughout history. To associate it only with the feminist movements of the nineteenth and twentieth centuries is to ignore the fact that, more notably in some historical epochs than in others, it has preoccupied philosophers, social commentators and creative writers since earliest times. The issue of women's position in society was certainly debated publicly in Greece of the fifth and fourth centuries B.C. Euripides in his tragedies shows an almost feminist sympathy for women. The satires of Aristophanes, which make fun of various aspects of women's condition, nevertheless illustrate the currency of certain 'progressive' ideas, such as women's suffrage, satirized in the *Ecclesiazusae* (Women in Parliament). The Platonic-Aristotelian debate on the role of women in society is a further indication of a certain seething of opinion on the question at that time.

The call to give women a separate definition from that of men has been a historically persistent demand. That the problem was formulated at all—as if women somehow had a destiny different from that of men—is itself revealing. Just as important is the fact that the definitions handed down through history are those of men, who have been in a position to impose their analyses and prescriptions, whether intellectual, economic or political. For there is no doubt that cultural images reflect and promote the values of the powerful. Polemics against women were common, for example, during the late Middle Ages in Europe. Generally speaking, the arguments were based on old misogynist themes; woman is cursed by the sin of Eve, crooked because made from a rib, bestial by nature, greedy and crafty. The Renaissance and Reformation brought major shifts in viewpoints and values: '*la querelle des femmes*' (the dispute about women) became a long-running debate on woman's capabilities. Erasmus lent his authority to the faint call for education for girls and women. Castiglione submitted that 'women can understand all the things men can understand and that the intellect of a woman can penetrate wherever a man's can' (*Il Cortegiano*). Christine de Pisan, one of the most learned women of her time and probably the first female voice to be heard on the question, suggested that if women 'understand less it

is because they do not go out and see so many different places and things but stay at home and mind their work', in fact, she ventured, 'their understanding is more sharp' than that of men (*Cyte of Ladyes* I,11). This was strong stuff in an age when Aristotle was still much quoted to the effect that the female state is a state of deformity.

The historical importance of Aristotelian thought can hardly be underestimated in Western civilization. Through the cultural transformations brought about in the process of colonization, its impact on other societies has also been considerable. In the medieval and early modern periods, Aristotelian generalizations were set down and perpetuated as natural truths. Aristotle's closely reasoned biological theories—in which the female was defined as a sort of 'mutilated male'—were influential in embryological work (for example, in William Harvey) and in psycho-analytical theory (notably in Freud) as late as the nineteenth century (Horowitz, 1976). While Plato's egalitarian arguments for the common education of women and men for joint military, intellectual and political leadership were radical and exceptional, Aristotle—following on his belief in fundamental biological and psychological sex differences—placed women firmly in the household and took for granted, without discussion, the exclusion of women from any political or even public function. The Aristotelian private-public polarization in which certain roles and functions are judged 'natural' and appropriate to women and men, has prevailed; it is a polarization which underlies the entire historical problem of the differential social status of the two sexes. Most political theories, for example, have an ontology which is male: after Aristotle, Rousseau, Hobbes, Locke, Hegel, all explicity exclude women from their theoretical models and assign them a 'different' (and disadvantaged) social status, based on their reproductive role (Clarke and Lange, 1979).

The 'politics of the personal' is thus central to an understanding of women's subordination. 'Defined primarily through our destinies as wives and mothers—to be somebody else's private life—women are principally placed, politically, ideologically and economically, in "the personal sphere" of the family.' (Brunsden, 1978). Yet women's place in this personal world is contradictory. The historical 'separation out' of the domestic sphere has been accompanied by, indeed articulated through, ideologies of domesticity, femininity and personal life which have represented the home and the family unit as unrelated to the outside world of work. But the world of production *is* nevertheless dependent on the home world, in that the work involved in the reproduction and maintenance of the labour force is done mainly by women as unwaged work in the home, regardless of whether they also do waged work (which is, incidentally, usually of a similar nature) outside the home. These determinations on domestic and personal life by the industrial-economic sphere are central to an understanding of the status of women and of the nature of their relationship to the socio-economic system.

Chapter 2

The status of women and the socio-economic system

Analysis of women's status in society is therefore inseparable from analysis of the social-economic structure as a whole. The fundamental nature of this relationship was originally proposed by Engels. The link between women's disadvantaged status, on the one hand, and the growth of private property and economic classes, on the other, was in Engels' view the emergence of the individual family as an independent economic unit. Taking shape within and subverting the former collective economy, the family as an economic unit transformed women's work from public production to private household service. The critical development which triggered the change was, according to Engels, the specialization of labour: this increasingly replaced the production of *goods for use* by the production of commodities for exchange, and set up economic relationships which lay beyond the control of the producers (Engels, 1972).

Since unequal control over resources and subjugation by class and by sex developed in very different ecological settings in many parts of the world prior to, as well as within, the period of European colonialism, it is important to separate Engels' statement on women's subjugation from the specific context of his discussion. Eleanor Leacock's recent ethnohistorical research indicates that Engels' thesis can, in fact, be substantiated by study of other cultures and periods. In the first place, she has shown that in precolonial horticultural 'band' societies where egalitarianism still prevailed, women *did* function publicly in making economic and social decisions. Secondly, by comparing such societies with those characterized by differences in rank and wealth she has demonstrated that the main concomitant of women's oppression originally outlined by Engels is indeed found cross-culturally.

The transmutation of production for consumption to production for commodities for exchange . . . begins to take direct control of their produce out of the hands of the producers and to create new economic ties that undermine the collectivity of the joint households. Women begin to lose control of their production, and sexual division of labour related to their childbearing ability becomes the basis for their oppression as private dispensers of services in individual households. (Leacock, 1978).

However, as Leacock points out, the process is by no means simple, automatic, or rapid, and where women retain some economic autonomy as traders they retain a relatively high status too. In West Africa, for example, women were organized to maintain and protect their rights well into the development of economic classes and political states.

The effects of colonization on the position of women in pre-colonial egalitarian society must also be set in the context of its impact on society as a whole. The ultimate goal of colonization was economic exploitation of both women and men. The self-perpetuating process of transforming colonized people into producers and consumers of commodities served the colonial power's need for both raw materials and markets. In pursuit of this transformation the colonizers addressed their demands and their technical innovations to men, thus favouring men's access to cash, the economic dependency of women and, as a result, the emergence of the patriarchal nuclear family. These changes were often compounded by the transition from group rights in land to private property, also to the advantage of men (Boserup, 1970). Direct ideological action—the attempt to transform attitudes and beliefs—often through religious conversion, also had a profound effect on the nature of personal relationships in societies where women had been relativity autonomous. But patterns of male-female dominance existed in many pre-colonial societies: in New Guinea and other parts of Oceania, among the Aztecs and the Incas, for example, man's need and supposed right to control women are documented (Etienne and Leacock, 1980). Moreover, colonized peoples have often resisted institutions such as the nuclear family or private property: the Baule of the Ivory Coast for example have adopted neither (Etienne, 1980).

Colonization, in the political or economic sense, explains only part of the global picture of women's subordination. Fundamentally, there is perhaps another sense in which *all* women have been subject to a form of 'interior colonization', resulting from 'the birthright priority whereby males rule females' (Millet, 1970). The interplay between these two 'types' of colonization for women in countries which have been subject to political-economic colonization is hinted at by Achola Pala when she describes the position of women in Africa. They are, she argues, affected by two interrelated factors—Africa's economic and political dependency on the West, and indigenous African socio-economic norms (Pala, 1977). While this notion of dual colonization helps highlight the differences in the struggle of developing country women from that of women in the industrialized world, it is also a reminder of some basic similarities. For example, one study of West African literature and film found that while the African woman did enjoy a certain status in traditional society, she still confronted problems—such as the stigma of childlessness and the degradation of prostitution—common to women everywhere (McCaffrey, 1980).

If the origin and development of women's problematic social status is linked to the dynamics of the world socio-economic system, approaches to solution of the problem are similarly linked. Moreover, differing contemporary approaches exist, reflecting varying positions—often politi-

cal in origin—towards the basic nature of the relationship between women and the socio-economic domain. For instance, many less developed countries see improvements in women's legal and social status as a prerequisite to their increased participation in economic development; in some advanced industrialized societies, however, women question the political and economic philosophies which require substantial inputs from them to the maintenance of economies that not only provide women with scant financial rewards but, in doing so, underline and reinforce their continuing inferior position in the labour market. Taking the imbalance in the distribution of world economic resources as a starting-point, many countries—particularly in the developing world—see the establishment of a new international economic order as a prerequisite to a change in women's status. Thus while in a diagnostic sense concern with women's status is based on recognition of a problem spanning all societies (the problem being broadly that when measured by standards of literacy, political participation, social mobility, occupational mobility, economic position, the status of women is less favourable than that of men), prognoses of the problem encompass positions or points of view which are not only different but fundamentally incompatible.

These differences and incompatibilities are inevitable and may be debilitating to the potential resolutions of the situation. At present they seem much less significant than the achievement of what has been described as 'putting a finger' on a complex problem which until recently has been ignored or scorned, but which is now taken more seriously (Olivera, 1978/79). Betty Friedan, writing in the early 1960s, called it 'the problem that has no name', underlining the difficulty of coming to grips with women's experience of subordination when the culturally limited representation and exclusion of women's experience was one of the very conditions of that process.

Chapter 3

Culture, communication and the production of meanings

The effects of these long-term cumulative processes of discrimination are strikingly apparent in the present world profile of women: while they represent 50 per cent of the world adult population and one-third of the official labour force, they perform for nearly two-thirds of all working hours and receive only one-tenth of the world income and own less than 1 per cent of world property (WCUNDW, 1980a, para. 14).

Realization of the subordinate—and indeed largely unacknowledged—role which women play within the socio-economic system gives rise immediately to the question of how and why this role is broadly accepted by women themselves as inevitable and natural. The very placement of women within the personal rather than the public sphere is one answer. Gramsci in his *Prison Notebooks* argued that for a subordinate group, working only through direct, personal experience and common sense does not allow the construction of a coherent oppositional world view. What is experienced may be in contradiction to available explanations, but it is very difficult to work out why or to understand how. So despite the experience of contradictions, what is often 'felt' by women is the naturalness of the way things are. The overarching role of culture—which can be defined as the socially and historically situated process of production of meanings (Barret et al., 1979)—in this entire process of role and identity formation is fundamental. For the roots of inequality are buried deep in the cultural consciousness.

Cultural 'absences and exclusions' of women have begun to be noted by women themselves. Increasingly, women can see that 'we have been defined negatively in relation to the culture into which we have been born: our experience has tended to be made invisible' (Dalston Study Group, 1976), or can describe an 'inability to find ourselves in existing culture as we experience ourselves' (Rowbotham, 1973). Yet the step between the experiences of contradiction, and action to resolve the contradiction remains enormous in a world where—even for a majority of women—cultural meaning decrees that 'women mean love and the home, while men stand for work and the external world' (Sharpe, 1972).

The basic significance of the cultural exclusion, or partial representation of women can be found in the relationship of cultural processes to the socio-economic system and in the economic determination of cultural practices and products. Consequently, communication industries and their output can be seen as another link in the chain binding women in their particular relationship to social-economic structures.

Raymond Williams, in a seminal study of modern communications in the United Kingdom, writes of the 'long revolution' in culture, initiated by the extension of the education and communication systems, as a third current of change alongside the industrial revolution in the economy and the democratic revolution in the political sphere. These three processes together define the 'texture and tempo' of contemporary experience. Consequently he argues it is necessary to study the complex interactions between the spheres of culture, polity and economy. In a later work, Williams acknowledges the pivotal position of the economic structure and the determinations it exerts on cultural production. He suggests that the growing concentration of control in the hands of the large communications corporations is the key defining characteristic of the emerging situation, and that as a result 'the methods and attitudes of capitalist business' have penetrated deeply into more areas and 'have established themselves near the centre of communication' (Williams, 1968).

However, the point is not simply (and Williams certainly does not suggest that it is) that the communications media have an economic function, but that they play a fundamental ideological role which is articulated through their relationship to the economic structure. This is a point which is not always grasped. For instance, in Dallas Smythe's analysis the media's primary function is to create stable audience blocks for sale to monopoly capitalist advertisers, thereby generating the propensities to consume which complete the circuit of production (Smythe, 1977). A similar analysis is often applied to the media's treatment of women, in terms of their singling women out as the consumers *par excellence* (for example: Embree, 1970; Cantarow et al., 1971; Lopate, 1976, among many). Yet how do important media sectors with minimal dependence on advertising revenue—notably paperback publishing, the cinema and the popular music industry—fit into this schema? The trap into which this type of theorizing falls is that by highlighting the role played by the media in the circulation of economic commodities, their complementary role in the reproduction of ideologies is ignored. Consequently, there can be no exploration of the ways in which economic determinations shape the range and forms of media production and its resulting products.

It is these crucial links between the economic and ideological dimensions of media production which Golding and Murdock stress when they call for a comprehensive political economy of culture. Their argument is that the production of ideology cannot be separated from, or adequately understood except in relation to, the general economic dynamics of media production and the determinations they exert (Golding and Murdock, 1979). As they go on to suggest, these economic dynamics operate at a variety of levels and with varying degrees of

intensity in different media sectors and different divisions within them. At the most general level the distribution of economic resources plays a decisive role in determining the range of available media: the absence of a mass circulation radical daily newspaper in the United Kingdom, for instance, is primarily due to the prohibitive costs of market entry and to the maldistribution of advertising revenue. Economic imperatives also help to determine the general form of available media. The lack of fit between the media systems of many developing countries and the social needs of their populations—the institutionalization of domestic, studio-based television in communally oriented outdoor cultures, for example—is due in large measure to the historical and economic dominance of the major multinational corporations. Similarly, dispersed rural populations are not particularly well served by urban-based daily newspapers. Within individual media organizations economic imperatives may play an important role in determining the allocation of production resources between divisions with varying ratios of costs to audience appeal, as between sports coverage and educational broadcasting, for instance.

Although Golding and Murdock make no mention of the fact, it is clear that each of the various levels of determination which they identify impinge—either singly or in combination—on the specific position of women as both subjects and objects in the media. Reasons ascribed to the absence of a radical newspaper, for example, apply just as well to the absence of a feminist paper. If the needs of rural populations in developing countries are not well served by urban-based newspapers, the needs of rural women—the overwhelming majority of whom are illiterate—are particularly ignored. The differential ratio of costs to audience appeal as between sports coverage and educational broadcasting could equally obtain between sports coverage and programming directed at women. Clearly, then, the media do play a central ideological role in that their practices and products are both a source and a confirmation of the structural inequality of women in society.

Chapter 4

Specific characteristics of women's relationship to the communication media

There are some distinctive features which characterize women's relationship to the media industries and their products in quite a specific way. It should be clear that each of these features has its roots in both the economic and the ideological spheres, and furthermore, that each has a distinct functional role to play in both of these areas.

In the first place, as Cornelia Butler Flora has pointed out, 'almost since the invention of the printing press, women's fiction has proved a lucrative venture. Middle-class women—women from the class that was literate and had the leisure and money to read—were avid audiences for the 'romantic scribblers' (Flora, 1980). Clearly, with increased access to education and the extension of female literacy, this particular market has expanded considerably in most industrialized countries. Moreover, the growth of the electronic, visual media has opened up completely new market groups among women (as well as men) and has led to a distribution of cultural products which is as diversified as the products themselves. However, an examination of some of the production processes involved even at the very earliest stages of the industrialization of cultural ouput indicates clearly those aspects of women's subordination in and through the media industries which persist to the present day in a very wide variety of contexts.

In a study of the production and consumption of novels in the nineteenth century, Rachel Harrison has argued that this rested on a fourfold subordination of women (Harrison, 1978). First of all, there was the subordinate position of female novelists themselves. The writing of novels by women in the home was tolerated, rather than encouraged, so long as it did not disturb the routines of domestic life. Nevertheless, it was considered that writing should not be 'the business of a woman's life' (Basch, 1974). In a direct allusion to one of Roland Barthes' 'mythologies' entitled *Children and Novels*, and arguing that children justify novel-writing, Michele Mattelart suggests that even now 'the woman who writes novels ... must testify to her submission to the eternal female status quo in order not to become a symbol of rebellion' (Mattelart, 1978). These contradictions are clearly internalized by women writers and

reflected in their work: so, for example, we find Lily Briscoe, Virginia Woolf's alter ego in *To the Lighthouse*, struggling to complete a painting against a mocking, insistent inner voice which whispers 'women can't paint, women can't write'. Sallie Sears has argued that the strength of the contradictions has driven certain women writers, such as Sylvia Plath and Virginia Woolf herself, to despair and even suicide (Sears, 1979). In another sense, women writers were subordinated through the discrimination which was practised against them in male-run publishing houses. Although the consumers were predominantly female, the attitudes of publishers dictated that authorship of novels should be male and led women to adopt pseudonyms—Currer Bell, George Eliot and George Sand among them. The content of the novels too was affected by predominating male values and assessments as to what was important. This led Virginia Woolf to argue that the whole structure of the nineteenth-century novel, when written by a woman, was 'made to alter its clear vision in deference to external authority' resulting in a high proportion of works which were centrally flawed (Woolf, 1975).

Turning to the second aspect of Harrison's fourfold characterization of the subordination of women in the process of novel production, this refers to the position of women in the printing trade. Here technological changes had allowed the substitution of the unskilled labour of women (and of children) for skilled male labour. Marx, in the first volume of *Capital*, noted that London printshops had come to be known as 'slaughterhouses' and that the chief victims there, as well as in the sorting of rags for paper production and in the process of book-binding, were 'chiefly women, girls and children' (Marx, 1974). Thirdly, Harrison argues, a similar exploitation of women in domestic service (made possible by the greater volume of profit and wealth among businessmen, itself a result of the move from absolute to relative surplus value in nineteenth-century industrial economy) ensured that middle-class women had time to read—and sometimes write—the novels which were produced.

Finally, there is the aspect of the female consumer. Here the particular form of subordination can be said to be primarily sexual, legitimated through the ideologies of romance, femininity, domesticity and motherhood which saturate the content of many of the novels produced at this time. It is important to realize that the ideology of love and marriage, with its corollary of virginity and monogamy had, as well as a social function (that of ensuring dutiful daughters and chaste wives), a specifically economic role to play: indeed, its very roots lay in the emerging interests of new economic relationships. This is clearly expressed in the Finer Report:

Middle class families handled their accumulating industrial wealth within a system of partible inheritance which demanded a more severe morality imposing higher standards upon women than ever. An adulterous wife might be the means of planting a fraudulent claimant upon its property in the heart of the family; to avoid this ultimate catastrophe, middle class women were required to observe an inviolable rule of chastity (Finer Committee, 1974).

The 'feminine illusion' to which, as various commentators have noted, this historical period gave birth (for example, White, 1970; Cecil, 1974), thus coincides both with radical shifts in the socio-economic system and with the emergence of an industrial mode of cultural production. Its illusory nature lies in the fact that it masks or sets out to mask—the fundamental contradiction between the idealization and the structural subordination of women in society.

These problems in relation to women and cultural production, although they have been discussed in the context of a particular historical setting, are neither anachronistic nor culture-specific. Their modern corollaries should become apparent in the global review of issues affecting women in and through culture and the media which will follow. But there is one other factor which makes the relationship of women to cultural industries and their products a very distinct one. This is the way in which women as a group are used in cultural imagery for purposes both economic and ideological. Although this was raised to some extent above, the point is not simply that certain images of women which are mediated through the culture may affect the perceptions and behaviour of men and women in relation to each other. Beyond this, there is a sense in which the images of women (which have been socially and culturally constructed) can be appealed to, or centrally placed in, the construction of much broader social images than those directly relating to women themselves.

For example, in her discussion of the construction and ideological function of the image of 'modernity', Michele Mattelart highlights the prior image of 'woman' as the hub from which the media propagate their particular 'culture of modernity' (Mattelart, 1978). The image of womanhood, she argues, is basically—even mythically—related to ideas of continuity, perpetuation and perdurability. 'Through the hidden power of its image, its unconscious insinuation, the female face . . . is the indication of a non-aggressive proposal, exuding security and lawfulness.' Yet, in an apparent paradox, the media continually associate—visually—women with the 'arsenal of symbols', fashions, new commodities, new designs, new life-styles which delineate the culture of modernity. What this means, for Mattelart, is that a particular image of modernity is being constructed, in which tradition acquires a new validation and perpetuation, in which alongside the appearance of movement and change there is a reassuring sense of order and permanence, and which is 'hiding the basic fact that the modern themes do no more than renew the old myths' (Mattelart, 1978).

Chapter 5

Patterns of distribution and access

Despite what has so far been implied in terms of the general location of problems in what I have been describing as the relationship of women to media, the enormous differences which exist between and within the media in various parts of the world must also be considered. They have an impact not only on distinctive conceptualizations of the women and media relationship but also on the range of practical possibilities for development or change in that relationship.

The basic premise that the media are potentially powerful agents of socialization and of social change—presenting models, conferring status, suggesting appropriate behaviours, encouraging stereotypes—underlies almost all past and current analysis of the women and media relationship. However, within the overall analysis two broad and separate approaches can be identified. In the first place, there has been a call for an examination of the present influence of the media on the formation of attitudes, the development of self-concepts and social perceptions, and the creation of social values in both women and men. This approach is particularly concerned with reform, and responds to a set of political and economic conditions prevalent in countries with already developed media systems, in predominantly commercial or public ownership. Secondly, stress has been laid on the need to search out positive ways in which the media can be used to advance egalitarianism and to improve the status of women. This approach emphasizes development and it responds to possibilities in countries where the media system is not yet highly evolved and/or where there is a stronger element of government control. Delineation of these approaches does not of course imply that they are mutually exclusive. Clearly, they both recognize similar problems and potential in the interrelationship between the mass media and women's status: they simply seek to intervene in that relationship at different stages of its development.

It goes without saying that a basic fact affecting the women and media relationship is the differential distribution of media systems and output between the developed and the developing world. For the distribution of mass media in the world is strongly disproportional to the distribution

of population, with a tremendous concentration of media in a small number of countries in the developed regions (see Table 1).

In terms of individual media, the number of daily newspapers in the developed world is 4,620, whereas in the entire developing world it is only 3,280. In sixteen African countries, the ratio of radio receivers to population is less than 10 per cent; in nineteen countries in Asia, it is between 1 and 8 per cent. Twenty African countries are without television, and in most of those which have television less than 1 per cent of the population have receivers. In Asia, the proportion of television receivers per population is generally less than 5 per cent. In contrast 96 per cent of all American homes had at least one television receiver in 1978 (*Broadcasting Yearbook, 1979*).

It is just as important to consider the access of various sectors of the population to those mass media which do exist. Clearly, as far as television is concerned, only the élite urban strata are covered in many developing countries, and even there, differential access is likely between women and men. A Kenyan study, for instance, found that men were more than twice as likely to watch television than were women (reported in Okwenje et al., 1977). In the case of radio, however, the same study found a much smaller differential: while 70 per cent of men listened to radio, almost 60 per cent of women also listened.

With radio the ratio of receivers to population is less significant than in the case of television, largely because of the portability and flexibility of the transistor radio. There are reports from many countries of group listening to educational radio programmes while at work in the fields or in the market-place. In Egypt, for example, it has been estimated that women account for 70 per cent of the audience for radio literacy courses (Maddison, 1974). At the same time, differences between urban and rural women remain important. For instance, studies carried out in India found that 80 per cent of rural women claimed never to hear radio broadcasts, compared with 30 per cent of urban women (Yadava, 1976). In the West, the majority of radio listeners are women and not just those who are home-bound: the radio is a common source of news and entertainment for people at work in factories, industrial concerns and so on.

When it comes to the print media, differing literacy rates between men and women take on special importance. On every continent, the majority of the illiterates are women. In Africa, Asia and the Middle East, there is a difference of at least twenty points between male and female literacy rates, and in all three regions the difference has grown since 1960. Overall, 40 per cent of the world's women have no access to what is the cheapest, most durable and most accessible medium of communication, but the proportion reaches 51 per cent in Asia, 83 per cent in Africa and 85 per cent in the Arab states (Unicef, 1975).

Even access to film and cinema attendance in developing countries is very much more limited for women than for men, particularly among rural women. Studies carried out among rural women in Kenya indicated that only 2 per cent saw films regularly and even among urban people, men were twice as likely to visit the cinema on a regular basis (reported in Okwenje et al., 1977). Similar studies in India found that less than

TABLE 1. Percentage media distribution by region

Major areas	Population	Newspaper circulation	Book title production	Newsprint consumption	Radio receivers	Television receivers	Seating capacity in cinema
Africa	13.0	1.5	1.9	1.4	3.1	0.7	2.6
Asia[1]	44.6	22.1	15.5	19.2[2]	11.8	9.7	15.6
Northern America	7.7	16.2	16.2	41.6	46.2	35.8	14.3
Latin America	10.4	5.6	5.1	5.1	8.5	7.4	9.1
Europe	15.3	28.2	46.5	24.8	17.2	30.6	24.7
Oceania	0.7	1.7	0.9	2.8	0.6	1.3	1.3
USSR	8.3	24.8	13.9	5.1	12.6	14.5	32.5
(Arab states)	(3.6)	(0.7)	(0.9)	(0.5)	(1.9)	(0.9)	(1.3)
	100.0	100.0	100.0	100.0	100.0	100.0	100.0
Developed countries	36.6	85.8	68.3	85.5	82.6	89.5	80.5
Developing countries	63.4	14.2	31.7	14.5	17.4	10.5	19.5

1. Not including China, Viet Nam or the Democratic People's Republic of Korea.
2. Including China, Viet Nam and the Democratic People's Republic of Korea.
Source: Unesco, 1975.

1 per cent of rural women saw films regularly, and 78 per cent had never seen a film. Among urban women, nearly a quarter saw films regularly (Yadava, 1976). Both the Kenyan and the Indian women, as well as Senegalese women interviewed by Aw (1979), said that domestic chores prevent their attendance at the cinema or mobile film unit in the early evenings; later at night they are not expected to go out, either alone or in groups.

So, despite an overall growth in world communication facilities in recent years, a large percentage of the world's population—women in particular—is not reached by the mass media at all. Those who do form the audience are often presented with an output which does little to reflect, explain or comment on life as they experience it.

Quite apart from the problem, which exists in all societies, of the concentration of media facilities under the control of urban élites (and a consequent irrelevance of much content to rural or less privileged groups), there exists in many developing countries a lack of resource for the production of local materials: this is particularly true of television programmes, which are exported on a massive scale by the United States. Small local networks find it much more economical to import American programmes than to produce their own, and the United States exports to almost all countries with television systems. In some countries of Latin America and the Caribbean, United States imports account for up to 50 per cent of the total programming while in Western Europe, the Middle East and parts of Asia, more than 20 per cent of programming is made up of United States imports (Nordenstreng and Varis, 1974).

Considerable debate—though less detailed research—has centred on the implications of this vast traffic. To what extent are culturally alien social models and values imposed on and learnt by viewers in countries which 'buy American'? Although there is scanty empirical evidence to support it, it may seem intuitively correct to suppose that the large-scale display of American images of women must have an impact of some kind on the formation or transformation of local perceptions, both male and female. It is important to remember too that the programmes exported are often part of a now historical era. In Sri Lanka, for instance, where television was introduced on an experimental basis in 1979, almost all of the entertainment programmes were American in that first year. Noting that the old films regularly shown dated from the 1950s, Goonatilake (1980) commented that 'the age of McCarthy may be dead and a more liberal mass media may exist in America, but in Sri Lanka it apparently has got a new life'.

Perhaps even more insidious than the direct foreign import is the phenomenon of the transnational product, in particular the magazine, whose editorial seat and production base may be outside the country or countries in which it is distributed, but which is 'adapted' to the language and—in some superficial ways—to the customs and style of the country for which it is destined. For example *Amina*, a magazine edited and produced in France, is distributed throughout francophone Africa. It contains a curious mixture of homespun advice based on traditional patterns of male-female relationships alongside articles which purport to

illustrate for instance the expanded career possibilities open to the 'modern' woman—careers so esoteric as to be beyond the purview of almost all of its African readers. Its advertising, almost exclusively for beauty and fashion, directs readers to French mail-order firms or publicizes the products of large multinational firms. The same kind of role is played in Latin America by magazines such as *Vanidades* or *Buenhogar*, controlled by giant multinational enterprises such as the Hearst Corporation. Here, the role of advertising is paramount (almost a third of the total space in such magazines is devoted to advertising), and it is primarily of the 'universal' and transnational type. One study, for example, found exactly the same advertisement appearing simultaneously in six magazines in different Latin American countries (Santa Cruz and Erazo, 1980). It could, without doubt, be found in other magazines, in other world regions. For as the one-time president of Grey Advertising, one of the largest United States agencies, put it: 'The desire to be pretty is universal' (Fatt, 1967). Other advertisers believe and act accordingly, as some headlines from *Advertising Age* and *Business Abroad* indicate: 'Rubinstein Ads Not Altered for Señoras' or 'World Wide Beauty Hints: How Clairol Markets Glamour in any Language'.

The effects of these various transfers of media forms and imagery are likely to be just as important for media producers as for audience members. It is not simply that, over time, locally produced materials can take on the same stylistic and even substantive features as those of the imports (it is clear, for example, that many glossy women's magazines now being produced in Asia, Africa and Latin America have been heavily influenced by Western models). Just as important is the reliance of many media products on advertising revenue, most of which comes from a small number of Western-based agencies: the need to attract the right kind of reader (i.e. the reader who will buy the products advertised) will have a direct effect on the content and style of the material which provides the 'context' in which the advertisements are placed.

Finally, account must be taken of the various alternatives which exist in every country to the mass media as normally defined. For these 'alternative' media introduce new patterns of access among women. Traditional types of communication media, such as drama, story-telling, puppet shows, songs and mime are important in many developing countries, particularly in the rural areas. Although little is known about the role of such media in attitude-formation or in the portrayal of women, it is clear that in large areas of the world such media are very much more accessible—both to women and to men—than are the electronic media. It may be deduced, then, that their influence is likely to be substantial.

Small-format electronic media, such as audio and video tapes and cassettes, open up possibilities for women's greater access to media output in both industrialized and developing areas. There is growing evidence that these formats can successfully provide more progressive models for women than those which are the stock-in-trade of the major mass media. Freed from the cumbersome trappings of broadcast studio production, portable recording equipment can be brought into villages and rural areas where the concerns and experiences of ordinary women

can be readily tapped. The fact that programmes can be played back immediately generate involvement and discussion. These small media have been used extensively by women's groups in the United States and Europe, and are increasingly being used in parts of Africa, Asia and Latin America.

Also growing outside the mainstream is an alternative women's press. On every continent, publications which range from type-set semi-commercial magazines to one-page broadsheets and which include cartoon comics for illiterate women have developed, with the purpose of filling a need not met by traditional women's magazines. Circulations range from 500,000 to less than 100. While important, the impact of these publications is badly hindered in many areas by the widespread illiteracy of women. Although several illustrated cartoon formats do exist—notably in Latin America—they require particular production skills, and resources which are not always available. As a consequence, publications of this kind tend to be criticized for reaching only those women who have least need of them.

Chapter 6

Women and media: some implications

Taking account of the considerable differences which rest—between media distribution and forms, and between the access of various strata of women to existing media—it is arguable that the treatment of 'women' as a single analytical category subsumes other distinctions of fundamental and greater importance; that to speak of 'women and the mass media' obfuscates and renders banal a set of complex and multi-faceted relationships. For instance, basic differences in economic activities, family patterns and life styles among urban and rural women create very different expectations and constraints for the two groups. Ethnic and cultural diversity and the adaptation of policy to local needs and values produce a complicated array of social outcomes which make it difficult to generalize about the consequences of particular measures for women collectively. Women's self-perceptions, roles and problems are not simply different from those of men; they are also profoundly different for different social classes.

Certainly there are profound analytical problems in assuming that women constitute a uniform category. Certainly there are enormous differences—for example, in terms of structure, purpose, coverage, and so on—from one media situation to another. Certainly, too, there is no necessary correspondence in particular diagnoses or prognoses of problems linking women and media from one cultural context to another. The preoccupations of the majority of women in the West *vis-à-vis* the media are the preoccupations of only a small élite group of women in the developing countries. Damaging, negative images of women which engulf vast audiences in the industrialized countries reach only a fraction of the populations of the developing world. Discrimination against women's access to decision-making posts within the media is hardly a problem in countries where only a handful of women enter the media professions in the first place.

Yet, in a striking way, aspects of the mass media's relationship to women—in terms of both portrayal and employment—transcend cultural and class boundaries. The same limited set of dominant characterizations of women, the same impoverished patterns of female partici-

pation in the media can be found—well-rooted—in established media structures and 'emergent' in younger systems. This in itself is highly indicative, pointing to the global context within which communication systems are developed and media content created. The context is primarily an economic one. For example, the growth of the United States media both at home and abroad must be seen in relation to the place of the electronics and telecommunications industries in twentieth-century American expansionism. The nature and influence of the British media must be related to the changing role of British capital in the post-imperial period (see, for example, Tunstall, 1977; Murdock and Golding, 1977).

Moreover, when the media are located within the overarching structure of cultural production as a whole, the global context within which women's status is defined becomes even more apparent. Links between the communication media and other cultural vehicles such as language and education become particularly clear in the context of colonial and neo-colonial economic relations. Much has been written, for instance, of the role of language in expressing and procuring the subordination of women. As Robin Lakoff has pointed out, women's speech and language differ substantially from those of men. Women tend to use weaker expressions, be excessively polite, use questions rather than statements. These differences are argued to be a result of women's position of powerlessness within the social structure (Lakoff, 1975). And as Ali Mazrui has underlined in the African context, language, media, culture and structures of domination are all interrelated elements in the phenomenon of cultural dependency (Mazrui, 1975). The educational system also has a crucial role to play. There is a great deal of evidence to show that educational materials and curricula condition girls, even by the time they have finished primary education, to think in terms of feminine stereotypes (see, for example, Byrne, 1978). In the global context, the relationship between educational systems and the publishing industry enters into this conditioning process. For example, the largest producers of educational books include firms such as Xerox, ITT, CBS, and Westinghouse. When the fact that in 1977 exports accounted for 36 per cent of British book sales, with further profits derived from sales of local subsidiaries in developing countries, and the fact that most books in the developing world are college or school texts are set in this light (Golding, 1978), it becomes clear that the education and publishing industries are inextricably entwined. It also seems evident that each is central to both the subordination of women and the structure of cultural dependency.

A view of the media as potentially powerful agents of socialization and of social change lies at the heart of discussions of the relationship of media to the women's issue. In those countries or regions where media systems developed and established structures at a time when women's specific problems and needs had not yet been articulated, the fundamental problem is structural reform, to reflect changes in women's role and status. But, based on our knowledge of the essentially conservative or even discriminatory tendencies of the developed media in both the portrayal and the employment of women and the potential influence of

the media on the formation of attitudes, self-concepts and social perceptions, the debate in countries with newly emerging media systems is more concerned with how to make these media work in women's best interests. Here, although questions of reform are relevant to certain media practices which have already been established, the crucial issues concern the early development of appropriate structures and mechanisms to ensure a fair representation of women as employees and as audience members. Additionally, in conjunction with the educational system and the introduction of legislation, the media are seen as having a positive developmental role to play in improving women's status.

In many ways, mass-media systems are a reflection in microcosm of distributions of power and control. In a world where women's access to political and economic power is in most cases severely limited, their status and roles are defined within political, economic and cultural systems which tend to exclude them from active participation. The mass media's role is primarily to reinforce definitions and identities set in a framework constructed for and by men. When that framework expands to admit women, the media can be seen to reflect this expansion. This interrelationship between mass media and politico-economic systems highlights the very limited sense in which the media can be described, much less used, as independent change agents.

An overriding concern for women, therefore, should be with changes in the political and economic structure. At the same time, a fundamental question is whether and which mechanisms can be developed to minimize ways in which the media have been observed to lag behind change in the broader social system. For even if the media cannot be expected to initiate change, they can certainly be expected to reflect it.

Part II

What do we already know?

Part II

What do we already know?

Introduction

The assumption that media messages and images constitute a powerful social, cultural and political force dominates both public debate and research perspectives in the field of mass communication. It is an assumption which underlies practically all questions concerned with the link between media output and social consciousness. Historically, media research has tended to be preoccupied with analyses of communication content and its effects rather than with studies—for example, of communication institutions or processes—which aim to explain how or why media output comes to be as it is. While analyses of media content were common place in Europe and North America in the 1940s, it was not until 1950 that David White introduced the powerful concept of the 'gatekeeper' who selects, processes and organizes the information to be made available to the audience. More recent work has redressed the balance somewhat, although the judgement that the emphases of research 'perpetuate the predominant view in which the media messages sometimes appear to be reaching the audience members' eyes and ears as if from heaven above or (in some perspectives) hell below' (Tunstall, 1970) still has a ring of truth.

This imbalance is reflected faithfully in work on the relationship between women and the communications media. In relation to the vast number of studies of media portrayal of women, research into the context, nature and extent of women's participation in the production of media content is scant. In part, this is simply a mirror of overall trends and tendencies in media research; for example, in presenting their institutional framework for studying women and the media, Butler and Paisley admit that 'writing this book a decade ago, we might have omitted a section on institutional analysis' (Butler and Paisley, 1980). The present imbalance, however, is also a reflection of the specific historical context which has given rise to much of the research into women and the media—a context of social concern, of engagement, in which the studies have often been carried out by, or on behalf of, women's groups and organizations. In such a context, critical analysis inevitably focuses on the artefact itself: it is immediate, accessible, all-pervasive and it is relatively cheap to research. But once carried out, analyses of output *per se* are weak in

terms of suggesting or justifying action for change. Moreover, they tend to raise yet other questions for research, the most obvious being why is the content as it is? This throws the focus back squarely on the organizational context of production, the composition of the media workforce, and the relationship between the output and its producers.

Consequently, although implicitly linked in terms of the fundamental problem addressed, there is a *de facto* disjunction between studies of media portrayal of women and most research into women's participation in the media. In every world region the imagery 'side' of the problem is more extensively documented than the question of participation, which in many countries is completely unresearched. For this reason, the research evidence relating to the two 'sides' of the problem will be presented separately, although an attempt will be made to link both sets in a concluding interpretive section. First, however, a note on some limitations of what is to follow.

A basic problem is the tendency in all research to describe situations which are themselves somewhat in the past. This is partly because of the difficulty of making objective analyses and interpretations of current problems. Partly, too, it is due to the inevitable delay between the completion of research and its publication: studies published in 1980 are likely to refer to circumstances existing a couple of years earlier. This is an important point to bear in mind when attempting to reach conclusions based on research into women and the mass media, since in a number of countries legislative and other changes may be affecting the relationship in ways which are as yet impossible to specify.

A second problem results from the geographical bias of the available data, much of which originates in North America and Western Europe, although there is a growing body of research and documentation from Australia, Latin America and the Caribbean, and from Asia. Information from Africa and the Pacific remains scant, while data from Eastern European countries are difficult to locate. In the case of Africa and the Pacific, the lack of documentation primarily reflects a preoccupation with developing what are relatively young media systems: experiences tend to be documented at later stages in the process. The difficulty in obtaining data from Eastern European socialist countries arises largely from the fact that a specific set of problems, or even questions, concerning the relationship of women and the mass media do not seem to be formulated in a distinct way in these societies. In the context of an explicit government commitment to full sexual equality, such formulations may seem politically irrelevant.

There is the problem of the quality of the data which does exist. Approaches ranging from the narrowly empirical, through the subjectively impressionistic to the polemically committed, pose problems of comparability and credibility in terms of findings. Documents do not always state the methodology used; methodologies described at times reveal a very poor conceptualization of the problem to be studied. Nevertheless, there exist a number of soundly based studies in Latin America, Asia, Europe and North America whose findings do not in general fundamentally conflict with those of the methodologically more suspect analyses.

Chapter 1

The portrayal of women in the mass media

Two related concerns underlie studies of the ways in which women are portrayed by the mass media.

The first is directed fairly explicitly towards the relationship between media presentations of women and men, and objective demographic fact: for instance, the extent to which the media misrepresent the real proportions of women *vis-à-vis* men in the population or in the workforce; or the extent to which social class, age, occupational status are ascribed to the two sexes in a way which contradicts reality. The assumption behind this concern is not that in every sphere of their output the media should faithfully and accurately represent reality; it is generally accepted that in many ways the media deal with fantasy, and that this fantasy is recognized as such by the public. The argument is, rather, that if the media, for instance, over-represent or glamorize certain occupations, then women and men should be portrayed as holding those occupations in proportions which reflect the proportions of women and men with those occupations in the real world. In other words, that within the fantasy there should be consistency with reality. This area is relatively simple to investigate and provides a potentially concrete indication of media bias against women.

The second concern is really an extension of the first, but invokes a more complex theory of the relationship between women and media and poses greater problems for research in terms of both analysis and interpretation. Its basic hypothesis is that the mass media as a cultural force do not simply reflect, but subtly and indirectly help to shape social reality. The hypothesis arises from sociological and social psychological theories of socialization. These essentially propose that social attitudes and behaviours are learnt through a complex process of imitation and comparison with the attitudes and behaviours presented by significant individuals and groups and by cultural forces, including the mass media.

In theory, as one of a number of socializing agents, the media should carry no greater or lesser responsibility or power in the socialization process than any other cultural force. However, a number of factors

particular to the structure and internal demands of media organizations have suggested to some theorists of sexual inequality that the mass media play a particularly conservative role in socialization, reinforcing traditional values and beliefs. These factors include the sexual composition of the media work force which in almost every country is predominantly male—overwhelmingly so in the influential areas of management and production; then there is the reliance of many mass media organizations on commercial backing and a consequent pressure to deal in known and accepted images and contents; thirdly, mass media products —whether television or radio programmes, magazines, newspapers, films—are, in general, required to make an immediate and vivid impact and to be quickly and easily absorbed by their audience: considerable reliance is therefore placed on the use of simplified, recognizable and **standardized characterizations in media output. For these reasons, it** has seemed possible to some commentators that the media present a social reality which—if not demonstrably false—feeds on the most conservative forces in society, ignoring new trends until they have become established and thus fulfilling a primarily reinforcing role—rather than a transforming one—in the culture.

To take, for example, the 'standardized characterizations' or stereotypes through which much media output can be seen to depict both men and women: these do not, it must be clear, originate within a vacuum in media organizations. Rather, they arise from fundamental beliefs in the wider society concerning behavioural and psychological differences between men and women. Even if the validity of such beliefs is open to question, it might seem unrealistic to expect the media—whose appeal is to a mass audience—to deviate from accepted norms. At the same time, the concern of some media critics has been that by repeatedly and consistently depicting women and men in stereotyped roles—and by tending to portray deviations from these roles in a negative rather than a positive way—the media may actually work against the potentially transforming effects of those meetings with counter-stereotypes which women and men may experience in ordinary social life. This would cast the media not simply in a neutral or even a conservative role, but as a reactionary force in the development of social equality.

Images of women in the media: a regional review

The presentation of a concise and accurate picture of how the media portray women around the world poses enormous problems of compression and synthesis. However, the adoption of a region-by-region approach is more than a presentational device. It should also help to illustrate a particular structural point. The method of presentation should **ensure that any marked regional differences are readily highlighted. But** as the analysis proceeds, it should become clear that although differences do exist, it is the similarities which are ultimately striking, suggesting the universality of certain dimensions of women's concerns and of the women and media relationship.

Images in North American media

There are two reasons for beginning with a review of women's portrayal in the media of North America. In the first place, most research and analysis of the subject originate there; consequently, a more comprehensive picture of female imagery in the media can be drawn for North America than for other parts of the world. Secondly, the portrayal of women in American media—particularly television—is relevant to a discussion of worldwide patterns because of the overwhelming predominance of the United States in the export of media materials, especially television programmes. As has already been pointed out, American imports form a high proportion of the total programming in many Latin American countries, parts of Asia and Europe, and in the Middle East.

So far, there has been virtually no research into the effects of imported sex-role images on the formation or transformation of local perceptions. However, in Australia for example, where 30 per cent of the programmes originate in the United States, research has indicated that children's perceptions of social reality in their home country were affected by those imports (Pingree and Hawkins, 1979). Other studies—for instance in Egypt and Yugoslavia—report contradictions between imported media images of women and indigenous cultural values (Suleiman, 1974; Bosanac and Pocek Matic, 1973). In the case of Finland, images in the imported programmes are said to run counter to current social and media policies vis-à-vis the portrayal of women (Harms, 1978). In a detailed study of newspaper and magazine advertisements in the Philippines, it was argued that the advertising reflected Western rather than Filipino cultural values: almost three-quarters of the men and women depicted were shown in traditional roles, with men being associated with characteristics of strength, leadership, decision-making, independence—and women with the reverse of those—while it was held, anthropological studies indicate that the masculine-feminine concept has never been rigidly defined in the Filipino culture (Marquez, 1975). Approaching the question from a different angle, a minutely documented analysis of national and transnational women's magazines in five Latin American countries (Santa Cruz and Erazo, 1980) concludes that the propagation of the 'American dream' fulfils a function which is as political as it is commercial: the models of womanhood provided by these magazines invoke aspirations which ensure the fundamental stability of the transnational commercial and political system. Portrayals of women in the media of North America are to be evaluated, therefore, not simply in terms of the pervasiveness of American media within national boundaries but of their potential resonance within an increasingly global order of communication.

Television

In order to systematize in some way the mass of documentation on the representation of women in North American television, a modified

version of a framework developed and tested by Jean McNeil (1975) in a comprehensive content analysis of television series will be used as a starting-point. McNeil's 7-point critique has been reduced to five basic statements from the research in this area.

Women are under-represented in general, and occupy less central roles than men in television programmes. Research results substantiate this finding for every category of television programming except day-time 'soap-operas', where men and women appear in roughly equal proportions (Katzman, 1972; Turow, 1974). In news programmes, women are grossly under-represented. An analysis of evening news programmes on the NBC, CBS and ABC networks in 1974-75 (United States Commission on Civil Rights, 1977) showed that only 14 per cent of newsmakers were women, while an update of this study in 1977 revealed a *decrease* in the percentage of women in newsmaking roles: they then represented only 7 per cent of the newsmakers (United States Commission on Civil Rights 1979). The exclusion of women from the 'news' is of course related to definitions of what actually constitutes 'news'. As Tuchman (1978) points out, the professional ideology to which 'newsmen' subscribe identifies male concerns as the important news stories, and accordingly relegates topics traditionally characterized as 'female' to a peripheral status as news. The proposition is convincingly validated in an empirical study of evening news broadcasts on CBS and NBC, between 1965 and 1969, and between 1975 and 1978 (Gans, 1979): this exhaustive analysis led to the conclusion that indeed 'the news reflects a white male social order'.

Perhaps more surprising is women's low visibility in other types of programming. Analyses of various types of prime-time network dramatic programming (situation comedies, family drama, drama-adventure) indicate percentage of female characters varying from 39 per cent (Miles, 1975) to 26 per cent (United States Commission on Civil Rights 1977) across all types of drama, while in drama-adventure the percentage is much lower, reaching 11 per cent of total characterizations (Weibel, 1977). There is little to choose between commercial and public television in this respect. A study of drama on public television (Isber and Cantor, 1975) found women accounting for only 20 per cent of all roles, although an updated study (Signorielli and Gerbner, 1978) found that women were occupying 28 per cent of roles on public television drama in 1977. But despite this, and although the updated study of the United States Commission on Civil Rights (1979) indicated a slight increase from 26 per cent to 28 per cent in female characterization, it has to be pointed out that since the early days of television, the appearance of women has apparently become *less* frequent. For instance, one of the earliest analyses of American television—carried out in the 1950s—found that women were 34 per cent of the characters (Smythe, 1954). But in eleven studies from the 1970s examined by Butler and Paisley (1980) women averaged only 28 per cent of characters.

In children's television, the picture is similar: research reports percentages of female characters varying from 15 per cent (O'Kelly, 1974) to

25 per cent (Dohrman, 1975). More recently, the studies of public television which have already been mentioned found no change between 1975 and 1977 in the percentages of female characters in *Sesame Street* (22 per cent) and *The Electric Company* (31 per cent, although in the same period female characterization in two other children's programmes —*Villa Alegre* and *Mr. Rogers*—had increased from 31 to 42 per cent, and from 26 to 48 per cent respectively. Another finding, from a wide range of studies, is that in commercials screened during children's programming, women and girls are much less visible than men and boys (Barcus, 1971; O'Kelly, 1974; Busby, 1974; Chulay and Francis, 1974). Across all these studies the ratio of males to females was found to be about 2 to 1.

Marriage and parenthood are considered more important to women than to men; the traditional division of labour is shown as typical in marriage. Ceulemans and Fauconnier (1979) in their review of American research conclude that despite difficulties of making comparisons across methodologically different studies, there is plenty of evidence to support the thesis that in television programmes marital status is a more crucial factor in identifying women than in identifying men, and that parenthood is more frequently associated with women than with men. On the basis of their examination of seventeen separate American studies, Butler and Paisley (1980) reach the same conclusion, adding that the same holds true for children's television programming: they cite nine separate analyses which illustrate not only that children's programmes consistently show men in *more* roles than women, but that women are more often shown in *family* roles. In Canada, in a study of eight categories of programme produced by the Ontario Education Communications Authority (Raices, 1976), there were similar findings: although women tended to be presented as wives and mothers, men were rarely presented as husbands and rarely as fathers. Advertising, in particular, places women firmly in the home, and identifies housework as a woman's special responsibility. Various studies of television advertising in the United States (for example, Maracek et al., 1978; O'Donnell and O'Donnell, 1978) and Canada (Courtney and Whipple, 1974; Task Force on Women and Advertising, 1977) have underlined the extent to which advertising associates domestic tasks and products with women, while men in advertisements tend to be depicted outside the home, in a wider range of settings.

Employed women are shown in traditionally female occupations, as subordinates to men, with little status or power. An overwhelming body of North American research indicates that, in relation to women's actual participation in the work force, television programmes of all kinds, as well as television advertising, under-represent women workers (for example, McNeil, 1975; Tedesco, 1975. Downing, 1974). Although in reality almost half the labour force in both the United States and in Canada is female, studies show percentages of working women in television portrayals which vary from 30 per cent to as low as 12 per cent (in both the 1975

and 1977 analyses of *Sesame Street* (Isber and Cantor, 1975; Signorielli and Gerbner, 1978)).

Studies also show a concentration of women who are shown as employed in a limited number of jobs and in predominantly female fields and roles. Although there is some indication that women may be increasingly found in occupations traditionally reserved for men (Northcott, 1975; Signorielli and Gerbner, 1978), the recent United States Commission on Civil Rights study (1979) noted that there is a significant difference in the extent to which women are seen in occupational roles compared with men's appearance in occupations; men are seen as doctors while women are nurses; men are managers while women are secretaries. It concluded that a 'considerable amount' of sex-stereotyping of occupations was still occurring.

The question of power and status of men *vis-à-vis* women in television portrayals relates in part to the kinds of occupational role to which each sex is predominantly assigned. Since women are rarely seen in authoritative positions such as lawyer, doctor, judge, scientist (Culley and Benett, 1976) they are rarely in a position to exercise direct authority over an adult male. In a study of the pattern of advising and ordering in male-female interactions, Turow (1974) found that dramatic characters on television were selected, occupations were assigned and plots developed in such a way as to minimize the chances for women to display superiority, except in traditionally accepted female areas of knowledge. A further indication of television's emphasis on male authority is the reliance on male voices in advertising to 'sell' the advertised product. All studies in both Canada and the United States of America report an overwhelming predominance of male 'voice-overs'. For instance, reviewing eleven studies carried out between 1972 and 1978, Butler and Paisley (1980) found that overall about 90 per cent of the voice-overs are male, and only 10 per cent female. The assumption behind this practice seems to be that women depend on men for advice and assistance in the purchase and use of products, even those associated with tasks considered traditionally female.

Women on television are more passive than men. Various measures have been used in different studies to investigate the degree of passivity or activity in male and female television characterizations. Women's absence from action-adventure programmes and from decision-making roles, their tendency to be depicted as victims rather than aggressors, their financial and emotional dependence on men, their unwillingness or incapacity to solve their own problems: these traits have been interpreted in Canada (for example, National Action Committee on the Status of Women, 1978) and the United States of America (for instance, Tedesco, 1975) as reflecting an image of women which is typified by passivity. Research into children's programming (Rickel and Grant, 1979) also finds an overall image of women which defines them as dependent, victimized and passive people.

In news coverage too, studies indicate a tendency to foster the image of dependency and passivity associated with women. A 1974 survey

(American Association of University Women) concluded that television news programmes generally presented two stereotyped images of women: the helpless victim and the supportive wife or mother. Two years later, a study of WNBC-TV news (Women's Advisory Council, 1976) found that women considered newsworthy were mainly criminals, victims, entertainers or relatives of famous men. Moreover, during the monitoring period, a list of current women's issues and activities was compiled, none of which was reported by the news. The two studies by the United States Commission on Civil Rights (1977, 1979) underline these findings and indeed indicate some deterioration in the presentation of newsmaking women over the period 1974 to 1977.

Television ignores or distorts the women's movement. Studies carried out in the early 1970s find an absence of feminist characters and themes in television programmes. In the few programmes featuring independent, talented women, their personalities and actions tended to be ridiculed (Miles, 1975). Some later studies report a certain amount of progress in the treatment of women's issues. In a content analysis of dramatic programmes between 1971 and 1973, Northcott (1975) noted increasingly non-traditional portrayals of women; this is attributed to an awareness of and response to the growing feminist movement. Weibel (1977) accounts for minor positive developments—an increasing acceptability of women's issues as themes for situation comedies, and the portrayal of women as more responsible individuals—in this way also. However, more recent reports (Tuchman, 1978) do not appear to indicate a continuation of that progress. Indeed, current commentators, (Newland, 1979; United States Commission on Civil Rights, 1979) express concern at the growth of American programmes portraying women as sex-objects, possibly reflecting some misconceptions among broadcasters concerning women's 'liberation' and 'sexual freedom'. A more deliberately obscurantist or even exploitative explanation can be inferred from an analysis of programmes planned for network transmission in autumn 1978 (Farley and Knoedelseder, 1978), a striking proportion of which were described as 'jiggly' shows—programmes in which clothes or action emphasized women's bodies. In interviews with forty actors, writers and producers about the ideas behind the programmes, one writer commented that it was 'supposed to be a time for women's projects in television,' but that what the networks really wanted was girls who were 'good-looking, well-endowed and running towards the camera'.

News coverage of women's issues on television has fared little better. Early studies report a disproportionate treatment of issues related to women compared with other news topics. For example, Cantor (1972) found that out of twenty-one news categories, women's rights and changing role were least emphasized. In its first study, the United States Commission on Civil Rights (1977) reported that just over 1 per cent of the news stories in its sample dealt with women's issues; but two years later they reported that both the absolute number and the relative percentage of such stories had actually decreased.

Radio

If the problem in presenting research findings relating to television images of women is one of synthesis, the difficulty in the case of radio is the reverse. In North America as Butler and Paisley (1980) point out 'radio had the misfortune of being eclipsed by television in the 1950s when content analyses of media began to be conducted on a large scale'. Certainly there are no current qualitative analyses of the portrayal of women in North American radio, and very little of even a strictly quantitative type.

In a survey of local radio stations in the Philadelphia area, Kaplan (1978) found that only 13 per cent of voices heard in advertisements and public service announcements were female, a finding very much in line with those dealing with voice-overs in television commercials. A 1975 survey of public radio stations (Casanave, 1976) found that a third of them broadcast no women's programmes at all; those that did gave just over 1 per cent of their weekly time, and between 1 per cent and 3 per cent of their total programme budget to programmes for women. Similar findings emerged from a study conducted in the Boston area in 1977, and reported in Ceulemans and Fauconnier (1979).

The paucity of the data, however, makes it impossible to offer any conclusive statements about the portrayal of women in radio programming. For example developments in 'access' programming which have led to the establishment of groups such as the Feminist Radio Network in Washington are so far undocumented. A non-commercial station like WBAI-FM, operating from Manhattan, can broadcast 7½ hours of feminist programming per day, although the co-ordinators of its women's department report a constant battle with the management to maintain a regularly scheduled ouput (WBAI-FM, 1979).

Film

In general, studies of women's images in North American film present a historical perspective which place the high point in the portrayal of women as the 1940s when conditions of war encouraged or required women to become independent and self-confident. The retrospective approach taken by various studies which have analysed films in each decade of this century (for example, Haskell, 1973; Mellen, 1973; Rosen, 1973) reveal two overall trends. First, the number and significance of roles played by women have decreased since the early days of the film industry. Second, film portrayals of women reflect certain economic and political imperatives and concerns.

For example, between 1910 and 1930 women were important in the establishment of the star system and were given important roles (Griffith and Mayor, 1957). After the adoption of the Production Code in the 1930s, they began to be shown as more submissive (Haskell, 1973). In the 1940s, during the war years, women were shown as strong and self-assured (Rosen, 1973). But after the war and in the 1950s films reaffirmed the domestic subservience of women who were shown as 'simpering, dependent hysterics or as undulating sexual manikins' (Mel-

len, 1973). Overall, analysts agree that although in the late 1960s and 1970s films reflected some of the new feminist consciousness, women who rejected traditional roles tended to be shown as emotionally disintegrated, alienated and unfulfilled. Mollie Haskell concludes that currently the film industry 'is giving women the same treatment that it gave blacks for the half-century after *Birth of a Nation*: a kick in the face or a cold shoulder. And whether it is tokenism or the 'final solution', it is, as minorities everywhere have discovered, no solution at all.' (Haskell, 1973).

Magazines

Research into the content of North American magazines has distinguished between fictional and non-fictional content. In various analyses of the latter in magazines such as *McCalls, Ladies Home Journal, Cosmopolitan, Mademoiselle, Redbook* and *Ms.*, there are indications that even in the most traditional magazines there is some hesitant recognition of feminist aims and issues, and that alternatives to domestic images of women are being gradually incorporated into traditional formats (Newkirk, 1977). The fact that these magazines are directed to and read almost exclusively by women probably lies behind this: they are more likely to be in the vanguard of any changes in perception of women's roles than are the men who constitute half of the audience for broadcast programmes. Magazines can thus afford to—and indeed must—respond to these changes more quickly. Various analyses of *Cosmopolitan*, on the other hand, have suggested that the image it presents is merely another version of the traditional, passive picture of women, emphasizing as it does the importance of men in women's lives and of sexual rather than psychological, social or political liberation (Ray, 1972; Weibel, 1977). These conclusions recall the concerns regarding recent developments in images of the 'sexual woman' in current broadcast programmes. At the same time, studies of the fictional content of women's magazines reveal a conservatism which probably counterbalances any incipient progressiveness in the editorial content. Analyses reveal an overall decrease in the number of women characters with careers over time, when the real trend has been quite the opposite (Franzwa, 1975). The picture which emerges from magazine fiction is of a domestic, passive, emotional and dependent woman, seeking and finding happiness in conventional roles, while depending for her identity on the man in her life (Smith and Matre, 1975; Lugenbeel, 1975).

Finally, in view of the fact that magazines are a major vehicle for advertising, it is not surprising that magazine advertisements have been studied more extensively than any other aspect of print media. A seminal study from 1971 (Courtney and Lockeretz) has been twice replicated (Wagner and Banos, 1973; Culley and Bennet, 1976). These, as well as more recent work, including some longitudinal research (Belkaoui and Belkaoui, 1976; Venkatesan and Losco, 1975), point to the following general conclusions. Despite some increase in the percentage of women shown working outside the home, in general women are portrayed as housewives or in low-status jobs. Secondly, women are used by advertisers to sell products to both women and men on the basis of their

sexual appeal. According to Dispenza (1975) advertising strategies vary depending on the sex of the target group. In female-oriented advertisements, women are encouraged to identify with the female representative who achieves success with men as a result of using the product. In advertisements directed at men, male consumers are promised the female as a prize accompanying the product.

Newspapers

Analyses of newspaper portrayals of women echo much of what has been said earlier concerning the representation or lack of representation of women and women's issues in television news. Some special attention has been given to the study of 'women's sections', the very existence of which are perceived by some as inherently sexist (Merritt and Gross, 1978). Discussing the traditional women's page typical of American newspapers, Van Gelder (1974) suggests that a Martian reading such a page 'would conclude that every female earthling spent at least several days every month getting married'. Attempts to restyle traditional women's pages into a general interest section, in order to attract both male and female readers, have been studied (Miller, 1976; Guenin, 1975). The general conclusion of these studies has been that 'modernization' simply means a shift in emphasis towards entertainment, and that the restyling has produced no major change in coverage of lifestyles and consumer news.

On the other hand, Tuchman (1978) considers and analyses *The New York Times* family/style section (i.e. its women's page) as a resource for the women's movement. Although Epstein (1978) holds that the placement of news about women's issues on segregated women's pages tells men that this is not their concern, female editors and reporters interviewed by Tuchman argued that 'If the feminist stories didn't run on our page, they wouldn't run anywhere'. The then editor argued that other (male) editors were 'realizing the importance' of topics covered by the staff of the women's page and that more women's stories were starting on page one.

Yet how and why a story makes page one remains ambiguous: for example, a women's page reporter was assigned to cover a press conference held by Julie Nixon Eisenhower when she was scheduled to replace Barbara Walters on television for one week. When 'Eisenhower made comments about her father, the story was reassessed as hard news and moved to page one.' (Tuchman, 1978). In the final analysis, Tuchman argues, the debate as to whether news about women should be carried on the women's pages or the general pages of newspapers must confront the reality of the ideological structure of the news narrative. For once it becomes 'the responsibility of beat and general reports', women's news cannot 'undercut the news net by challenging the legitimacy of established institutions'.

The point is a fundamental and political one, which highlights the extent to which information and knowledge are socially constructed. It directs women to the question of the extent to which it is actually

possible to effect real change in the media—in North America and elsewhere—by attempting to work within existing structures, or whether those structures may be more successfully challenged and changed from without.

Images in the media of Latin America and the Caribbean

One particular concern of Latin American social scientists has been with the role of the mass media in the communication of ideas and values, and in the development of ideologies (Beltran, 1978). Within the last ten years there has been a notable growth of media research in this part of the world, and studies of the role and effects of media in the formation of sex-role and other social perceptions (for example, Colomina de Rivera, 1968 and 1976; Marques de Melo, 1971). More recently, responding to the influx of North American media products, particularly women's magazines, studies have looked at the role of transnational media in the transmission of values and ideological construction (for instance, De Marmora, 1979; Santa Cruz and Erazo, 1980). This research background informs the concerns behind many Latin American studies of media portrayals of women.

A cross-cultural comparison: magazines in Latin America and the United States

In one of the very few cross-cultural studies of media imagery, Flora (1973) analysed a total of 202 stories in a sample of working-class and middle-class magazine fiction, and found that the fictional heroine is characterized by dependence, ineffectuality, humility and virtue, lack of initiative, lack of career, lack of independent social mobility, emotional reaction to stress, lack of self control. Although differences were present by class and especially by culture in viewing passivity—there was a tendency for women to be more passive in the Latin American fiction, and for working-class women, particularly in United States fiction, to be more active than middle-class—women were overwhelmingly *idealized* as passive in *all* class and cultural situations. In these stories, women were more often rewarded for *passive* behaviour than for actively controlling their own lives.

The transnational model: United States magazines in Latin America

A major study of fifteen national and three transnational women's magazines circulating in Brazil, Mexico, Colombia, Venezuela and Chile, was carried out in 1977 (Santa Cruz and Erazo, 1980). The researchers examined the advertising and the general content of these magazines in detail, concluding that Latin American women are constantly exposed to a transnational feminine model whose psychological, physical and material characteristics derive from a Western cultural value system which is primarily capitalist and consumerist in orientation. The fact

that women take between 75 per cent and 85 per cent of the decisons on private consumption makes them a particularly important target for advertising messages, and the study found that on average 30 per cent of the total space in the magazines examined was devoted to advertising. But an important finding was that in many cases, identical advertisements were placed in different magazines and in different countries: for example, one advertisement for perfume, appeared simultaneously in six of the magazines studied. Moreover, a striking 60 per cent of *all* advertisements were for the products of transnational corporations, the majority for articles associated with beauty or fashion, followed by products for use in the home.

According to the researchers, then, readers of these magazines are constituted as potential consumers. This is evidenced not just in the sheer amount of advertising itself but in the nature of the other contents of the magazines which promote ascription to values and life-styles dedicated to consumption. Youth and beauty become deified, while the importance of finding a husband is paramount. For example, *Cosmopolitan* advises: 'If you want to be successful, cultivate your beauty . . . Most marriages between beautiful people are happy . . . The more attractive we are the fewer difficulties we face in love, in professional and social life . . . We can all be beautiful with the help of cosmetic products and plastic surgeons.' The achievement of beauty thus becomes a career, a prerequisite for success. And work itself becomes transmuted into a method of marketing for the woman. *Cosmopolitan* again: 'The woman who works is more attractive and more sexy to her man (or men in general). Working outside the home gives a woman a market place. Goods which aren't on display don't sell. The girl who isn't seen stays single. Daily contact with work colleagues, with clients, or with other men, gives her the chance to be seen and admired (if she is worth admiring) to establish interesting friendships, to learn about men, to learn how to talk to men, to overcome shyness and to acquire "savoir faire". ' Is this the liberated 'new woman' which the large-circulation women's magazines proclaim?

A painstakingly detailed analysis leads the study to conclude that the image projected is one of a universal woman capable of appealing to all women irrespective of race, class or creed. In this woman and her environment, problems, differences and realities are sketched out. She moves in a harmonious world without contradictions in which nothing changes and everything is equal. The consequence is an acritical, accepting female reader who is encouraged to value all those aspects of society and of her own situation within it which are vital to the maintenance of the system (Santa Cruz and Erazo, 1980).

Magazines in Colombia and Brazil
In a study of Colombian *fotonovelas*, Flora (1980) traces developments in female imagery since the 1960s. The *fotonovela* is a series of still photographs with balloon captions, telling, usually in about thirty pages, a complete romance. Changes—from an exclusively romantic image in

which sex was *implicit*, to a situation in which this idealized image is paralleled by imagery relying on *explicit* sex and sexuality, constant physical violence, and a juxtapositioning of good and evil—are attributed to technological, economic and social changes in Colombia. For example, a shift in the locus of production—from Europe to Latin American—and the way it is structured nationally and internationally, is related to potential profits and magazine contents. Audiences have been growing to include men, which has had the effect of sharpening some negative female images, especially those related to sex and violence. The study concludes that the switch from the association of women with romantic or sentimental images, to the definition of woman in terms of her sexuality, does *not* challenge the fundamentally passive role ascribed to women in these magazines. In fact, woman's very sexuality apparently makes her most vulnerable to oppression, just as in the earlier imagery her poverty laid her open to pressure.

A further Colombian analysis of the magazine *Cosmopolitan* (De Marmora, 1979) echoes many of the findings of the Santa Cruz and Erazo study reported above. Examining the image of the *chica Cosmo*, the study concludes that the magazine is manipulative in extremely subtle ways: work is recommended, but is associated with the maintenance and manipulation of emotional relationships rather than as any form of development for women themselves; feminist arguments are presented as something to which the 'modern' women should subscribe, but in their presentation they become no more than the middle-class concerns of the middle-class housewife; sexuality is treated as an object for consumption, through which certain fears can be overcome—loneliness, the loss of youth and of beauty.

In Brazil, findings from a 1979 analysis of three national magazines —*Claudia*, *Carícia* and *Nova*—support the general direction of other Latin American studies (Sarti and Quartim de Morães, 1979 ; Quartim de Morães, 1979). Man remains the centre of the woman's universe, even if the male-female relationship is cast primarily in sexual rather than domestic terms. Woman is still synonymous with mother, even if motherhood is presented as an option rather than an obligation. Work is still a secondary concern for women, and it is treated with outstanding lack of realism: on the one hand employment is idealized as unproblematic, on the other, women are assumed to successfully and cheerfully sail through their domestic chores single-handed on top of a day's work outside the home.

Advertising in radio, television and magazines in Costa Rica
A Costa Rican study of advertising—commercial and government—in radio, television and in one women's magazine, as well as content-analyses of soap-operas on radio and television, suggests that a particular ideological concept of women and women's role underlie the various stereotypes through which appeals to women are made (Quiroz and Larrain, 1978). A strong emphasis on motherhood and reproduction is sublimated in romantic love; women's role in looking after children

is fostered through values associated with motherhood—self sacrifice, dedication, etc.; her role in caring for the husband is promoted through appeal to notions of faithfulness, weakness, need for protection; her need to sacrifice herself in the cause of others is assured of reward in the hereafter, emphasizing a particularly Catholic value; her home must function well, so she must be efficient, feminine, have good taste. This 'superwoman', with a set of values ready-made to function within the ambit of home, husband and children takes her place within an acknowledged and accepted order which must be maintained. Here again, the media are said to be functioning as a conservative force maintaining a status quo dictated by ideological imperatives.

Radio, television and magazines in Venezuela

Two studies, one of radio and television soap-operas; the other of women's magazines and *fotonovelas* in Venezuela reveal a reliance on similar themes and images to those already described. The soap-opera analysis finds a very marked emphasis on the idea of 'love' as a solution to problems, and the presentation of love as the only possible means of social mobility—reflecting to some extent a Catholic orientation to social problems. The 'good/wife', 'bad/siren' dichotomy is also prevalent (Colomina de Rivera, 1968).

The same basic set of characterizations was also found in the analysis of ten different *fotonovelas*. Typically in these, couples struggle to overcome enormous obstacles which separate them and are eventually united in happiness and marriage. Ever-present female myths—submissiveness, dependency, intuition—describe the women who live out their lives on these pages in pursuit of men, in front of mirrors, and (although only occasionally) in temporary, unspecified jobs.

The analysis, covering an eight-year period, of three transnational magazines—*Vanidades*, *Cosmopolitan* and *Buen Hogar* (Good Housekeeping)—concluded that the idea of liberty or independence propagated by these was fundamentally false. Emphasizing youth, beauty, prestige and status, the magazines suggest that these can be achieved through the use of products advertised alongside the articles and editorials. An idealized version of what work means for women—the types of job most frequently discussed were the 'super' secretary, the business executive, the actress, the model—and the presentation of sex as a commodity, which a women should make available for certain returns, completes the distorting picture. This, suggests the author, is liberation through subordination (Colomina de Rivera, 1976).

Television in Puerto Rico

Several studies here point to two fundamental traditional roles generally ascribed to women in television portrayals: the mother and the siren. Each of these can be expressed through a number of variations. The 'mother' image may be vested in the abandoned wife, sacrificing herself for her children; she may be the spinster aunt dedicated to her nieces

and nephews; the sister who sacrifices her youth for her brothers; the daughter preoccupied with her parents. Throughout the imagery runs a consistent stress on subordination, sacrifice and purity. The 'siren' may be the seductive secretary eventually abandoned by the faithless husband in favour of wife at home; the 'bad girl' who incites to crime; the irresistible artiste who torments her lover; the 'fab chick' pursued by all the guys. Here, the 'bad' anti-heroine is shown as cruel, inhuman, insensitive, unscrupulous; she will also be decisive, independent and tenacious, but these characteristics are defined as 'bad' in her, even though they are defined as 'good' in the male hero (Barreto, 1978).

These traditional roles are propagated by the notion of rewards and punishments: if the woman behaves 'well', she will be given the unparalleled reward of the love of her man. If she behaves 'badly', she will be ultimately alone, unloved and castigated (Rios de Betancourt, 1977).

Radio, television and film in Jamaica

A comprehensive study of the media in Jamaica carried out in 1979, concludes that the image of women here varies among the media (Cuthbert, 1979). On radio, nearly 80 per cent of air time is devoted to entertainment, mostly music; about half of this music is American in origin, and its imagery (in relation to both women and men) is characterized by 'romantic escapism'. On the other hand, when women are projected in reggae—Jamaica's local popular music—it is more often in the image of *mother* (someone trying to stay at home and care for the children) than of *lover*. Excluding music, only about 5 per cent of Jamaican radio programming is foreign and the majority of the latter is religious. Thus, the study concludes, most images of women on radio in the non-music sphere are local images. These are said to be fairly dynamic in that—through educational broadcasts and soap-opera formats which are sometimes openly didactic in purpose—women, including low-income and rural women, are portrayed in a diversity of social roles.

On television, where 60 per cent of the programmes are foreign —mainly American—in origin, the overall image of women is mixed. Imported drama and films, the study finds, are usually of low quality and offer a fairly traditional and stereotyped image of women. On the other hand, in a few cases—for example, the American series *Rhoda*—relationships of male-female equality in such programmes contrast with the traditional Jamaican value of male dominance. Although locally produced educational and information programmes are said to highlight positive information on women in the society, their treatment of sexual equality at times remains ambiguous. For instance, one television film made by the Agency for Public Information told the story of a youth who resented being taught agricultural skills by a young woman. Persuaded by his aunt to realize that these are 'new days of equality' and that he should try another approach with the young woman, he does so and they fall in love. Thus the old themes sometimes appear in new outlines. News coverage of women in Jamaica too reflects the pattern noted elsewhere: women are hardly portrayed unless they are political,

have achieved high government office or have status as the wives of prominent men.

Jamaica spends up to $10 million a year importing foreign films. In the seven-week sample taken in the study, 75 per cent of films showing in the cinemas were American and 25 per cent were from Hong Kong. Most of these are cheap productions typified by violence and present an almost totally negative image of women as sex objects and appendages to men. So far, three feature films have been financed and produced by Jamaicans. In two of these women are shown as 'part of the backdrop, hardly a realistic representation of the Jamaican woman's role since she is often the only strong and dependable figure' (Cuthbert, 1979). The third and most recent film *The Children of Babylon*, although written and produced by a man is said to present what is essentially a woman's perspective, and to portray the central female character as someone trying to determine her own life style.

Advertising which supports all of the media in Jamaica, is now virtually all locally produced. The study finds that advertisements have improved in the last decade. Although images of woman as household drudge or as sex object are still in evidence, these are now in a minority: 'the majority present balanced and positive images both of women and the family'. However, advertisements still encourage a consumption orientation and acquisitive values, and women are the main target here (Cuthbert, 1979).

Images in the media of Western Europe

European studies of mass media imagery are in general less systematic than most of those conducted in North and Latin America. In the main, the studies in Europe tend to have a rather narrow empirical base, and to describe and illustrate rather than to analyse. At the same time, their overall arguments point to a concern with many of the issues which the sometimes more conceptually limited American research has identified through detailed empirical inquiry.

Television

Detailed studies on television portrayals of women are available from the United Kingdom, Federal Republic of Germany and Norway. A review in German-speaking European countries provides additional information on the Federal Republic of Germany, Austria and Switzerland (Van Briessen, 1979). Finally, a review of Scandinavian research literature on the topic gives some data on Denmark, Sweden and Finland. Both the British (Koerber, 1977) and the German (Kuchenhoff, 1975) analyses reveal the by now familiar under-representation of women in news programmes, while under-representation is also reported in dramatic programmes on television. In Norway, female characters occupied only 26 per cent of the roles (Tsuda, 1975). The Scandinavian research review reported women in less than 20 per cent of the televised roles (Andersen and Korsgaard, 1978). Even in Finland, where they were less clearly numerically under-represented, women are seen in traditional roles.

Overall, the findings of the Scandinavian, British and German analyses correspond to the general trends noted in the North American context: under-representation; depiction in predominantly domestic and maternal roles, or as beautiful or sexual 'objects'; in passive relationship to men, who are portrayed as the 'doers'; in service occupations rather than in positions of authority, and so on.

There may be exceptions: in the United Kingdom for instance, Koerber (1977) concluded that although in light entertainment programming active, adventurous men dominated victimized, laughable or token women, television drama showed a shift in favour of women. More programmes were written by women and provided a female perspective. However, exactly how television drama deals with the 'female perspective' remains problematic. Baehr (1980a) looked at the way the perspective of 'the liberated woman' was treated in two separate plays in a serious British television drama series *Play for Today*, broadcast in late 1976 and early 1977. *Play for Today* has a long tradition of showing plays 'with a message', and the decision to deal with the theme of women's liberation marked a rare opportunity to accord media legitimacy to feminist issues, as the series, since its inception in the 1960s, has achieved enormous professional and public acclaim. However, the analysis leads to the conclusion that 'the themes and issues of feminism are drawn on and presented in a way that leads to the ultimate re-affirmation of the patriarchal family', in which the female protagonists 'are rendered unnatural, ridiculous and wrong' (Baehr, 1980a).

Moreover, however the 'female perspective' in such programmes is interpreted, the scarcity of exceptions merely underlines the general correspondence between situations described in both North America and Europe. This is not surprising, given that most European countries import sizeable proportions of their programming—as much as 40 per cent in the case of Finland (Harms, 1978)—and that much of this is American-originated.

Radio

The same lack of documentation on women's portrayal on radio which was noted in the case of North America is found in Western Europe. Two British studies (Ross, 1977; Karpf, 1980) and one Austrian review which was mainly concerned with newspapers but in which some analysis of radio commercials was also included (Arbeitsgruppe Frauenmaul, 1979) provide the only available data. Both of the British studies point to the important role which radio plays in the lives of many women, particularly those who are housebound. Women account for two-thirds of the British radio audience, and individual women generally listen more to radio than do individual men (Ross, 1977). Women are under-represented as contributors in most areas of radio especially in daytime networked programmes, which are designed to maintain the illusion of housewifely contentment which a woman presenter might rupture (Karpf, 1980). Ross (1977) makes the same point highlighting the sexual undertones of such shows, when she quotes from an interview given by

a well-known presenter of a daily programme 'I try to talk to one person. I've got this picture of a young woman, a housewife, young or young at heart. She's probably on her own virtually all day. She's bored with the routine of housework and her own company and for her I'm the slightly cheeky romantic visitor'.

Women presenters, both studies argue, on the basis of interviews with radio management, would by identifying too closely with housewives' tasks and problems, disrupt the etherizing, palliative timbre of day-time radio which is built round certain assumptions: 'In constructing programmes to appeal to women (and to a large extent women as housewives) two things have to be borne in mind . . . Women are sentimental . . . Women are fanatical . . . They are escapist, or they are not sufficiently cold-blooded to enjoy drama which if taken seriously would represent alarm and despondency' (Capital Radio, 1973). Consequently, afternoon radio plays, phone-in and medical programmes, and magazine programmes all tend to present images of nuclear families with fulfilled women at their centre (Karpf, 1980). The Austrian analysis of radio commercials also found an emphasis on appeals to the virtuous, loving housewife in the advertisements studied (Arbeitsgruppe Frauenmaul, 1979).

On the other hand, both of the British studies detect changes; for example, the introduction of new themes such as social and legal issues in traditional women's programmes. Local radio has also been more experimental than national channels. For instance, three series of programmes titled *Stuck at Home*, on subjects such as 'Getting Depressed', 'Getting Angry with the Children', 'Feeling Lonely', have raised issues of importance to housebound women with children, and have dealt with them in a direct, realistic fashion. Many of the programmes were listened to by mothers in groups and used as the basis for discussion (Karpf, 1980).

Film

Little special reference will be made to studies of film in Western Europe, since the international marketing of films means that the conclusions reached about film in North America can, in general, be seen to apply to European films: indeed a number of the studies from which those earlier conclusions arise are concerned with the images of women in both American and European films.

However, one additional study is worth mentioning. This analysed twenty-five Greek films in circulation in the late 1960s (Safilios-Rothschild, 1968). These are held to make the same clear distinction between 'good' and 'bad' girls, which exists in traditional Greek normative categorization. The triumph of love, and the glorification and reward of the 'good/poor' girl through marriage to an 'ideal/rich' man, have resonances of some of the imagery attaching to media portrayals in Latin America. As there, the Greek study suggests that these definitions provide checks on social change and offer psychological compensation for the frustrations of reality.

Magazines

There are numerous studies of various aspects of female imagery in magazines throughout Western Europe: reference will be made to only a few of these, since there is considerable overlap in the analyses and conclusions of these studies, carried out in Austria, Belgium, Denmark, France, Italy, Netherlands, Norway, Sweden, Switzerland and the United Kingdom. One specific focus of concern has been the relationship between women's magazines and their advertising revenues. In British (Smith, 1978), Danish (Sepstrup, 1978), Italian (Lilli, 1976), Dutch (Wassenaar, 1976) and Swedish (Andren and Nowak, 1978) studies, this economic dependence has been held to account for the predominantly conservative and traditional images of women projected in magazine advertisements and—more indirectly—in the editorial content of the magazines. In their careful analysis of Swedish magazine advertising between 1950 and 1975, Andren and Nowak conclude that images of women in advertising tend to preserve prevailing social conditions, to be largely unaffected by current social change, and to act as a form of specific oppression against women.

At the same time, economic imperatives have been linked in many studies to the lack of major change in women's magazines in response to the feminist movement, which poses a threat to commercial interests. Although change of a sort is noted in the magazines of France, Italy, United Kingdom and elsewhere—in terms of the introduction of such new themes as sexuality, psycho-analysis, social investigation—it is seen as a response to changing market forces, rather than as a specific break with previous conceptualizations (Lilli, 1976).

Finally, despite somewhat more critical attitudes towards consumption and the expansion of feature content, contemporary mass circulation magazines continue to project a limited image of the women's environment; particularly with respect to education and employment, coverage of the world outside the home is narrow. Just as in North America, commercial pressures and the threat of falling sales curtail freedom of radical movement.

Mention must be made of the large number of small-circulation feminist magazines and newspapers which are to be found in virtually every European country (as well as in North America). These range from one- or two-page cyclo-styled broadsheets to fully commercially produced papers such as *Spare Rib* in the United Kingdom or *Emma* in the Federal Republic of Germany. The preoccupation here is first and foremost with women's status and with the provision of news and information which will help women to understand their present social position and thus to change it. Although they cannot—and dare not—compete in the commercial marketplace, such publications can constitute a radical alternative to mass-produced images for a very large number of women. The genre is new, and still awaits a serious evaluation: current criticism tends to centre on a tendency to high-flown language and an élitist approach which can make these papers inaccessible to all but a narrow group of highly educated women. However, their ever-growing numbers and increasingly large circulations (one of the oldest magazines, the

American *Ms* which is now in its eighth year, sells almost half a million copies of each issue) suggest that they strike a growing chord of response in women.

Newspapers

The portrayal of women in British newspapers is documented in a number of studies from 1974 (Butcher) to 1978 (Smith) as well as in part of a study of papers published in other European countries (ISIS, 1976). Most newspapers devote more than 80 per cent of their entire coverage to men (NUJ, 1978). Apart from a handful of women politicians the only category of women regularly considered newsworthy is that comprising celebrities. The treatment of women in 'hard' news involves the use of a series of stereotypes concerning physical appearance, domestic role, marital status and so on, so that women are portrayed as perpetual dependants. On the positive side, Barr (1977) notes that stereotypes of women are slowly being recognized as such by the press, and that coverage of issues related to women's position in society is increasing.

In Austria, a daily review of four of the most influential newspapers over five months in 1978 concluded that the most frequently projected images of women were: the careful, homeloving housewife; the tramp or sex-object; the efficient secretary; the *femme fatale* or model; and the devoted mother. The main exceptions came in the paper *Arbeiterzeitung*, the newspaper of the largest political party, which did occasionally include feminist, emancipated images (Arbeitsgruppe Frauenmaul, 1979).

A Swedish study which examined the appearance of women in the editorials of five newspapers over the period 1945 to 1975, found a gradual increase in the percentage of editorials in which women were mentioned—from 8 per cent in 1945 to 15 per cent in 1975 (Block, 1979). Most of the editorials (three times as many as any other topic) dealt with the relationship of women to the labour market: there was little change in this over the entire research period. The study found a growing radicalism in the newspapers' treatment of the question of women's work in the home and in paid employment. While the three more socialist-oriented papers remained reasonably sympathetic to the role of the housewife (seeing her work as hard, time-consuming, responsible), the two others changed from a favourable stance in the 1950s to a position in the 1970s which saw housewives as 'naïve aunties'. *None* of the editorials questioned the basic assumption that women *should* go out to work, even if they had children (Block, 1979).

Images in the media of Central and Eastern Europe

The problems in obtaining data regarding mass media images of women in these countries relate largely to the way in which political concern for sexual equality impinges on the formulation of research questions. In a society where there is complete commitment to the total participation of women in all spheres of life, to what extent is it meaningful to single women out as a special analytical category? One answer is that to the

extent that full sexual equality has not yet been achieved in any socialist country, studies of the range of social, economic, political and cultural forces which operate on women may help to provide explanations. Despite extensive official efforts to ensure that mass media reflect the dimension of sexual equality in social and economic policies, scattered sources in Poland and the USSR suggest that even in government-controlled systems, the media may to some extent play a subtle role in promoting traditional conceptions of sexual differences.

Periodicals and readers in the USSR

Two studies—one Soviet and one American—echo faithfully the findings of many Western analyses of media portrayals of women. In a content of the descriptions of marriage and love in the two most popular youth magazines, Semenov (1973) discovered that there were five times as many authors as authoresses, that males were featured in central positions twice as often as women; that whereas in 48 per cent of cases no information is given about the occupations of the female characters, this is true in only 9 per cent of cases regarding males, implying that occupational role is a more important descriptor for men than for women.

A content analysis of samples of Soviet children's readers (Rosenhan, 1977) indicates that from a very early age children are exposed to different images of male and female roles. Despite high rates of female participation in the actual labour force, women in these readers are overwhelmingly identified as mothers and grandmothers. Men are portrayed in a broad range of activities almost exclusively outside the home. Men are shown as active, confident, ambitious for advancement, and politically involved, while women are portrayed as passive, expressive, supportive, nurturing, unconcerned with advancement, and politically naïve.

The press in Poland

According to Lewartowska (1975), as a result of its economic independence women's periodicals of Eastern and Central Europe are able to concentrate on social education. The tradition of these publications is a feminist-oriented format which is highly popular, as judged by the number of titles produced, and circulation figures.

On the other hand, a study of press readership (Adamski, 1968) suggests that the media-audience relationship may differentiate between men and women in a similar way to Western readership patterns. The fact that men read more newspapers and fewer periodicals than women; that better educated women read more; that men are said to have 'a more lively interest in political and economic issues'; that 'interest in cultural and educational issues, in everyday trifling events, prevails among women'; that women's interests tend to stay at the regional level, while men's tend more to the national level; all this points to a system in which a pattern of male-female differences, similar to that existing in Western Europe and North America, is accepted and responded to by media producers.

In a second study, Sokolowska (1976) blames the mass media for per-

petuating a traditional belief that the father's role refers very little to child-rearing. The press publish photographs of women as mothers, but not of men as fathers. Reports about women generally refer to the fact that they have children, while reports about men do not mention their family life. Although no empirical base for this account is given, it reflects concerns expressed, and images reported, in the treatment of women in the media of other countries.

Film in Hungary

Taking a somewhat different approach, Andrassy (1980) examines the way in which the documentary film highlights some of the fundamental problems and dilemmas facing women in a changing Hungarian society. Some of the questions addressed include: Why do girls have to marry while they are still children in a Hungarian village? Why does the village drive out the schoolmistresses who come from the town? What is at work in a 16-year-old city girl when she takes it as an 'honour' that her boyfriend goes to bed with other girls for the sake of her virginity?

At times, the amateurs who appear in these films are invited to look again at their lives as captured in the filmic image, in order to help them analyse and understand their problems and conflicts. Making the point that these problems are not *simply* those of women or of certain social strata, the study reaches the important conclusion that, nevertheless, 'introversion, alienation and atomization can be most dramatically caught in the lives of women' (Andrassy, 1980).

Magazines in Yugoslavia

Probably because of its rather different relationship with the West, from which it imports more media products than other Central and Eastern European countries, media portrayal of women in Yugoslavia has raised different concerns. In a survey of magazines in Yugoslavia in the 1970s, Bosanac and Pocek Matik (1973) identified an emphasis on sexuality which bordered on the pornographic. They conclude that by replacing social with sexual emancipation, the media have reversed the sense and substance of the women's movement, a judgement reminiscent of the findings of many studies from North America and Western Europe.

Images in the media of the Middle East

Only a few completed studies are available from the countries of the Middle East and North Africa, reflecting a relatively recent concern with the question of the media's relationship to women. Three of these studies come from Egypt. There is also some information from Israel and from pre-revolution Iran. Finally, a detailed longitudinal analysis of the press in the Lebanon is now in progress, under the sponsorship of the Institute for Women's Studies in the Arab World. A restricted interim report indicates that the final study will provide comprehensive data.

Press and film in Egypt

In a study of Egyptian middle-class women's magazines carried out in 1974, Suleiman detected a tendency in the characters portrayed to assume Western rather than Egyptian attitudes, and found a generally equal treatment of males and females, although the relationships between men and women were depicted as relatively formal. On the other hand in an analysis of Egyptian films projected between 1962 and 1972, Al-Hadeedy (1977) concluded that, with few exceptions, these stressed women's negativism and incapacity to solve problems; women were usually shown as physically attractive, but lacking intellectual ability and social awareness. A rather less gloomy picture emerged from an analysis of the women's page in two newspapers and of a women's magazine over the period 1965 to 1976 (Abdel-Rahman, 1978). He detected an increased interest in women's activities in economic and cultural fields and a generally wider range of topics being treated; but at the same time, the percentage of advertising in all three papers had increased and the concerns and interests of only urban middle-class women were considered.

Media in Israel

In a review of the image of women in the media in Israel, Goren (1978) found that as far as radio and television are concerned, broadcasters are aware of the problem of stereotyping, but find it difficult to avoid, since much programming is based on existing literary materials. There is also awareness that if the 'exceptional' woman is overemphasized, this may reinforce the 'exceptional' status of women.

The highest circulation magazine in Israel is a women's magazine, but this and others like it reinforce the traditional stereotypes of women as home-oriented or decorative dependants. On the other hand, in some respects these magazines, together with special sections for women in the press, perform a valuable socialization function for women and—with the tendency to label such sections 'life style' or 'modern times'—perhaps also for men.

Television and magazines in Iran

Although the social situation, the role of the media, and the status of women have all changed dramatically in Iran since the studies to be reported here were carried out (in 1978), they are presented as having immediate relevance to the overall regional review, in that they reflect the nature of the women-and-media relationship in that country at a historically recent point in time. Later changes have yet to be documented.

In 1978, the media were found wanting in terms of active support in reflecting new roles for women and men. Little communication was addressed specifically to women (Sreberny-Mohammadi, 1978). Content analyses revealed a limited number of female images, stereotypic in nature, which seemed to run counter to the national development goals articulated at that time.

Television serials revealed a basically traditional outlook. The majority of men were shown as the dominant marital partner and prime breadwinner. The image of the perfect woman was one who performed household duties gracefully, and who was sympathetic and obedient towards her husband. Marital conflict was best settled by discussion and flexibility on the part of the wife (Assadi, 1978; Aflatuni, 1978).

Magazine analysis revealed a slightly different focus. The most popular woman's weekly, *Zan-e-Ruz* (Woman of Today), with a circulation of over 100,000, was found to present three main types of story. First were direct translations or plagiarisms of Western teenage romances, with blonde, blue-eyed images and foreign names. Second were the Iranian-based fantasies, in which the village girl finds love, excitement and a rich husband in the city. Third were cautionary stories in which adventure-seeking girls are betrayed by men, ending up in the streets or in a brothel (Mohammadi, 1978).

Running through many television soap-operas, and particularly in television and print advertising, was an ostentatious life-style, supported by excessive consumption, in which women were portrayed as the main propagators. While television advertising tended to be more familial in orientation, of the 35 per cent space of *Zan-e-Ruz* taken up with advertisements, much was devoted to beauty and cosmetic products used by skinny foreign blondes, provoking the observation that 'the great stress on physical appearance in a situation of acute sexual repression is . . . somehow ironic' (Sreberny-Mohammadi, 1978).

Images in African media

Documentation concerning the mass media in Africa is fragmentary in general, and it is particularly sparse when it comes to the specific question of how the media portray women in Africa. Studies from five separate countries have been identified. In addition, a cross-country analysis of a more general nature has been carried out. This latter study reviewed the contents of six African dailies—*The Standard, Ethiopian Herald, Chapian Times, Daily Sketch, Daily Graphic, Progrès Socialiste*—over a one-month period, and found that women were largely ignored. The rare articles which did exist centred on urban women, and the following were typical themes: fashion, new trends, social events, crime, and news items about 'prominent' women. Feminine myths and stereotypes were used in all of the newspapers for the purposes of advertising. Although there were occasional articles on women and the law, or on social and economic status and development, these were found to be presented in the most general terms (Dawit, 1977).

The press in Ghana

One review of the two main Ghanaian newspapers indicates changes in the portrayal of women in both of them in the decade up to 1975 (Abbam, 1975). The government-owned *Ghana Review* has become more commercial and lively, partly through the use of women on its covers as a

sales bait; at the same time stories about women have doubled in space over the ten-year period. In the *Daily Graphic* there have been changes in the content of the women's page between 1965 and 1975. The portrayal of women has moved away from its earlier emphasis on the role of woman in the home and as a wife and mother. Now, women are recognized as having a place outside the home, and women's page articles deal with subjects such as women's social, legal and political rights, or their potential contribution to development at national and international levels. The review reports some concern that pressure from the all-male editors will force the women's page to disappear.

Newspapers in Zambia and Uganda

As part of an anthropological study of women in Lusaka, Glazer Schuster (1979) analysed two daily newspapers, *Times of Zambia* and the *Zambia Daily Mail* in an attempt to index social attitudes about women. On the basis of material reviewed between 1971 and 1975, it was concluded that an intense ambivalence towards women in the wider society was reflected in the media's portrayal of women as both 'folk devils' and 'folk heroes'. As folk devils, women were presented as a threat to traditional values and interests and a symbol of the loss of control of those values. They were portrayed as immoral, tough, unsentimental, materialistic, expensive and cunning. To describe this 'devil' words such as 'prostitute', 'call girl' were used interchangeably with more 'hip' terms like 'fun girl', 'late night girl'.

As folk heroes, women were depicted in at least three different ways. In the image of equality, women were shown as equal to men in their potential for contributing to national development. As the indigenous pin-up, women helped overcome a collective national self-image of inferiority and became partially cleansed, sanitized versions of the folk devil. As mothers, women were seen as positive and strong, providing comfort and security to a population facing rapid social change. But the treatment of women as folk heroes is itself ambivalent, carrying within it many contradictions. So while pin-ups were applauded, girls in mini-skirts were condemned; although career women were praised for their initiative and independence, they were condemned for being unmarried. This ambivalence, Glazer Schuster concludes, reflected the ambivalence felt in the wider society which was then in the midst of a period of rapid social change. Confusion and conflict led to scapegoating, and women were particularly vulnerable targets, given their economic and political status and their lack of access to media. Women were expected to change their position in society and at the same time to uphold morality, peace and cultural traditions. Consequently, women could easily be blamed 'when the position of all but a few remained unchanged, when the state of morality was chaotic, when there was political unrest, and when cultural traditions became 'contaminated' by Western influence' (Glazer Schuster, 1979).

A similar point is made by Obbo (1980) in her study of the urban press in Uganda over almost the same period (1971 to 1974). Four English-

language newspapers were analysed. Two of them were Kampala publications, the *Uganda Argus* and the *Voice of Uganda;* two were published in Nairobi, the *Daily Nation* and the *Sunday Nation*, though widely read in Uganda before 1974. Intriguing contradictions run through the portrayals of women. They were seen, for example, as both unwelcome competitors in the job market and as a wasted resource, as the upholders of traditional ways of life and those most vulnerable to Western influence. 'Women therefore find themselves scapegoats not only for male confusion and conflict over what the contemporary roles of women should be, but for the dilemmas produced by adjusting to rapid social change. Where men have given up traditional customs and restraints on dress, but feel traitors to their own culture, they yearn for the security and compensation of at least knowing that women are loyal to it.' (Obbo, 1980).

Newspapers, radio and oral literature in the United Republic of Tanzania

In a study dealing with the images of women projected by the Tanzanian entertainment media, the contents of short stories published in Kiswahili and English-language Sunday newspapers, and of popular Kiswahili songs broadcast by radio were analysed. Two major themes are identified. The first is that of the innocent male who is the victim of feminine wiles. A different, though related theme is that which portrays women as inherently evil and/or weak, in need of a male guiding hand which will not only teach them to behave but will also support them. The study makes the point that while, in terms of feature writing and issue reporting, more positive and realistic approaches are currently finding their way into the media, entertainment continues to degrade and humiliate women. The insidiously demeaning images of women in much popular music, in particular, go unnoticed as men and women themselves respond to the appeal of rhythm and melody (Besha, 1979).

Kyaruzi (1979) reports that Tanzanian newspapers rarely consider women as a source of news for the front page. Women's activities are rarely reported in their own right but are sure to be covered if an important male personage is associated with them. For example, President Nyerere's opening of International Women's Year in 1975 got headlines in all of the newspapers and on radio. However, much of the attention which might have centred on what women had to say about their 'year' was centred on what the President had to say about women. A further feature of media coverage is that when women are prominent newsmakers there is a tendency to trivialize or ridicule what they have to say: an emphasis on the 'lighter' aspects of a woman speech-maker's presentation leaves her subtly bereft of authority and weight.

On the other hand, a separate study of coverage of women's issues in the Tanzanian English-language press found a growing effort to present a picture of women's questions. In an analysis of the contents of daily and Sunday newspapers between 1972 and 1978 Bryceson (1979) found a marked increase in the amount of space devoted to women's issues. Coverage was most extensive in 1976, since when it had decreased somewhat: however, even so, there was about four times as much cover-

age in 1978 as there had been in 1972. This overall increase is attributed partly to the fact that women's news is new and different.

Finally, in one of the very few studies of traditional media available, Matteru (1980) found three dominant images of women in Tanzanian oral literature. This tends to depict the woman as a mother, as the man's pleasure object or as the man's property. The values and beliefs embodied in these images, it is argued, undermine women's confidence in their own ability and obstruct their development as social beings. The study observes that there are some pieces of oral literature which counter these thematic images but that these are exceptional.

Radio, television and film in Senegal

Focusing on the perspective of the woman in the audience, Aw (1979) surveyed a cross-section of women living in urban areas in Senegal in terms of their reaction to radio, television and film. She found that television is still a medium for the élite, but that 70 per cent of those interviewed had a radio and listened to it. Film is also popular, with 35 per cent of the women going to the cinema at least once a week, and 5 per cent going every day.

At the same time, women remain relatively unaware of the images and values transmitted in most of the films they see, the study found. The women saw themselves reflected in three main ways in both European and Senegalese films. First, there is the 'foreign type' (even though she may be Senegalese), the woman of high social standing due to her husband's position; the woman who is successful because she earns a lot or because her job makes her a star; the woman who sponges off her man. The interviewees described such a woman as being emancipated (because she copies foreign values, smokes, drinks, etc.), 'toubab' (meaning 'white' in Wolof), idle and neurotic, a painted doll.

Secondly there is the 'woman of tradition', always Senegalese; the woman who waits on her husband, watches him eat and fans him during his siesta; the woman who, if her behaviour is not strictly in accordance with what society expects of her, will find herself an outcast. The interviewees viewed such a woman variously as 'a good girl who does her duty'; a plaything; an inferior, subordinate and oppressed being.

Thirdly there is the 'great lady' who serves her country, in some episode of colonial history for example.

Some of the women interviewed said that the cinema simply portrays women as they are in the society; but most felt that the cinema should do more than produce a mere factual record. Since overall, films were felt to give a 'bad impression' of Senegalese women, at least one woman felt that through them 'reactionary ideas' were encouraged.

A further point made in the study is the foreign, alien nature of much of the broadcast material in Senegal, which at least some of the women felt did not in any way reflect the reality of their problems and lives: for example, programmes giving cookery recipes which use ingredients available to few women create an impression of a world in which luxury is—or should be—normal. On the other hand, advertising—which is

concerned in a major way with developing new and culturally alien habits in women—is less criticized by them. Although 30 per cent of those interviewed said that advertising promoted foreign patterns, 'very few women have the heart to speak ill of it'. Because of the glamorous and desirable images used in advertising '[women] have good reason to be reluctant to admit that it portrays women in an unfavourable light'. Thus 'advertising clearly helps to deprive women of their own culture and its aiders and abettors are the women themselves' (Aw, 1979).

Images in the media of Australasia

This vast area contains within it an enormous diversity of social systems and media, spanning extreme capitalist to extreme socialist political and economic types and reflecting a continuum of social development which includes some of the least developed and most advanced industrialized nations of the world. Documentation of the media's role in presenting images of women is increasing in South Asia, India leads the way in research and in the beginnings of the development of a truly feminist press; in South-East Asia, both Japan and the Philippines have a growing body of research findings; Australia also demonstrates an increasing preoccupation with the question of how its media treat women.

Film and press in India

A certain emphasis on female imagery in the film in India reflects the importance of the medium as used by government agencies in the promotion of development purposes, such as birth control, and also the growth of a strong commercial film industry in India. A detailed analysis of two government films aimed at promoting family planning found a heavy sexist and patriarchal bias in the imagery of both (Kishwar, 1979). The study found an emphasis on the importance of sons, and an undervaluation of female children; a stress on the passive and self-sacrificing characteristics of women; and the promotion of family planning as a woman's duty to her husband and family rather than as a prelude to a potentially expanded role for herself.

Among several studies of the commercial film, the most comprehensive to date has been a systematic analysis of twelve Hindi and six Gujarati films released and shown in 1976 (Pathak, 1977). Among the main findings, the following trends were found across all films: an emphasis on young, beautiful and sexually attractive women; portrayal of women primarily in terms of their relationship to men; of the 46 female characters portrayed, only 12 were shown to be in gainful employment and of these 9 were in traditional female occupations; prediction of women as overwhelmingly emotional, dependent, superstitious, timid and irrational creatures incapable of rational actions or decisions; an emphasis on marriage as the only important goal for women; the presence of a double standard of morality for men and women and frequent portrayal of women's submissive acceptance of physical violence and cruelty by men.

On the positive side, most women were shown as literate and some as self-confident. Overall, this and several other analyses (for example, Anu and Joshi, 1979) find a fundamental double image of women in the Indian film, which mirrors an ambivalence noted in other cultures: she is either the 'mother' (or sister, daughter, wife) who is demure, submissive, passive, self-sacrificing; or the 'whore' who is immoral, smokes, drinks, wears trousers and is highly sexual.

An analysis of Hindi periodicals over the past thirty years actually showed a decline in the discussion of women's issues; and an almost exclusive emphasis on traditional concerns such as food, fashion and beauty (Press Institute of India, 1975). This is attributed to the same dependence on advertising found in magazines in the West, paralleled by a similar orientation towards consumption.

The weekly women's sections of two Gujarati daily newspapers were studied over a three-month period in late 1978 (Pathak, 1979), in order to assess the scope and relevance of articles published and the relationship between topics addressed by readers and those dealt with by the editors. (In one of the papers, articles sent in by readers are published alongside those of the section editor.) Several conclusions were reached. In the first place, certain problems touched on by readers—for example, the 'predicament' of the single woman, family acceptance of the educated wife—were ignored by the editors. On the contrary, the editors preferred a self-sacrificing housewife, who should be doubly self-sacrificing if she is educated. Secondly, although readers wrote reflective articles, presenting the problems of women in day-to-day living and asking for solutions, the editors refused to comment on the practical difficulties experienced by the readers: instead, they included a fanciful story of offered consolations. Thirdly, the editors did not seem to probe any problem deeply in order to find possible explanations for offending social behaviour *vis-à-vis* women. Fourthly, although readers wanted to discuss the status of women in society today, there was no attempt to deal with questions such as the women's movement, legal status of women, women's rights, policies concerning women and so on. The overall picture is one of a readership alive to certain issues which are being ignored in favour of a conservative and traditional smoke-screen (Pathak, 1979).

A somewhat similar conclusion emerged from an extensive study of three national women's magazines carried out in 1978-79 by the Manushi Collective (1980). All issues of *Femina, Eve's Weekly* (both English language) and *Sarita* (Hindi) were analysed over a period of a year. Despite their claim to be 'concerned, involved, alive' the magazines are found, without exception, to foster traditional patterns of female subordination although wrapped in deceptively modern trappings. Competitiveness (within 'feminine' spheres) and consumerism are the dominantly promoted values. Half the pages in *Eve's Weekly* and over half in *Femina* are taken up by advertisements. Of these, about 95 per cent are for cosmetics, women's clothing, household goods and children's product, suggesting an 'ideal' role for women as alluring housekeeper. Fiction dominates *Sarita*, where the necessity of deference and

submission to the husband is consistently underlined; stories in the English magazines, too, inevitably uphold the status quo after temporarily criticizing it. All three, in different ways, repeatedly deny women's sexuality, intellectual independence and political situation. All in all, the survey concludes, the aim of these magazines seems to be to daze readers into becoming passive spectators rather than to activate them. 'Because an active equation with readers would threaten the flimsy structure of "happy womanhood" sought to be upheld by these magazines. The experience of too many readers would demolish this structure completely.' In fact, the same survey's analysis of readers' letters suggested that women are by no means completely satisfied with what the magazines offer. Criticisms included complaints about the exploitation of women's bodies as a selling device, conservatism on equality issues, superficiality in analysis of social problems, irrelevance of the content to most Indian women's lives. However, the magazines paid little attention to these critiques. In *Femina*, no replies to readers' letters are printed, and in *Eve's Weekly* the replies are very brief. Paradoxically in *Sarita*, where debate is conducted more seriously, the great majority of letter writers is male (the same is true of feature and story writers for the magazine). 'The overall attitude to readers is that they had better remain readers. Their participation is only required in entering contests, answering occasional quizzes, cutting out and following paper patterns, and solving crossword puzzles' (Manushi Collective, 1980).

Film, radio and press in Sri Lanka

A very comprehensive review of the portrayal and participation of women in the mass media (and also in the 'arts'—literature, drama, music and dance, painting and sculpture) was made in 1979 as part of a larger study of the status of women in Sri Lanka. Not surprisingly, as far as cinema is concerned there has been a strong influence from India where the film industry developed much earlier. The same 'double image' too is found in both Sinhala and Tamil films: women are either 'good' or 'bad'. The 'good' woman has all the traditional virtues—she is docile, submissive, respectful to her husband and parents, self-sacrificing, and she places the interests of her husband and children first in life. The 'bad' woman is immoral, stoops to any level to 'catch' the man she wants and trap him into marriage and, once married, debilitates him with sexual demands. Although 26 per cent of the labour force in Sri Lanka is female, only a handful of films have depicted women in working roles and, with the exception of one or two, these have not been concerned with any realistic probing of the problems of working women. In fact, the continued popularity of the 'formula' film in the Indian tradition means that documentary realism or social analysis is very rare in the Sri Lanka cinema.

Radio broadcasts are in Sinhala, Tamil and English, and the review covered women's programmes as well as radio serials (soap-operas) in all three services. The Sinhala women's programmes were found to be

highly traditional and romantic, with virtually no discussion or analysis of problems. The programme titles, such as *Pasan Nivasa* (Pleasant Home), *Vilasitha* (Fashions), *Malaka Mahima* (Enchanting Flower), indicate their orientation. Even the 'more serious' *Vanithalatha* (Grace of Women), which goes out on the weightier Channel 2, fails: its 'seriousness', the study finds, lies in its use of an over-blown literary style which actually disguises the triviality of its content. For example, a July 1979 broadcast informed listeners that 'You, the woman, the most marvellous creation of the world—you who make your journey on the long path of life, lend not yourself to desires that bring misery'. Literary sophistication hides a basic and traditional lesson in passivity.

The Tamil women's programmes, however, although containing their share of housewifely advice do deal with a much broader range of issues such as women's freedom to choose a husband, the dowry system, **problems of working women, time budgeting and nutrition. Here, the** study concludes, an attempt has been made 'to move away from the clichéd thinking of women's issues' (Goonatilake, 1980).

The English programmes for women also reflect some rethinking. In fact the programme entitled *Mainly for Women* has been replaced by *Family Circle* in response to fears of ghettoization of women's concerns. Subjects such as health, child care, nutrition, education and careers are regularly covered. As for the radio soap-operas, with the exception of **one Tamil serial** *Avalukku oru velai vendum* **(She Needs a Job), the overriding impression is of a world in which men are independent, responsible and dignified, while women are hysterical, irrational and preoccupied with trivia.**

Eighteen major newspapers in Sinhala, Tamil and English were analysed for content and photographs, as part of the study. Five categories of 'newsmakers' were used: politicians, governmental officials, professionals, entertainers and sports. Overall, women newsmakers were 8 per cent of the total, although this was largely made up by their high representation as entertainers (they constituted 36 per cent of all entertainers in the news). If this category were removed, their share of newsmaking roles would fall to 3 per cent. Using the same five categories, women's appearance in photographs amounted to 20 per cent of the total, again inflated by their depiction as entertainers (almost 60 per cent of all entertainers pictured were women). Excluding this category, women appeared in 6 per cent of the photographs. As far as specific women's columns are concerned, most of these appear in the English-language press. Three Sinhala and one Tamil paper carry columns and these, without exception, promote the image of women as home-oriented, fashion-mad and kitchen-bound. The five English-language papers do not generally contradict this image, although there are one or two exceptions. The *Sunday Times* page 'Woman's World' carries a scattering of thought-provoking articles, sometimes reproduced from foreign journals. But the *Ceylon Daily News* takes the most non-conventional approach. Its column 'Woman's View', introduced in October 1977, is 'what a women's column should be. It is the first attempt by a Sri Lanka newspaper to raise the consciousness of women by discussing, from a woman's point of view, intellectual issues

that are generally believed to be 'beyond women' (Goontilake, 1980). On the other hand, there is a certain élitism in this approach, and the study also makes the point that the values enbedded in the women's columns of the press are a good indication of Western influence on the Sri Lanka upper classes, to whom the English-language papers are in the main directed.

Magazines for women, such as *Tharuni* (The Young Woman) and *Kumari* (The Princess) remain closely tied to the traditional formula. However, the study notes that the use of sexually exploitative imagery in advertising is relatively rare in Sri Lanka, as compared with its use in Western media. 'Advertising is still, often, matter of fact and the advertisements sell these products on the basis of the prestige value of the goods.' However, the traditional image of the family is very commonly used, and women are very rarely shown in occupational roles.

Media in Pakistan and Bangladesh

Information from these countries is less detailed, though studies now in progress should fill out the picture shortly. In Pakistan, the media in general are said to present women exclusively in the stereotyped roles of housewife, mother and consumer of advertised goods, while as far as development is concerned, women are very rarely spokespersons for their own problems (Habib, 1975). The commercial feature film is particularly important: it remains the most widespread and most popular medium of entertainment in the country. Yet the typical Pakistani formula film seldom depicts women outside the stereotyped roles of deserted heroine, shrewish mother-in-law and so on (Habib, 1980).

In an excellent and detailed study of school textbooks in Bangladesh, Krippendorff (1977) found that these books seriously discriminate against women, both in terms of the amount of attention given to them, and in the attitudes expressed about their capacity to cope with their environment. Only 15 per cent of the characters in the books were women, and these were portrayed as passive, unintelligent and dependent. They were depicted as unimportant, deriving what little social importance they had from association with others, in the roles of wife, mother, daughter and so on. The values ascribed to them were private, emotional values, and there was no indication that women had a capacity to control human relationships or a role to play in social or economic affairs.

Film, television and press in Japan

In a society governed by rules in every aspect of life, including relationships between the sexes, exceptionally rigid forms are said to direct the lives of Japanese women. Given the almost total media saturation of society, the mass media reflect, according to various studies of television, press and film, the great difficulties experienced by women in any attempt to step outside the highly traditional framework within which they have been culturally set. According to one analysis of the Japanese press (Matsui, 1978), there is a definite tendency in news reporting to

provoke hostility towards women who transgress traditional boundaries and approval towards those who remain within them. Another analysis points to the linguistic mechanisms by which this is done: the use of emotive words, such as *kiiroi koe* (yellow voice) or *akai kien* (red yells) to describe the dissent or protests of women towards traditional roles, evokes a sense of irrationality, emotion or hysteria (Ide, 1978).

In an analysis of the work of several leading Japanese film directors, Mellen (1973) notes the predominance of the perception of women as either wife or whore—the dichotomy already found in media portrayals elsewhere in this review. In her analysis, Mellen was unable to find a single example of a woman managing to free herself from the image of passivity and submissiveness which is typical of the Japanese patriarchal social order, and which the Japanese film reflects.

Studies of television confirm this picture, reporting that television presents an extremely narrow range of female images. Women in Japanese television dramas, for instance, are typically portrayed as young; in traditionally feminine occupations—if employed at all; seeking identity through love and/or marriage; with a passive attitude to the solution of problems; diligently home-oriented; self-sacrificing and dependable (Murumatsu, 1977). At the same time, this study detects some very slow response to changing social currents in the most recent programmes, with some limited admission of the possibility of roles for women outside the strictly traditional sphere of home and family. This trend is also noted in a study by Nuita (1979) who nevertheless makes the point that the general rule is for television dramas still to depict women as 'home-keepers' and men as 'bread-earners working outside.'

Brady (1980) discusses the main features of Japanese general-interest women's magazines, ranging from young girl's comics, through young women's magazines to magazines for housewives. She finds that 'the younger the group of women for whom the magazine is designed, the further removed from reality are its contents'. Some new lifestyle magazines indicate a response to perceived changes in women's needs and desires. Insofar as they focus on the woman herself rather than the family, they are innovative. But they are also consistently cheerful, always careful to present the sunny side of modern life while minimizing its problems. For example, there is *Croissant* whose name is indicative of its editorial orientation: the title was chosen to reflect the popularity of French bread in the life-style of the so-called 'New Family'. Another new magazine, *More*, advocates a life-style far beyond the means of any but the most affluent reader. 'One might easily mistake *More* for a glossy fashion magazine from Europe or the United States. Apart from the Japanese script on the cover there is little to indicate that *More* is a Japanese product: all of the cover models and most of the models in its fashion sections are foreigners, which further removes *More* from the everyday reality of Japanese women's lives.' Seen as a whole, Brady concludes, women's magazines offer women very little that is new. The fantasy-reality continuum is a double bind. Magazines for the young woman urge her to have fun now on the assumption that there will be little time for fun once she meets her destiny: marriage and motherhood.

They foster a belief in the power of sex appeal to assure her a happy and secure life. **The housewives' magazines reinforce a status quo which would doom women to eternal housewifery.** 'All share a narrow vision of the world' (Brady, 1980).

Film, newspapers and television in the Philippines

In one of the few studies of media imagery which have attempted to link dominant images with actually prevalent social perceptions, it was found that the values portrayed as being associated with women in a sample of ten Filipino Tagalog films did *not* coincide with those of a sample of female college students. Of nineteen values—ranging from 'traditional', e.g. self-sacrifice and passivity, to 'modern', e.g. achievement orientation, and independence—there was an emphasis on five in the films: respect for the old, double-standard of morality, loyalty to a loved one, service to others, self-sacrifice (National Commission on the Role of Filipino Women, 1978c). Clearly, the social group used in the study was an élite one and the implications of the findings are therefore limited. However, in a general sense the direction of the trends identified is conservative, confirming findings from almost all other studies of the media's portrayal of women and suggesting that where new values are emerging in society, the media will be slow to recognize or emphasize them.

The study of images in Tagalog films was one of three organized by the National Commission on the Role of Filipino Women in co-operation with the National Media Production Center and the Ateneo University, Manila. The other two concerned images of women in newspaper advertising and in prime-time television commercials. These reinforce findings from other countries regarding advertising's heavy appeal to, and use of women: almost 60 per cent of the television commercials either used women as sales bait or addressed women as consumers. In newspapers the percentage was lower, at about 30 per cent—reflecting the lower proportion of **women among newspaper readers. Both studies found women inevitably overrepresented in adverts for personal or home use, and as** decorative elements in advertisements for luxury items such as cigarettes, liquor, restaurants and cars. Concomitant with this were the usual findings related to the generally passive, dependent and secondary roles assigned to women compared with those ascribed to men.

Mass media in the People's Republic of China

An altogether different picture emerges in relation to the women and media relationship in China. Various studies of imagery in children's books report the extent to which these challenge traditional Western perceptions of sex roles, and provide positive models for girls (for example, CIBC, 1975). A fascinating and detailed study of the relationship between feminism and socialism in China (Croll, 1978) traces the role of the media—primarily the press—in reflecting the twin development of feminist and political concerns from the beginning of the twentieth century. In a political environment of awareness of the potential economic and

social contribution of women, the press acted to raise the consciousness of women towards the particular form of cultural oppression historically directed against them. Interestingly, in relation to many of the findings reported earlier, a tendency of one major women's magazine to promote familiar Western values, such as the achievement of happiness through the family or the attractions of good food, was stamped out in a firmly political action during the Cultural Revolution in 1966 by the removal of the editor of the paper. The 'real' concerns of women were redefined, not only in the press, but in films, operas and ballets, as politics and production. Heroines were portrayed only in leadership roles. But this was no real solution to the fundamental problem. For the media revealed the same sort of stereotyped vision—showing no hint of the competing demands that real women in such positions actually faced —which other media in other cultures had displayed in their portrayals of women as unquestionably non-political and unauthoritative creatures. Croll's interviews with women in 1973, for example, indicated a feeling that government and media had neglected the specific difficulties inherited by women from their historical past or through their reproductive roles (Croll, 1978).

Media portrayals of women in China probably represent the most extreme example of how, in a historically brief time-span, the mass media can make a major contribution to a revolutionary reversal of women's self-image and of social definitions of women's roles. Clearly, the importance of government intervention in this process is paramount, the success —or otherwise—of media in promoting acceptance of change being directly related to the adequacy of political conceptualization of women's problems and their solution.

As yet little information is available concerning the role of the media in China's new political climate and in the opening up of its cultural and economic activities to outside influence. Interest will focus on this over the next few years as new economic imperatives gain currency and different social groupings and orders are formed in the process of their adoption. Already there are some signs that a new media imagery (with a well-known orientation) is creeping in. For example, members of the French group Des Femmes en Mouvement reported, after a visit in May 1980, 'bill-boards full of advertisements . . . for cashmere sweaters and beauty creams (modelled by curly-headed, blonde, slant-eyed 'Chinese')' (*Des Femmes en Mouvement*, 1980). Another commentator, this time British, described the techniques used to advertise colour television sets, on sale at what amounted to three years' wages for the average worker.

Though the brand name differs, the marketing approach is the same everywhere. An entire shop window has been filled with the products of the company concerned, in the home setting of a model consumer family—Mum and Dad plus child. Dad looks Eurasian, and is listening to his stereo on a headset. Mum has an apron, blonde hair and nice European legs. She may be doing the ironing, or using one of those new vacuum cleaners which can get into all the corners. The son in the Toshiba display on Xidan (Peking) is wearing a Snoopy shirt and looking bored. The daughter in the Sony display on Nanking Road (Shan-

ghai) is wearing shorts and has the looks of a trim nymphet. It is all absolutely amazing for the crowd, rarely less than a hundred strong, pressing its collective nose against the shop window (Gittings, 1980).

Such developments await detailed and systematic analysis. They appear to offer one of the clearest contemporary illustrations of the relationship between values and political ideology, between individual self-perceptions and economic policies, between women and socio-economic systems. For as the British report concludes 'the masses do not demand, unprompted, these expensive goodies from abroad. Just as the ads have replaced the quotations from Mao on the bill boards, so these inviting displays are an act of official propaganda, a deliberate attempt to substitute the myths of consumer socialism for those of a revolution which went wrong'.

Media in Australia and New Zealand

There is to date little systematic research into how the media portray women in Australia, but a growing feminist concern with the issue is reflected in a number of journalistic accounts of general emphases in the treatment of women in the Australian press (Women Media Workers, 1978). These analyses report a pervasive trivialization and sensationalization of women's concerns: stress on women's role as consumers; definition of women in terms of their relationship with men; preoccupation with women's sexual attractions and perpetuation of the myth that rape is the victim's fault; emphasis on the family responsibilities of women; a use of the narrowest and most deprecating stereotypes of women in sexist cartoons. An earlier and more conventionally systematic study of Australian prime time television shows (Edgar, 1971) echoes these points and finds women commonly portrayed as acquiescent, self-deprecating and as the objects of male humour.

At the same time, the development of a committed feminist press and of independent feminist film-production in both Australia and New Zealand indicate the emergence of new themes and images. No studies or analyses of the impact of these developments exist as yet, although one account of the difficulties of producing feminist films within a male system (Coney, 1977) illustrates how the dominant male environment forces compromises on the output of even committed feminists, who nevertheless need to achieve visibility through male-controlled channels.

Media images of women: a summary of themes

Some regional variations

An extensive review of the dominant images of women in the output of mass media throughout the world presents a picture remarkable only for its overall consistency when compared from one country to another. Certain exceptions have been noted. Those media controlled by governments with a strong commitment to social change—notably

the People's Republic of China, and to a lesser extent, the socialist states of Eastern Europe—do, as far as can be seen from the very limited evidence available, seem to offer exceptionally positive images of women and lay stress on women's contribution to economic and social development. Even here, however, problems have been identified: in China, the media's reflection of an inadequate political conceptualization of problems arising from the need to reconcile women's new economic and political roles with their reproductive roles. In Eastern Europe, the same dilemma for women has been observed, and here the media appear to play a part in maintaining traditional beliefs by continuing to ascribe unequal responsibilities to men and women in terms of their roles as parents and members of the family. Moreover, there is some evidence that media directed at children and young people retain images which embody traditional distinctions between women's and men's emotional make-up, intellectual capacities and motivations.

The other exception which may be tentatively mentioned is the portrayal of women in the media of certain African countries. Again, the evidence is perilously thin, but there is an indication that images of women in some of these countries may reflect and benefit from a relatively self-conscious use of the media in the general process of development. On the whole, however, negative features of media treatment of women have been observed in Africa as elsewhere: under-representation of women and women's concerns; the use of women as a commodity in media advertising; an ambivalent attitude to women evident in certain stereotyped images in which women are exclusively and unalterably 'good' and pure, or definitely and unchangeably 'bad' and immoral.

Elsewhere, media treatment of women can best be described as narrow. On film, in the press and the broadcast media, women's activities and interests typically go no further than the confines of home and family. Characterized as essentially dependent and romantic, women are rarely portrayed as rational, active or decisive. Both as characters in fictional media material and as newsmakers in the press and broadcasting, women are numerically underrepresented—an absence which underlines their marginal and inferior status in many spheres of social, economic and cultural life. Prevalent news values define most women, and most women's problems, as unnewsworthy, admitting women to coverage primarily as the wives, mothers or daughters of men in the news: in their own right, they make the headlines usually only as fashionable or entertainment figures. Much media advertising directed at women as consumers is condescending in tone and manipulative in intention; as the 'bait' through which products are advertised, women are exploited in terms of their sexuality and physical appearance. Underlying practically all media images of women—though characterized somewhat differently from one country to another—is a dichotomous motif which defines women as either perfectly good or wholly evil, mother or whore, virgin or call-girl, even traditional or modern.

Resonances of the particular sex biases expressed in the media of the United States can be detected not only in many countries of Western Europe, but also in certain Latin American media output, in Australia,

the Philippines and even countries such as Finland and Yugoslavia which import a relatively high proportion of media product—usually television programming. As yet, there is little research into the effects on indigenous perceptions of sexual characteristics resulting from such transfers, though the scant studies which do exist point towards the possibility that imported images can feed into the formation or transformation of local perceptions. However, the general finding that, from one culture to another—even in those countries which rely less, or not at all, on imports—the media present a somewhat distorted picture of reality *vis-à-vis* the demographic characteristics of men and women, is of sufficient significance to indicate that media bias against women starts at home, even if it becomes reinforced and perhaps transformed by other, foreign, influences.

Mass communication processes and media organizations cannot be separated from the social, economic and political systems in which they are located. Although at the level of theory the media may be somewhat abstractly identified as agents of change, at the level of reality, their ability to promote change is dependent on the range of socio-economic and political policies prevailing in the wider society. It is no accident that in those countries in which women have made quickest progress towards full social, economic and political participation—for example, China, Cuba, countries within the USSR—economic imperatives have underlain formulations of policies on women, and the mass media have in general reflected government commitment to these policies. Elsewhere, in the economies of the capitalist world, the media have tended to respond to other, commercial, pressures which characterize women's participation primarily in terms of consumerism.

The dominant images

Perhaps the most important image is, in fact, a 'non-image': it is the absence of women in the media output which becomes most striking, once it has been highlighted. Women's presence, in most media output, is typified by a few pervasive characteristics.

Under-representation of women
Research from almost every world region—excepting the socialist states of Eastern Europe and certain others such as the People's Republic of China—indicates that in all media categories, but particularly on broadcast television and radio, and in newspapers, women are grossly under-represented and occupy less central roles than men. Figures from the United States, United Kingdom, Scandinavia, the Middle East, Africa and Asia all point to the exclusion of women and women's interests. To cite just a few examples: in Lebanese newspapers, only 4 per cent of the total space between 1935 and 1975 was occupied by women; a study of Bangladesh textbooks found only 15 per cent of characters to be women (Krippendorf, 1977); a one-month review of six African dailies found that women were largely ignored (Dawitt, 1977); a review of Scandina-

vian research reported women in between 13 per cent and 25 per cent of the televised roles (Andersen and Korsgaard, 1978); numerous studies in North America report percentages ranging from about 10 per cent (Weibel, 1977) to about 40 per cent (Miles, 1975) for female characters in entertainment programmes, while studies by the United States Commission on Civil Rights found that the percentage of women in newsmaking roles actually fell from 14 per cent in 1975 to 7 per cent in 1977 (United States Commission on Civil Rights, 1979).

Wife and mother: the home-orientation of women
The fact that women are commonly portrayed within the confines of the home, while men tend to be seen more often in the outside world of work, is well documented. Here it is possible to detect differing emphases between countries reflecting somewhat varied social perceptions of what the female role is or should be. Thus, for example, research indicates some emphasis on the role of the long-suffering, self-sacrificing mother in many Latin American countries, in southern Europe, in certain Asian settings—reflecting various religious ethics; in the United States and Europe, there is rather more emphasis on the role of women in the home as housewives and good housekeepers—reflecting material and consumer values. Almost everywhere, it is clear that marital status is a more crucial factor in identifying women than in identifying men, and that parenthood is more frequently associated with women than with men: numerous studies, for example in Canada (Raices, 1976), Japan (Murumatsu, 1977), India (Pathak, 1977), Egypt (Al-Hadeedy, 1977), Ireland (Hussey, 1978), even Poland (Sokolowska, 1976) and the USSR (Rosenhan, 1977) point to an almost universal indentification of women with children. This is equally true of countries such as Sweden where paternity leave has been introduced (Andersen and Korsgaard, 1978).

The sex object and glamour girl
One of the most deeply reactionary, and yet insidiously flattering, images which the media present of women—to themselves and to men—is that of beautiful sophisticate, or of the sexually alluring siren. These images are most clearly associated with the visual media—television, film and magazines—and are the frequent recourse of the advertising industry, working through those media. The use of women as 'bait', in the sale of products ranging from cosmetics to liquor or cars, is noted in countries as diverse as Ghana (Abbam, 1975), Norway (Werner, 1975a), the United States (Dispenza, 1975), Yugoslavia (Bosanac and Pocek Matic, 1973), the Philippines (National Commission on the Role of Filippino Women, 1978c), India (Press Institute of India, 1975) and countless others. Complicating this basic picture is the fact that—primarily in North America and parts of Europe—the last five years has seen the growth of a relatively new emphasis on women's sexuality as an element in their liberation from dependence on men. Various analyses of magazines such as *Viva* and *Cosmopolitan* in the United States (Weibel, 1977)

and Europe (Laine, 1974) have suggested that by presenting men, rather than women, as sex-objects, these journals merely present another version of the traditional picture of women: emphasizing as they do the importance of men in women's lives, they substitute sexual freedom for economic or social liberation. Recent studies of American television programming note a similar development in broadcasting (United Commission on Civil Rights, 1979).

The virgin-whore dichotomy
Underlying these images of the woman as housewife/mother and as sexual object, runs a strain noted in studies in numerous countries, but particularly well documented in Colombia (Flora, 1979), Venezuela (Colomina de Rivera, 1976), Puerto Rico (Barreto, 1978), Greece (Safilios-Rothschild, 1968), Zambia (Glazer Schuster, 1979) and India, (Anu and Joshi, 1979). This points to a fundamental paradox in female imagery and an inability to cope with women's real sexuality. The good-bad virgin-whore distinction is a dichotomous strand in an enormous amount of the imagery which the media ascribe to women. Each side of the dichotomy can be expressed through a number of variations. Throughout the imagery of the 'virgin' runs a consistent stress on subordination, sacrifice and purity. The 'whore' imagery is connected with cruelty, inhumanity, insensitivity and unscrupulousness. These roles are propagated by the notion of rewards and punishments: if the women behaves well, she will be given the love of her man; if she behaves badly, she will be alone, unloved and castigated. Various anthropological studies have accounted for this in terms of an intensive male ambivalence towards women, carrying within it a fundamental fear of the potential challenge of the opposite sex (Glazer Schuster, 1979; Lederer, 1968).

The working woman: power and authority
An overwhelming body of North American and European research indicates that, in relation to women's actual participation in the work force, all media under-represent women workers. For instance, although in reality almost half the labour force in both the United States and Canada is female, studies show percentages of working women in television portrayals which vary from 30 per cent to as low as 12 per cent (for example, Signorielli and Gerbner, 1978). A similar picture emerges from research in countries such as India (Pathak, 1977) and the Philippines (National Commission on the Role of Filipino Women, 1978*b*). Even in the Soviet Union, where 93 per cent of women work, one study of youth magazines found that men were five times more likely to be associated with their occupation than were women (Semenov, 1973). Studies worldwide also show a concentration of women portrayed as employed in a limited number of jobs and in predominantly female fields and roles.

This is significant because the question of power and status of men *vis-à-vis* women in media portrayals relates in part to the kinds of occupa-

tional role to which each sex is predominantly assigned. Since women are rarely seen in authoritative positions such as lawyer, doctor, judge, scientist (Culley and Bennett, 1976) they are rarely in a position to exercise direct authority over an adult male. In a study of the pattern of advising and ordering in male-female interactions, Turow (1974) found that dramatic characters on television were selected, occupations were assigned and plots developed in such a way as to minimize the chances for women to display superiority, except in traditionally accepted female areas of knowledge. A further indication of the media's emphasis on male authority is the reliance on male voices in advertising to 'sell' products. All studies in both Canada and the United States report a striking predominance of male voice-overs, the implication being that women depend on men for advice and assistance in the purchase and use of products, even those associated with tasks considered traditionally female.

Psychological characteristics: passivity, dependence, indecisiveness

Numerous measures have been used to investigate the psychological characteristics attributed to women by the media, in detailed studies in North America, Scandinavia, Latin America and Bangladesh (for example, Rickel and Grant, 1979; Andersen and Korsgaard, 1978; Quiroz and Larrain, 1978; Krippendorf, 1977). Consistent findings are that passivity and emotional dependence are rewarded in women while in general, characteristics which are defined as 'good' in men—decisiveness, independence, forcefulness, tenacity—are defined as 'bad' in women. According to the fictional reality of the mass media, then, women are actually rewarded for ineffectuality, rather than for actively controlling their own lives.

Functional roles of the media

The mass media perform a number of quite different functions in society, providing news and entertainment and acting as vehicles for both education and advertising. It is at least possible—indeed, it is often assumed—that within each of these separate functions the media's portrayal of women may be more or less damaging.

Advertising

Probably greatest concern has centred on images of women in advertising, whose reliance on women—particularly women's bodies—as sales bait is in universal evidence. The particular degrading nature of many advertising images of women is well-documented, for example, in studies in Canada (Task Force on Women and Advertising, 1977), United Kingdom (Millum, 1975) Austria (Arbeitsgruppe Frauenmaul, 1979), Denmark (Sepstrup, 1978), the Philippines (National Commission on the Role of Filipino Women 1978*a*, 1978*b*). Successful campaigns against particular advertisers or advertisements have been waged in a number of countries.

However, these tend to be drops in the ocean of negative images projected in the name of commercial interests. Those interests control, or at least influence, not merely the advertisements themselves, but the context which surrounds them: indeed, the purpose of such commercial media content—whether television, radio or print—is to attract an audience which will then be exposed to the advertising message. This allied to the fact that advertising tends to deal in known, safe, traditional, appeals makes for an insidiously manipulative and conservative appeal to the audience.

On the other hand, to be successful, advertising must sell: it therefore needs to take account of the attitudes and behaviours of its target audience. There is no doubt that advertisements aimed at certain groups are taking account of changes in women's roles: in the United Kingdom, for instance, one series of successful advertisements for a popular daily newspaper plays on the words of a well-known saying with its slogan 'Behind every successful woman there is a *Daily Mail*': women in these advertisements are shown as business executives, lawyers and so on. Another series emphasizes the growing independence of women by urging them to open their own bank accounts. In the United States, United Airlines, having found that 16 per cent of its business travellers were women in 1978, aims a quarter of its print-advertising towards them: a third of the managers in its television advertisements are women (Lovenheim, 1978). According to Cuthbert (1979) advertisers in Jamaica now present a more balanced and positive image of women. But in spite of these instances, and despite Canadian research which demonstrated that advertisements reflecting modern roles were rated as more effective by consumers and advertisers alike (Courtney and Whipple, 1978), advertisers are unlikely to initiate change: they have a vested interest in the status quo. Moreover, there have been numerous instances of what has sometimes been called 'value prostitution' in advertising: cases in which a genuine value, which has nothing to do with a product, is used to sell it; for example, the appropriation of the value of independence for women in the 'You've come a long way, Baby' series of the campaign to sell Virginia Slims cigarettes (Andren et al., 1978). Stuart Ewen points out how, in a similar way, the demand for equality for women in the 1920s in the United States was appropriated into the jargon of consumerism—in, for instance, the advertisements of the American Tobacco Company (Ewen, 1976). These historical instances do indicate the correctness of a definition of advertising as 'the rhetoric of modernity' (Mattelart, 1978).

Entertainment

Severe criticism has also been levelled at the media—film, print, radio and television—for their portrayal of women in the context of entertainment. Here it is the powerlessness of women which is most apparent, both in terms of their under-representation (they are outnumbered three to one in United States peak-time television, drama, and by about five to one in popular radio and television programming in many European countries) and in terms of their professional and emotional subordina-

tion to men. Magazines, including the *fotonovelas* of Latin America, Spain and Italy, and broadcast 'soap-operas', pander to vanity and indulge fantasies and escapism. Other types of radio and television programming systematically exploit women to the advantage of men's self-esteem. Numerous studies around the world report consistently on this fact: women are shown as dependent, foolish, indecisive, deceitful, incompetent and so on. More worrying, however, may be the fact that often these flaws are presented as being desirable or even funny. The dizzy ultra-feminine bird-brain is an image to which women, men and children are continually exposed: better to be wide-eyed and pretty than a forceful blue-stocking.

News

Here, criticism centres not so much on how women are presented as how they are *not*. The fact that women rarely appear in news coverage —no country from which data are available report more than a 20 per cent incidence of news about women (National Union of Journalists, 1978) and the percentage falls as low as 4 per cent—may be as important as the fact that they are vastly over-represented in advertising. News is associated with important events, and news in every country reflects a male social order.

At the same time, when women are included, there is a tendency to refer to irrelevant detail about appearance, age and family status —detail which would not be included in a report about a man. Even in relation to powerful and influential women, reporting often falls into this vein. Thus, we have the pervasive image of the British Prime Minister as the 'Iron Lady'. More damaging and demeaning is the reduction of important concerns—when women are involved—to the level of trivia: the debate in 1979 as to whether the British Government would approve a visit by the Queen to Zambia was reported in the British media as a decidedly female tug-of-war between 'two very strong-minded independent ladies'. This presents a particularly virulent undermining of women, involving a lack of serious acceptance of those successes they have achieved.

Education

It is perhaps reasonable to assume that educational mass media may be more balanced in their portrayal of women, that educators may be more alert to sexual stereotyping and may seek to avoid bias in the projection of sex roles. But, although less analysis has been made of educational media *per se* than of other functional roles of the media, evidence of stereotyping in curricula of the educational systems of the world is not encouraging.

As far as formal education is concerned there is a growing literature from countries such as Bangladesh (Krippendorf, 1977), France (Beraud, 1975), the USSR (Rosenhan, 1977), Sweden (Berg, 1969), India (Indian Federation of University Women's Association, 1977), the United States (Rickel and Grant, 1979) to name only a few, attesting

to sex-role stereotyping in children's textbooks. A recent EEC report found that girls were under-achieving in all EEC countries because of sex-role stereotyping and discrimination. A 'hidden curriculum' exists to condition girls, by the time they have finished with primary education, to think in terms of feminine stereotypes (Byrne, quoted in Tagney, 1979). But some American research has demonstrated that aspects of sex-role stereotypes are present in 3-year old children before they enter the formal educational system, indicating the crucial importance of pre-school informal education (Flerx et al., 1976). In this context, it is worth noting that one of the most heavily criticized children's television programmes in the United States, *Sesame Street*, in which female characters are outnumbered five to one by males, and in which males are stereotyped as dominant and aggressive, and females as traditional home-makers (Signorielli and Gerbner, 1978) was specifically designed so that pre-school children could 'model' behaviour. Moreover, much research exists to show that *Sesame Street* has been successful in teaching children (Lesser, 1974).

Non-formal educational programmes for adults are not exempt from criticism. Although numerous television and radio programmes are directed towards the education of women, these tend to emphasize domestic skills and child-care to the exclusion of other, less traditional pursuits. This is not to deny that such things are important to women —particularly in many of the developing countries—but it is notable that in a country like the United Kingdom, television's 'further education' for women still consists mainly of series on cookery, dress-making, knitting and so on; programmes dealing with women's retraining and re-entry to the labour market hardly exist. Even programmes which deal with crucial topics such as health and contraception may contain sexist biases (Kishwar, 1979). It seems possible also that the drive towards stereotyping may be more forceful in programming for older children and adults. In Sweden, for example, an analysis of two weeks' educational television for pre-school, primary and secondary school children, and of educational programmes for adults, found that programmes contradicting the concept of sexual equality were most commonly aimed at students in grades 7-9 of primary school and in secondary school, followed by adult educational programming.

Chapter 2

Participation of women in the mass media industries

Concern with women's employment in the mass media industries springs from two basic preoccupations. The first is a simple interest in the development of job opportunities for women at all levels and in the removal of obstacles to their equal participation in every field of work. The second rests on an assumption that there is a link between media output and the producers of that output: since the presence of women —particularly in creative and decision-making positions—in media organizations is severely imbalanced in relation to that of men, the assumption is that the images of women disseminated by mass media reflect and express male concepts and interpretations. The implication of this assumption is that by opening up the media to women workers on a larger scale, the images which have given cause for concern will gradually change for the better. However, an immediate and fundamental problem undercuts the apparently simple link between imagery and participation of women in the media. For images of women are constructed, and women find their identity, outside the media too: it is the marginality of women in cultural and social life generally which contributes to and reflects their subordination. This subordination is, moreover, constituted not simply through a particular configuration of media images, but also through basic political and economic structures.

Problems of working women

A number of common problems apply to working women across a wide variety of work situations and settings. Before considering specific questions on the composition of women within the structure of media organizations, it is important to consider some of these difficulties in a more general context. Such consideration will underline the nature of women's relationship to the overall economic system and the structural base of sexual inequality in society.

The context of women's work: marriage and service

The striking increase in the paid employment of women in this century —and attendant changes in the structure of the female labour force—is a characteristic of all developed countries. In the United Kingdom, for instance, 90 per cent of the increase in the labour force between 1950 and 1971 is accounted for by women (HMSO, 1974). In most industrialized countries more than a third of all adult women are in the labour force; in Scandinavia and Eastern Europe the proportion is well over half. In the United States, the proportion of women in the work force increased from 34 per cent to 50 per cent between 1950 and 1976 (PRB, 1977); a similar pattern is true of the United Kingdom where by the early 1970s, women constituted 56 per cent of the labour force (HMSO, 1974). Most of this increase is attributable to increase in the numbers of married women who work. In Sweden, for instance, the proportion of working married women rose from 16 per cent to 54 per cent between 1950 and 1972 (Barrett, 1973); in the United Kingdom and the United States the proportion increased from about a quarter to 42 per cent in each county over the same period.

Similar trends can be noted in many countries in the process of development. For instance, a survey of secondary school girls in Sri Lanka in the early 1970s found that 89 per cent expected to remain in paid employment after marriage (Unesco, 1975). An increasingly internationalized industrial market has affected the employment of women in developing countries. In Malaysia, for example, between 1957 and 1970, the proportion of women in export-oriented manufacturing increased from 17 per cent to 29 per cent. In Singapore, between 1970 and 1974, the proportion of women in manufacturing grew by 118 per cent as against a corresponding increase of only 36 per cent for men; most of this increase occurred in the four main export industries of clothes, footwear, textiles and electronics (WCUNDW, 1980*b*). A further factor is the location by transnational corporations of plants in developing countries to manufacture consumer products and components for export. For instance, a study of employment in Federal Republic of Germany textile and clothing foreign subsidiaries found that more than 90 per cent are women (Frobel et al., 1978). The phenomenon is particularly characteristic of labour-intensive industries whose location in low-wage countries increases economic viability.

Then, too, as economies develop, increases in the rate of female participation in the labour market are generally paralleled by rapid growth in the service industries. In this century, for example, the service sector has grown faster than all other sectors in most countries in the West. Moreover, the two phenomena—increase in female participation and growth in the service sector—are interrelated: most women are employed in the service industries. In the United Kingdom, 64 per cent of all women in employment in 1971 were concentrated in the service sector. Service jobs account for two-thirds of all employed women in the United States and for 40 per cent of employed women in Latin America (Chaney, 1979). Between 1950 and 1975, the service sector was responsible for 85 per

cent of the increase in the female labour force in Latin America (PREALC, 1978).

Clearly then, the service industries have become strongly identified with female labour. Child-care workers, nurses, domestic servants, hairdressers, laundry workers, shop assistants, waiting staff, clerical workers, all include an overwhelming proportion of women. This 'feminization' of a particular sector, or of jobs within a particular sector of work, is simply a modern variation on an age-old sexual division of labour. In many agricultural countries, for example, men plough and sow while women transplant and weed. The fact that in Sweden 80 per cent of working women are in occupations in which at least two-thirds of *all* workers are women is one which is repeated worldwide (Barrett, 1973). An analysis of twenty-five countries shows that certain occupations are almost completely filled by women: some obvious examples are secretaries, nurses and para-medics, cleaners, tailors, dress-makers, where 80 per cent or more of all workers (on the average of the twenty-five countries) are women. Women make up substantial proportions of several other service occupations such as catering (ECE, 1979). With the possible exception of secretarial work, these jobs are regarded as 'typically female' in the sense of drawing on skills also exercised, on an unpaid basis, in the home.

Along with this segregation among jobs, goes another segregation within each occupation. Even in female-dominated occupations, administrative and supervisory posts tend to be held by men. For instance, although half of the food industry workers in Czechoslovakia are women, less than 1 per cent of food processing plants (a total of five) were directed by women in 1973 (Scott, 1974). In the United Kingdom, although 78 per cent of all primary (elementary) school-teachers were women in 1974, only 43 per cent of head-teachers in such schools were women (Byrne, 1978). Although 70 per cent of doctors in the USSR are women, half of the senior physicians in 1970 were men (Lapidus, 1978). This concentration of women at the bottom end of the labour ladder and men at the top has an inevitable impact on their relative earning levels.

Equal pay for equal work

Across the world as a whole, between a quarter and a third of all families are supported by women; yet these are consistently the world's poorest families (Buvinic and Youssef, 1978). In 1975, in the United States the median income of female-supported families was less than half that of families supported by men (Newland, 1979). In the United Kingdom, 43 per cent of people claiming family-income supplements (paid to low-income heads of households with dependent children) are single, nearly all of them women. In Canada, for female single parents with at least one child under the age of 18, average family incomes are only 45 per cent of the national average. In Metropolitan Belo Horizonte, Brazil, in 1977 the percentage of households at poverty level headed by women was 41 per cent, compared with 26 per cent of households headed by men (WCUNDW, 1980*b*).

Statistics provided by the International Labour Office suggest that in many industrialized countries women still earn less than men for equal work (ILO, 1975). But in any case, the concept of equal pay for equal work—like that of equal educational opportunity—has been found inadequate in a world where there is massive sexual division of labour. Low-paid jobs—whether unskilled, skilled or professional—are women's jobs. In the Soviet Union, for example, although 70 per cent of doctors are women, doctors' starting salaries are 30 per cent less than the starting salaries of factory workers (Northrup, 1977).

In the United States, full-time women workers earned only 59 per cent of what men earned in 1977. In Thailand in 1969, the percentage of women's earnings was 61 per cent that of men's (Newland, 1979). Roughly similar figures can be quoted for most countries. A Unicef study found that in Panama 34 per cent of the non-agricultural female wage-earners were in the lowest income category, compared with 6 per cent of the non-agricultural male wage-earners; in Venezuela, these proportions were 13 per cent and 2 per cent respectively (Unicef, n.d.) In Czechoslovakia, women's wages in industry averaged 65 per cent of men's in 1975 (WCUNDW, 1980*b*). Even in the Soviet Union, the husband's earnings were higher in 73 per cent of families in 1970; only in 7 per cent of cases were wives' earnings higher (Lapidus, 1978).

Reasons for this are complex and include factors such as women's predominance in part-time work (usually because of unpaid family commitments), a faster-growing female—compared with male—entry rate to the labour market (resulting in a disproportionate number of women at lower levels), as well as women's predominance in low-paid female-type jobs. A small number of countries has narrowed the earnings gap through alternative policies, allied to favourable economic climates: in Sweden, women now earn 82 per cent of average male earnings (Newland, 1979). In Western Europe, throughout the manufacturing industries, there are three countries in which the average gross hourly wages of women are coming closer to those of men: Sweden, Denmark and the Netherlands, where they represent 87, 86 and 80 per cent of men's wages, respectively (WCUNDW, 1980*b*). However, such cases are quite exceptional.

Dual responsibilities of working women

The major constraint on women's earning power—apart from the enormous problem of occupational segregation, which divides the labour market into 'male' and 'female' jobs—is women's need to combine the dual responsibilities of domestic work and paid employment: in Denmark, 46 per cent of married women work; in the United States, 56 per cent. And these do not necessarily comprise young, childless women, or mothers returning to work after having raised their families: in Sweden in 1974, 57 per cent of women with children under 7 worked, as did 37 per cent of American women with children under 6 (Barrett, 1973). In Eastern European countries the proportion of women in paid employment falls only very slightly in the main child-bearing ages (ECE, 1979).

The persistent attitude that housework and children are women's, rather than men's, responsibility remains engrained. In a few countries —for example China, Cuba, Sweden and Albania—sharing of housework is official policy. In Eastern Europe—where the proportion of the work force made up by women is the world's highest—it is the state which aims to take over part of women's family burden through the provision of child-care services. Elsewhere, working women tend to have either two full-time jobs, or to be pushed in the direction of part-time work—usually in low-skilled, routine, dead-end jobs—outside the home.

The double burden for working women affects not only women's real ability to compete on an equal basis with men in the labour market —they must divide their time among a greater number of tasks than do most men—but also their status as prospective employees. Because continuity of service is a problem for most women, employers tend to fear that investments in training will not be recouped. Moreover, the fact that child-care costs, or a proportion of them, are everywhere charged to the mother's and not to the father's employers is a further obstacle to the recruitment of married women.

Despite the fact that paid maternity leave in many countries means that an increasing number of women have relatively short breaks in service—of less than a year—employers continue to view prospective female workers as simply filling in time until child-rearing begins. Sweden, Norway and France give parents freedom to decide whether child-care leave (on the birth of a child) should be taken by the father or the mother. In Sweden, the percentage of men using these rights has increased annually since they were introduced in 1974, and reached 12 per cent in 1978. In Austria, Israel, Sweden and Finland fathers as well as mothers are now entitled to leave (paid or unpaid) in the case of children's illness (WCUNDW, 1980b). However, such measures are exceptional, and in many countries even basic maternity protection is fragmentary or non-existent. Cash maternity benefits correspond to full pay only in a very few countries in Africa and Asia, for example. Most developing countries exclude the entire informal and agricultural sectors from maternity leave provision, thus leaving the largest group of women workers without provision. In a number of countries, employers have to pay—in full or in part—for maternity allowances to their staff. Again, this gives rise to discrimination against women, creating a constraint on their employment opportunities (Gerona-Adkins, 1979).

Education and training

Lack of education and training also seriously hinders women's possibilities as workers. Not only do girls in most countries complete fewer years of schooling than boys, but girls complete their education with notably fewer marketable skills.

At the level of technical and vocational training, there is an overwhelming predominance of men: 99 per cent of those enrolled in technical high schools in the Republic of Korea were male in 1977; enrolment in

industrial and trade courses in the United States is 98 per cent male (Newland, 1979); only 12 per cent of women in Italy and 38 per cent in the Federal Republic of Germany receive any kind of vocational training. In developed countries with market economies, only 12 per cent of girls and women receive training for skills in industry. In developing countries, where agriculture is an essential component in the economy, few women receive training for agricultural skills: 11 per cent in Africa, and 7 per cent in Latin America, for example (WCUNDW, 1980c). On the job training is even more of a problem for women: in the United Kingdom, only 7 per cent of women obtain apprenticeships at work, and these are mostly in hairdressing (McDonald, 1979).

Entry to the professions is hindered by women's lower access to higher education. Only in Eastern Europe and North America do half the higher education places go to women; in Western Europe and Latin America the proportion of women in higher education is about a third; in Asia and Africa, it is a quarter or less.

This is a legacy which women carry with them into the job market. For not only do women in most countries lag far behind men in the sheer amount and quality of education and training received. In most parts of the world women have not been able to use their education in the same way, or to the same extent, as men within the economic system.

Unionization
A further structural factor which works against women is their lack of unionization. While 42 per cent of American workers are women, for instance, only 31 per cent of union members are female (Raskin, 1977). At the leadership level, women's representation is low even in those unions where their proportion as workers is high. For example, a New Zealand survey of the unions of eleven industries, in which more than half of the members were women, found that only 6 per cent of the executive members and 9 per cent of the local delegates were women (WCUNDW, 1980b). Moreover, occupational sex-typing is sometimes reproduced in women's trade-union activities. A Latin American survey of trade unions for instance, found that in Brazil, although female membership was comparatively high, actual participation by women was restricted to the co-ordination of recreational activities; in Peru, women continue to perform 'female' tasks—for example, secretarial and social work—as members of trade unions.

Such a situation makes it almost impossible for women's interests to be served. It is no accident, for example, that in the global recession of the mid-1970s female unemployment was much higher than that for men in all of the market-oriented economies of the developed world. In Belgium, for instance, 19 per cent of the female labour force was unemployed in 1978, though the corresponding male figure was only 6 per cent.

Women in less developed countries are particularly susceptible to overall job scarcity. Rising population rates and the increasing use of capital-intensive technology mean crowded labour markets. When jobs

have been created, they have tended to go to men. Between 1961 and 1972, the proportion of women in paid employment in Peru fell from 22 per cent to 15 per cent (ILO, 1975); in India, from 21 per cent to 12 per cent (Indian Council of Social Science Reserach, 1975). In Brazil, the percentage of women employed as industrial labour remained at 10 per cent between 1950 and 1970, while the percentage of men in industrial jobs doubled from 10 per cent to 20 per cent. (WCUNDW, 1980*b*). In Mexico female underemployment has increased disproportionately to that of men in the process of industrial modernization (Arizpe, 1977).

The fact that female unemployment tends to rise disproportionately to that of men at times of overall recession or under industrialization processes masks the fact that in certain sectors women's jobs remain very much more intact than those of men. This relates to the lower wage levels associated with women's work and helps to explain why male union members have tended to see women as a threat: as a source of cheap labour, women can replace men in a declining labour market. Even in periods of economic buoyancy, women can undermine wage levels by selling their labour cheaply. At the same time, it is primarily this realization which has led male trade unionists actively to seek the involvement of women in union affairs, resulting in considerable increases in female participation rates in some countries. In the United Kingdom, for instance, between 1950 and 1970 two-thirds of the increase in membership of the Trades Union Congress was accounted for by women (Trodd, 1972). Moreover, an analysis of recent trends in the participation of women in some developed countries shows that since the economic recession women make up a substantially higher number of new union members than do men. However, their participation rate in union office remains consistently low (WCUNDW, 1980*b*).

Legislation

Finally, there is the problem of legislation. This is a particularly delicate and much debated question, in which there are two strands. First, there is the issue of protective legislation. Conceived to protect women against exploitation, protective legislation—often reflecting the assumption that women are weaker or more vulnerable than men—can put women at an enormous disadvantage in the labour market. Studies in countries such as Japan (Iwao, 1977), Peru (Chaney, 1979) and in Africa (Boserup, 1970) have suggested that measures to restrict women's overtime, night work and so on make women more expensive and difficult to employ, and are thus a cause of high female unemployment. An Indian Factory Law, for instance, stipulates that if there are eight or more women, the employer must provide separate facilities—restroom, lounge and so on: in practice, it is easier for many firms to employ less than eight women to counteract these problems.

Sweden has rejected the principle of protective legislation for women and has adopted a policy of protection for all workers as necessary. In Japan, a labour law research group within the Ministry of Labour has

recommended the abolition of all articles protecting women, except for maternity provisions. On the other hand, certain groups in Japan —including feminist activists—have argued that the abolition of protective legislation would lead to the 24-hour operation of certain industries, particularly manufacturing and service industries in which the labour force is predominantly female. This, it is felt, would simply exacerbate the problems faced by Japanese working women, 60 per cent of whom are married (Atsumi, 1980).

A second aspect of legislation is that concerning laws to promote sexual equality. Clearly, an Equal Pay Act does not guarantee that women will earn as much as men, as long as some jobs are 'women's' work. Sex Discrimination Acts—for example, making it illegal for employers to discriminate on grounds of gender—are notoriously difficult to enforce. On the other hand, legislation can help to create a climate which can have a positive impact over time: this was the thinking behind the 1975 revision of the Cuban family law, by which men are legally required to share housework. Specific laws, on the whole, have been ineffective unless backed up by committed policies. In Sweden, for example, a programme of loans and subsidies to industries in high unemployment areas extends only to firms which employ at least 40 per cent of workers of each sex. This, linked to a project to introduce women workers into male-dominated jobs, has meant that, by 1975, more than 20 per cent of women coming into the labour market had taken up male-stereotyped jobs (Leijon, 1976).

Women media workers

It is within the context of these generalized problems that the situation of women working in the mass-media industries should be seen. In many developing countries, the media form part of what is sometimes called the 'modern industrial' sector. In such countries, as we have seen, jobs in this sector are few, and as a general rule men predominate overwhelmingly. In the developed world, jobs in the media industries have themselves been subject to sex-typed segregation. These factors, in addition to some media-specific variations on the problems highlighted above, underpin the overall position of women media workers.

The employment of women in the mass media

In contrast with the fast-growing body of research from almost all parts of the world into the question of women's portrayal by the mass media, relatively little is known about the extent and nature of women's participation in the media industries. Incomplete and often unreliable statistical data paint a patchy picture, in which entire world regions are missing. Practically no information is available, for instance, on women working in the media of Latin America, Africa, or Eastern Europe; data from Asia and from Western Europe are very fragmented, and often based on subjective impression rather than statistical fact. What follows,

therefore, should be seen not as an exact or detailed account of the employment of women in the world's media, but as an attempt to pull together existing information in such a way as to illustrate some trends and problems.

Broadly speaking, the situation of women working within the media industries reflects the fact that the world of work is a male-dominated world. Both in terms of overall numbers and of distribution across and within specific occupations, women media workers are at a distinct disadvantage when compared with their male counterparts.

Women as a proportion of the media work force

In attempting to establish the overall proportion of women across national media, or within any particular media sector, there is an almost intractable problem with the lack of data comparability from different sources. Thus, for instance, while some figures include *all* women working in *any* capacity (including cleaning women, restaurant staff and so on), others refer only to women working in professional or technical grades. Often, moreover, there is no way of knowing which categories of staff have not been included. This lack of a common data base seriously hinders comparative analysis.

Overall, the proportion of women employed in film, broadcasting or in the national press rarely exceeds 30 per cent in any country: often the percentage is very much lower. To give some examples from broadcasting: in the United States, 30 per cent of the work force at television network headquarters and also at network-owned stations in 1977 was female (United States Commission on Civil Rights, 1979); in Italy, women accounted for 20 per cent of the jobs in RAI television in 1975 (Toeplitz, 1980); in Canada, 25 per cent of the jobs in CBC were held by women in 1975 (CBC, 1975); in the Federal Republic of Germany in 1975, 28 per cent of employees in Westdeutschen Rundfunks were women (Von Welser, 1976), and in Jamaican broadcasting 28 per cent of workers were women in 1979 (Cuthbert, 1979). It has been estimated that there were about 25 per cent of women in broadcasting in India in the same year. Women do slightly better in some Scandinavian countries; in Sweden women comprise 33 per cent and in Norway 38 per cent[1] of all employees in the national broadcasting corporations (1976 figures). In the United Kingdom, 36 per cent of all staff in the BBC were women in 1978. In Israel in 1974, women constituted 40 per cent of all employees in broadcasting (Goren, 1978). At the other end of the scale, 6 per cent of those employed in NHK in Japan are women (Nuita, 1979); in Pakistan only 3 per cent of radio and television employees are women (Habib, 1980).

In the print media, the picture is really no better. As far as can be established, women rarely account for more than a quarter of the jobs in journalism overall: Hungary, Poland, Canada all have about that proportion and the United Kingdom and the Lebanon have slightly fewer

1. This, and other information on Norwegian broadcasting, received in private communication from Mie Berg, Norsk Rikskringkasting (NRK), September 1978.

(around 20 per cent) (AIJPF, 1978; Ghorayeb, 1979). Several European countries report about 15 per cent of women in press jobs—for example, Norway, Denmark and the Federal Republic of Germany had this proportion in 1977 (Marzolf, 1977). Elsewhere, the proportions can be even lower. Full-time women journalists in Pakistan account for just 3 per cent of all press jobs, although if free-lance workers are included the percentage increases to 8 per cent (Habib, 1980). The percentage of women in the Kenyan press is estimated at about 5 per cent. A study by the Press Commission in India found that only 3 per cent of journalists in South India are women; although there are more than 3,000 publications in the region, women occupy not more than 60 posts overall (Chabbra, 1980). In the Republic of Korea, only 2 per cent of jobs in the press are held by women (Cheong, 1977), while Japanese women occupy no more than 1 per cent of positions in the press medium (Paulson, 1976).

Such figures tell their own story: instances where men hold less than 70 per cent of all available media jobs are exceptional. In some cases, they are in almost exclusive control.

Occupational segregation

In some countries, certainly, women now occupy more than 30 per cent of media jobs; in a few, they approach 40 per cent of media workers. The Swedes have settled on a 60 : 40 ratio in most occupational sectors as representing national equality. Is it not arguable that in some countries, at least, equality at that level has almost been achieved within media organizations? However, scrutiny of the data to see just *where* in the media women are employed shows that the global figures mask even greater disparities between men and women. For instance, although 38 per cent of broadcasting jobs in Norway are indeed held by women, 63 per cent of jobs at the lowest wage level are also filled by women. Women are generally concentrated at the lower levels of particular job categories, or else hived off into areas which are overwhelmingly 'female'. For that reason, the Equality Project in the Swedish Broadcasting Corporation aims for a minimal 60 : 40 ratio within any *particular* occupational category (Sveriges Radio, 1978).

Vertical segregation

At the managerial level, women generally hold not more than 10 per cent of the jobs. In the United States, considerable debate has raged over the way in which various jobs are classified by the Federal Communications Commission, making it almost impossible to distinguish between truly authoritative managerial positions, and jobs with impressive titles but little or no power. (As a result, category definitions were slightly revised by the FCC in 1978.) However, conservative estimates put American women media managers at about 5 per cent, although official FCC sources have suggested that women hold more than 20 per cent of managerial positions. The United States Commission on Civil Rights found that in 1975, although 16 per cent of jobs in top management or

as departmental heads were filled by women, most of these women were not in key policy-making positions. In Jamaican broadcasting in 1979, 14 per cent of management posts were held by women (Cuthbert, 1979). In 1975, the Canadian Broadcasting Corporation found that 93 per cent of management-level jobs were held by men. In the Australian Broadcasting Commission in 1977, *no* management positions were occupied by women (ABC, 1977). The Italian RAI had 4 per cent of women in a category spanning administrative and managerial jobs in 1975 (Toeplitz, 1980). In Finland in 1978, all fourteen members of the Board of Directors were male, while at middle-management level 6 per cent of posts were held by women (Harms, 1978). The Norwegian Broadcasting Corporation (NRK) has 50 different departments: only two are headed by women. Of the 71 women in the Ghana Broadcasting Corporation in 1975, two were heads of section: these were the Head of Audience Research and the Assistant Controller of External Broadcasting (Abbam, 1975). In 1974, only 4 per cent of executive posts in British journalism were held by women (Smith, 1978). Of the 151 top management posts in the BBC in 1978, only 2 (1.5 per cent) were filled by women.

The same pattern is repeated at the creative/professional level, where access to top posts is very limited for women, unless the area of activity is 'feminized'. Thus, though there are a fair number of women heading programme departments in children's, women's or even religious and educational programming, and a large number of women editing similar features pages in the press, current affairs, news, drama, science, sport remain almost completely barred. In the United Kingdom in 1975, for example, the Association of Cinematograph, Television and Allied Technicians (ACTT) found that only 8 per cent of its members employed by the independent television companies (ITV) as directors or producer-directors were women. In fact, it established that in all job categories, a much higher proportion of men reached the top grade than women (ACTT, 1975). Across six programme departments in the BBC in 1980, 16 per cent of the producers were women (Baehr, 1980*b*). Only 2 per cent of television producers in the ABC (Australia) were women in 1977. These are particularly depressing figures, considering that the bulk of programme *support* staff—production assistants and production secretaries—are women. Two broadcasting organizations with untypically high proportions of women producers are the Swedish and the Singaporean services, where women account for 30 per cent and 38 per cent of all producers, respectively (Sveriges Radio, 1978; Chong, 1977).

In journalism too, women predominate at the lower echelons, although the overall picture seems somewhat better than in broadcasting. Thus about a quarter of the editorial jobs are said to go to women in the United States (Bowman, 1974) while 28 per cent of editorial posts in the United Kingdom are held by women (Smith, 1978). However, this general picture is heavily influenced by the very large number of female editorial staff concentrated in traditional women's areas. Women's page editors in the United States are overwhelmingly female; between 10 per cent and 20 per cent are male. In the United Kingdom, although in 1974 22 per cent of women editors were employed in 'women's fields', only 1 per cent of

news editors were women. Even in women's magazines, the predominantly female staff are very often working under the direction of men. Data from the United States (Strainchamps, 1974), Italy (Lilli, 1976), the Federal Republic of Germany and Belgium (Marzolf, 1977) confirm that men continue to hold key decision-making positions in this type of publication.

Horizontal segregation

Quite apart from the fact that very few women get to the top in any category, there is a noticeable concentration of women in certain areas —usually the less prestigious, less well-paid ones, from which promotion or career development is a near impossibility.

In the professional/creative field, most women are found well away from the important areas of news, current affairs, economics and politics. Even in drama, sport and light entertainment, they are severely underrepresented: these areas are particularly important in terms of audience pull, and are crucial to the success of most media organizations. In general, women are relegated to areas which are seen as having only marginal importance. The ACTT in the United Kingdom found its members working primarily on educational, arts and children's programmes in 1975—a frequent pattern. In 1980, the only woman Head of Department in BBC television headed Continuing Education, and all six executive producers in charge of children's programmes were women (although the department head was a man). This compared with the Current Affairs department where only 2 of the 33 producers were women; and news department, which had no woman editors or correspondents, although 2 of the 14 reporters were women (Baehr, 1980*b*). In the United States, only about 10 per cent of news personnel in television and radio stations, for instance, were female in 1974, and most of these were in low-level editorial jobs (Bowman, 1974). In Japan, NHK has recruited no news reporters for 20 years: women programme-makers (about 1 per cent of the total production staff) are almost exclusively concerned with children's programmes or programmes dealing with cookery and similar activities (Nuita, 1979). A Tanzanian study reports few women in the engineering, news and current affairs departments in the national radio corporation: 'women concern themselves mostly with women's and children's programmes' (Mwenda, 1979).

At the technical level, there is a negligible number of women in any broadcasting or film organization anywhere. This is an almost universally male-dominated area. One exception is Finland, where 20 per cent of all technical staff in the Finnish Broadcasting Company were women in 1978: women accounted for 42 per cent of film editors and 28 per cent of film supervisors, although only 1 of the 80 camera operators was female (Harms, 1978). But only 2 per cent of sound technicians and 9 per cent of engineers were women in the German WDR in 1975 (Von Welser, 1976). The ABC in Australia found that 95 per cent of its technical staff were male, in 1977. In the United Kingdom in 1975, the ACTT found that less than 10 per cent of its women members were technicians. In the BBC in 1978, of 1,158 employees in senior technical and engineering

grades, only one was a woman. Even in Sweden, only 9 per cent of women in the Swedish Broadcasting Corporation were working in technical areas in 1978. Almost everywhere, women technicians are confined to the very lowest grades.

At the same time, the secretarial and clerical jobs are almost completely filled by women in most broadcasting organizations. In fact, when we talk of 'women in the media', we describe for the most part women working as production secretaries, script/continuity staff and clerk-typists. In the United Kingdom, 100 per cent of production secretaries/producers' assistants among ACTT members were female in 1975, and 82 per cent of the secretarial and clerical staff in the BBC were women in 1978; in Taiwan, nearly 90 per cent of these staff across all three television networks were women in 1976 (Ying, 1977); all eighty-three continuity staff in the Finnish Broadcasting Corporation were women in 1978. In the ABC in 1976, 58 per cent of women employees were clerks. Of *all* ACTT women members in the United Kingdom, 60 per cent were employed as producers' assistants/production secretaries or as continuity personnel in 1975. These facts become particularly important when seen in the context of earning levels and career development: not only are women's jobs lower-paid than, for instance, the technical jobs dominated by men: they are also 'dead-end' jobs, with no obvious line of promotion.

Areas where women succeed

In general, media women are relatively successful in areas which are less competitive—if that, indeed, can be called real success. In many countries, television carries a particular glamour and prestige, along with high salaries, and competition for jobs in television is unusually strong. It is not surprising, then, that proportionately more women can be found in the upper echelons of the radio sector of many national broadcasting organizations. In Canada, for example, 18 per cent of radio producers in the CBC were female in 1977, compared with 14 per cent of television producers (National Action Committee on the Status of Women, 1978). The public radio system in the United States in 1974 had women in 12 per cent of its station management posts (as against 2 per cent in public television) and in 19 per cent of its operations management posts (compared with 7 per cent in television) (Isber and Cantor, 1975). In Taiwan, the Broadcasting Corporation of China employs women as 54 per cent of its reporters and 50 per cent of its section heads (this compares with 15 per cent of television reporters in Taiwan) (Ying, 1977). In the United Kingdom, a woman now heads one of the BBC's four radio channels for the first time ever. In Egypt and France the national radio systems are headed by women.

In India, very many more women are found in both television and radio than in the press for a similar reason. The government-owned broadcasting industry is less attractive to men because of the relatively slower promotion prospects it offers. Thus, while there are very few women in the Indian press, about a quarter of all broadcasting employees

are women, some of whom have reached relatively high-level executive positions.

Local, community radio and television—an expanding sector of many developing media systems—are also unusually open to women, mainly because of their relatively low status within overall media structures. The community systems' commitment to public access and a concomitant effort to train large volunteer staffs tend to result in a regular women's input to programming. In North America, these stations have a good record in the employment of women at official and managerial levels (NFCB, 1978). In the United Kingdom, the first community group to win a franchise for a local radio station from the Independent Broadcasting Authority has incorporated a clause in its charter to the effect that it will not show prejudice to, or stereotype, women: this will apply to staffing, programming and advertising policies.

It is at the local level, too, that women journalists do better. The American Society of Newspaper Editors documented this for the United States in 1975 (Jurney, 1978). Women tend to reach high levels in the weekly and small daily papers largely because these have recruited women with better skills than the men who can be attracted by the small salaries offered.

Cultural factors can also play an important part in advancing or hindering the position of women in the media. While it would seem that in some African countries women are discouraged from entering media professions on moral grounds, in parts of Asia and the Middle East broadcasting seems to be a particularly acceptable field for women to enter. In Egypt, both the national radio and the national television systems are headed by women; in Singapore, broadcasting is under a woman director. In the Arab States, where female employment overall is particularly low, a surprising number of women can be found in the production departments of media organizations. In 1975, for example, Qatar Television had a woman Scenic Designer while Jordan Television had a relatively high proportion of women on its news and production staffs (Anderson, 1975).

Working conditions of media women

Clearly, it is not easy for women, in most cases, to gain entry to the media industries and once there they are often at a distinct disadvantage—in terms of pay and opportunities for promotion, for example—when compared to men.

Earnings in the media

In theory, almost all media organizations respect the principle of equal pay for equal work. However, in practice, only a small proportion of women media workers can in any real sense be said to be covered by equal pay policies. This is largely because of the massive vertical and horizontal occupational segregation observed in the media industries;

when most women work at levels or in categories where there are few or no men, equal pay has little meaning. A further factor is the relatively important free-lance section in the media: here wage and salary levels can be varied tremendously, and informal agreements are often reached based on what is 'acceptable'. In general, women tend to 'accept' less than men.

It is, therefore, not surprising to find that in the United States Public Broadcasting System in 1975, 65 per cent of women were found to be earning less than $9,000 a year, compared with 25 per cent of men (Isber and Cantor, 1975); or that in the CBC in Canada, women were earning on average one-fourth less than men in 1974 (CBC, 1975); or that in the United Kingdom, the earnings of 45 per cent of male ACTT members were over £3,000 a year, compared with 17 per cent of female members. Part of the disparity can readily be accounted for by the fact that more women than men work for relatively short time periods, at low levels, before leaving to have children: this depresses average female salaries. Perhaps more surprising is the fact that the earnings gap between men and women in long-term media employment widens over career life. In CPB, for instance, while women increased their salaries fifteenfold, men increased theirs thirtyfold, over a thirty-year career life. A survey of women in the Norwegian press in 1973 found that despite the fact that women journalists' general education was often higher than that of the men, they had, on average, lower wages (Equal Status Council of Norway, 1980).

This situation has its roots in two interrelated causes. In the first place, women are usually confined throughout their working lives to the less skilled—therefore lower-paid—jobs. In the United Kingdom, for example, the lowest paid graded jobs in television are film cutter and joiner; in film production they are checker, tracer and colourist (all jobs in cartoon and diagram design); all of these jobs are done predominantly by women. Moreover, most of the female-typed jobs do not provide women with skills which are thought to equip them for work in other media areas, or at higher levels. Most secretarial-based grades are 'dead-end' ladders because the experience gained in them is not considered to have any relevance to any other grade. Some women, taking jobs as producers' secretaries in the hope of moving into production find themselves perpetually branded as secretaries, although in the nature of things they have picked up a great deal of information about production processes.

The second major cause of wage disparities is the low value put on women's skills, even in cases where these have been acquired through formal training. The skills which women typically use—such as manual dexterity, typing and the many organizational skills demanded in continuity and production assistant work—not only command less money, but also less respect. This is so much a taken-for-granted fact that employers seldom question why, for instance, women are described as having 'just typing' as a qualification when it actually requires more training than many male-typed jobs in, say, film processing.

Clearly, there is no real way of fairly deciding whose skills are most important in such a vast area as mass media employment. What is

unfair is that the values attached to skills are largely decided by sex. The only real solution here, in the long run, is an erosion in the sexual division of labour such as that aimed at by the Equality Project in the Swedish Broadcasting Corporation.

Conditions built around men's needs

The job structure and conditions of work in all media industries are related much more to the working pattern and needs of men than of women. The media expect and demand quick career development: in a world where 'talent' and vigour are important, people are expected to be near the top of the promotion ladder by the age of about 35, in many countries at least. Youth is highly prized. This is particularly hard on women, many of whom miss out on promotion opportunities which occur for men at the age when women are at home bearing their children. Often, if women return to work quickly, it is assumed that their domestic responsibilities are too great for them to cope with the increased demands of a higher grade job. Even if they have no children and never intend to, there is a tendency for employers to pass them over on the assumption that they will soon be leaving.

The fact that broadcasting particularly, but film and the press too, are held to have fast-changing technologies, and that their products are subject to rapid changes in taste and fashion, means that women who have a break of even two or three years in order to have children will be assumed to find it difficult to reintroduce themselves successfully. In such a situation, the provision of crèches or child-care facilities at the place of work would considerably ease women's problems. Such facilities are almost non-existent, although various task forces which have examined the employment of women in Australia, Canada and the United Kingdom have all made recommendations concerning their introduction. Similarly, maternity leave provision in many organizations is less than that recommended by the state: the BBC, for instance, grants thirteen weeks' paid leave, while the state recommends twenty-nine in the United Kingdom (Annan Committee, 1977). Paternity leave—although frequently recommended—is virtually unknown. In Sweden, where crèches are also provided, it is of course available. Perhaps more surprisingly, in the United Kingdom *The Times* gives male journalists two weeks' paternity leave, while the *Sunday Times* gives three—hardly generous, but cognizant at least of a principle.

In this situation, women with children often turn to free-lance work within the media. This is the only form of 'part-time' work which can be said to exist in many organizations. In 1975, the ACTT in the United Kingdom found that 47 per cent of their women free-lance members said they were working in this way because domestic commitments prevented them from taking a full-time job. None of the free-lance men gave this reason. Only by going free-lance can many women find work in the media at all. But free-lance work has many drawbacks. More than any other type of work it can involve long working hours and travel; moreover, there are many media areas in which free-lance work is not available.

The fact that women carry the dual burden of family and work responsibilities makes it difficult for women rather than men to have the freedom to work the hours or do the travelling demanded by many media jobs. In an area where flexibility is often crucial, women inevitably lose out when it comes to career advancement. In the United Kingdom for instance, only 24 per cent of women ACTT members with children, compared with 51 per cent of men with children, worked overtime. And whereas 84 per cent of women without children (compared with 80 per cent of men) took no time off for domestic reasons, this dropped to 63 per cent of women with children under 5. In most countries, if someone must stay at home to look after a sick child, it is the wife. It is consequently the wife's job which suffers. Again, Sweden has brought in measures to combat this situation: between them, parents may take twelve days' leave a year to look after children. The Swedish Government has actively promoted the concept of a two-breadwinner family in which both parents share responsibility for home and children.

Women in the media unions

The power of trades union activity varies in different countries, and in different media organizations. In some areas, official unions do not exist as such. In others, a 'closed shop' policy exists, which makes it impossible for people who are not union members to work in particular jobs or industries. This is the case, for instance, in the United Kingdom where it is impossible to work as a journalist without being a member of the National Union of Journalists (NUJ) or in various parts of the film and television industry without having joined the ACTT. In such cases, women media workers must join the union. In others, they have more freedom. Overall, however, women have a bad record of *active* union membership.

In Denmark, for instance, where almost all media employees are unionized, only 15 per cent of active members of the journalists' union are women. Although in the Soviet Union it is estimated that at least half of the media workers are women, women's membership of the Union of Journalists is 40 per cent. In the Union of Bulgarian Journalists, 24 per cent are women and only 2 per cent of these are in the managing bodies of the Union; of the nineteen different professional sections in the Union, three are chaired by women. In Greece, 5 per cent of the membership of the union of the daily press are women; the union for the periodical press has a 15 per cent female membership.[1] In the United Kingdom, men are twice as likely as women to hold positions of any authority in the ACTT, and are 20 per cent more likely to attend union meetings. In some world regions, on the other hand, where the concept of unionization is less developed, women media workers have been beginning to organize themselves into groups—like the Association of

1. Information provided in private communications from Nelya Ramazanova, Editor, *Soviet Woman*, May 1979; Sonya Bakish, Editor-in-Chief, *Women Today* (Bulgaria), January, 1979; K. Stassinopoulou, National Council of Greek Women, December 1978.

Women Ghanaian Journalists, founded in 1975—in order to further their own professional development and that of women in general through the media. Pan-African and Caribbean Associations of Women Journalists have also been mooted. In some countries such as the United Kingdom, however, there has been opposition to the idea of specific women's unions on the grounds that they lead to a siphoning off of women's issues into less powerful discussion forums. For that reason, the ACTT withdrew its support from the Women's Trade Union Congress in 1973.

At the same time, it is clear that women's unions can have a positive impact. The American Coalition of Labor Union Women (CLUW), for instance, by encouraging women workers to voice their demands and union officials to respond, appears to be having an effect on male union leadership. In 1977 the Communication Workers of America pledged that upgrading the status and wages of female jobs would become a priority area (Newland, 1979).

Women's pressure groups working *within* male-dominated unions can also have an important effect. In 1972, for example, members of the British NUJ who belonged to the Women in Media group, persuaded the Union to set up a Committee on Equality to inquire into the position of journalism on the grounds that the principle of equal pay did not exist in practice and that equality of opportunity was being denied. Not that setting up an Equality Committee necessarily makes an immediate difference: in 1977 a NUJ survey of newspaper journalism found that widespread discrimination against women still existed (Smith, 1978).

Many unions have long supported policies which have operated either to exclude women from certain areas or to confine them to separate occupational categories where separate pay rates could be negotiated. In many mass media industries job insecurity is particularly acute, a high proportion of employees being recruited on short-term contracts. It is also an area where—for a wide variety of jobs—applicants can outnumber vacancies by many hundreds to one. Given such circumstances, it is perhaps not surprising that the issue of equality should not be given priority by male union members, especially when managements can argue that the measures necessary to improve women's occupational opportunities (provision of creches, equalization of pension rights, maternity leave, and so on) carry financial implications which will have an impact on men's own employment chances.

Legislation for media women

In very many countries women are legally forbidden to work at night (usually between the hours of 10 p.m. and 5 a.m.). This protective legislation, originally instituted to safeguard women's interests, in practice works to their disadvantage in particular areas of the media. Night work is a feature of many media activities: often television and radio stations are actually transmitting programmes until midnight or later; night shifts are common in certain technical areas of film and broadcasting; night filming is relatively frequent in documentary or drama production;

the newsrooms of morning papers work through the night. Consequently, many women are excluded from these areas. In fact, most countries whose statutes include this law have clauses which permit women's night work on special request or in special circumstances. However, many people—both employers and media employees—seem unaware of this, and the view tends to prevail, when it comes to recruitment, that women must be exempt from nightwork. This makes them much less flexible and attractive as potential employees.

Various other protective measures—some of which have been mentioned earlier—work against women's interests in the media of many countries. In Japan, for example, women may work no more than two hours of overtime a day, and no more than six hours a week (Japanese Ministry of Labour, 1977). Again, this puts women at a severe disadvantage in a field where often there are no 'set' hours. Altogether, laws such as this tend to treat women in a paternalistic way, limiting their freedom to make decisions. Indeed, except in a few specific circumstances —such as maternity protection—it is questionable whether women need to be singled out from men in this way.

Turning to legislation for equality, this is not always outstandingly effective. In Japan in 1977, Fuji-TV refused to have women on contracts exceeding four years after a court had ruled that the company could not oblige women to retire at 25 (Newland, 1979). The ineffectiveness of Equal Pay Acts and Sex Discrimination Acts has been made clear. Nevertheless, legislation can be important—provided it is neither too far ahead of (nor too far behind) social change—in creating possibilities or in activating specific changes. In the United Kingdom, for instance, the maternity leave provisions of the Employment Protection Act—guaranteeing that women's jobs will be held open for a certain period of time—have had the effect of encouraging women to put additional pressure on media unions and media management alike, in order to obtain child-care facilities (Penderyn, 1978).

In the United States, there is little doubt that employment of women in the mass media has been speeded up by legal actions which have been brought against several leading media organizations. In the last five years, sex-discrimination proceedings have been fought, and won, against Reuters, NBC, *Newsday*, *Newsweek* and the *Washington Post*. Following a long dispute in 1977-78, the *New York Times* settled out of court by making compensatory payments and promising to speed up the promotion of women (Media Report to Women, 1978).

The United States Commission on Civil Rights has been active in encouraging legal challenges of this kind, many of them based on mechanisms under FCC procedures which allow private individuals or groups formally to challenge the renewal of a broadcaster's licence by filing a 'petition to deny'. In its most recent report (January 1979) the Commission recommended that the FCC should require each of its broadcast licensees to develop an effective affirmative action programme designed to ensure equal employment for women (and minorities) in broadcasting. At the Corporation for Public Broadcasting action had already begun: work on a 'Fair Share Parity' plan began in 1977, aimed at setting an

equal employment standard with which local stations could comply (CPB, 1978).

Overall, there is a limit to the extent to which legislation can promote change. Theories of social change underline the convoluted and often unpredictable nature of the processes by which change or development occurs. What is important is that legal guarantees of sexual equality should be rooted in firm political will and based on realistic assessments of social climates, rather than cosmetic tokens of appeasement or utopian paper schemes.

Training, recruitment and promotion of women in the media

Even where equal access to employment is guaranteed by law to women, the practical attainment of equality is problematic. Lack of appropriate education and training may hinder their initial entry or promotion. Cases of blatant discrimination are not unusual. Cultural and professional ideologies work at a subtle level, in an area where structural factors put women at a severe disadvantage.

Education and training for women in the media

The provision of formal training is not strongly characteristic of many media organizations. Although some companies, such as NHK in Japan, and to a lesser extent the BBC in certain job categories, do provide training courses for new recruits lasting from a couple of days to several months, depending upon the job—others expect new entrants already to have enough skills, qualifications or aptitude, for formal training to be unnecessary. Women, because of their home, social and school education, often do not have the right qualifications or aptitudes to secure a job in the first place. If they do, they may find it harder to pick up 'on-the-job' knowledge or skills, because they are not treated so seriously; they may also be less successful in applying for internal training courses or attachments because the grade jump may appear too high (for example, from secretary to production assistant in television). In Canada, for instance, the CBC found that in 1973 women were three times less likely to obtain places on training courses (CBC, 1975).

The BBC runs four main training schemes—for studio managers, research assistants, news trainees and personnel officers. In the first two years of life of the Personnel Training Scheme, as might be expected, more women than men were selected. For the trainee studio managers' posts, however, the ratio of successful women candidates to men is 2 : 3, and in the first two years' existence of the Research Assistants' Training Scheme, only eight women were successful although nineteen men were successful. In the case of news trainees, one woman in five trainees in 1973 had risen to one in three by the 1977 and 1978 intakes, perhaps reflecting the fact that women now appear more regularly as news-readers, reporters and presenters. The 1979 news trainee selection achieved an equal balance of eight men and eight women.

The BBC also operates a training 'attachments' scheme, in which staff from one department are 'attached' for a certain time to another, in

order to receive in-house training in a job category for which they may eventually wish to apply. In formal television training attachments, women fare comparatively worse than men. In 1978-79, 44 per cent of applicants were women. They formed 35 per cent of short-listed candidates and 28 per cent of those selected: in other words, 19 per cent of all male candidates were successful, compared to 12 per cent of all female applicants.

In the developing world, training is crucially important if the younger media systems are to avoid the male-dominated employment profiles of many Western organizations. Although training does exist, it is not notably commensurate with need, as far as women are concerned. The fact that in some countries—for example, Malaysia, Taiwan, Thailand, Singapore (Yu and Chu, 1977)—at least half of the communications students on certain university courses are women, is tempered by the academic and theoretical, rather than practical, orientation of many of these courses. Moreover, in Asia 70 per cent of the institutions offering degrees or courses in communication are concentrated in five countries—the Philippines, India, Taiwan, Republic of Korea and Japan (Coseteng, 1977)—countries where, for the most part, the media systems are already well established.

In Africa, the first institution to train journalists—the Africa Literature Centre—was founded in 1959. The centre, although positively concerned with the development of women, reports that up to 1977 less than 10 per cent of students enrolling in its journalism and art courses were women. Similar proportions of women students are reported over the same period by the All Africa Conference of Churches Training Centre in Nairobi, which trains radio broadcasters (Africa, 1977). At the Centre d'Étude des Sciences et Techniques de l'Information (CESTI) in Dakar, few women apply, or are accepted for training: of 300 applicants, only 50 are women. The one woman to have graduated from CESTI with special training in radio and television reporting by 1978 was still unemployed eight months after leaving the school (Aw, 1979). In an interview conducted at that time, she suggested that in Senegal women were reluctant to enter the media profession because it was held in low esteem, women media professionals being regarded as 'women of easy virtue'. However, there is also an element of dissuasion on the part of those selecting from among women who *do* apply for training: 'What if you get married?' is a question flung at all women applicants.

In Jamaica, the training possibilities for women appear to be somewhat better. An analysis of those enrolled between 1974 and 1979 in the one-year diploma course for journalists offered by the Institute of Mass Communication there showed that the media select women for training at least 40 per cent of the time, although only 28 per cent of media employees are women. This disproportionate selection of women for training may have an eventual impact on promotion and staffing at the higher levels (Cuthbert, 1979).

Blatant discrimination in recruitment and promotion

There are some instances of whole areas of media work which are simply banned to women, for which women are openly told that they need not

apply. In Japan for example, one commercial broadcasting station (TBS) has simply not hired any women since 1963. The total employment of women in newspapers in Japan (including office girls and telephone operators) decreased by one-third between 1957 and 1964, reflecting a policy of not hiring women. Although recruitment of women in most Japanese press and broadcasting areas is now officially open, a negative attitude persists. The Kyodo Wire Service's 'quota' for hiring women as reporters means that a woman is hired about every five years. In 1976, NHK (the Japanese Broadcasting Company) hired eighty men out of 2,000 applicants (4 per cent) and one woman out of 600 applicants (0.2 per cent). In 1975, the *Asahi Shinbun*—one of Japan's three major newspapers—hired three times more male than female applicants, despite the fact that women tended to do better on the written examinations which formed the first round of the selection process (Iwao, 1977).

Discrimination is, however, difficult to prove indisputably. Although a recent study, by the Press Commission in India, on the position of women journalists in South India concluded that 99 per cent of newspapers discriminate against women, it had to be admitted that *documentary* evidence of this could not be fully established. However, the fact that only 60 women are employed as practising journalists in the region, although there are 225 professionally trained women with degrees and diplomas, must be regarded as significant (Chabbra, 1980).

In specific job categories, women remain excluded, either consciously or unwittingly. This is particularly true of technical areas. In the United Kingdom during the Second World War, the BBC recruited women into technical and engineering posts, but after the war these areas became reserved for men once more. In 1973, as a result of union pressures, *all* jobs were opened to women (Croasdell, 1975). However, many women remained, and indeed some still remain, unaware that they could now apply for all jobs. And despite a public commitment to 'positively encourage' women to apply in areas where they had been under- or unrepresented, the BBC refuses to note on job advertisements that 'women may now apply for this post', where the category was once men-only (ABS, 1975).

A further problem arises in relation to recruitment advertisements and literature, much of which has tended to be heavily sex-stereotyped (Kaplan, 1978). Material which refers to prospective applicants exclusively as 'he', or which illustrates certain types of job with pictures of only men, or only women, conveys its message as strongly as if it stated outright—'no woman need apply' (or, 'no man', in the case of secretarial-type jobs). The names of certain jobs—cameraman, continuity girl—carry assumptions that such work can, or should, only be done by either men or women. All this is changing, of course, in many countries where legislation has intervened to make this kind of overt statement more difficult.

Occupational beliefs and ideologies in the media

Clearly the removal of formal barriers is, in itself, insufficient. For example, in 1973, the BBC issued a statement entitled 'Women in the BBC'. It

had three provisions. The first stated that all BBC posts would henceforth be open to women. The second said that women would be given 'a positive opportunity of demonstrating whether they can carry out their duties satisfactorily in areas which appear suitable to their talents and qualifications but where they have seldom, if ever, been appointed'. The third promised that steps would be taken to ensure that the potential of women staff members was always as positively encouraged and developed as that of men, particularly in more senior posts (BBC, 1973). Yet by 1976 the position of women in the BBC, and their occupancy of key posts, looked virtually identical to that which had prompted the 1973 statement. No 'positive opportunities' had been provided, or 'steps' taken: measures had not gone beyond the simple removal of formal barriers (Driver, 1976).

The difficulty of removing limitations on the recruitment and promotion of women is notorious. Affirmative action—such as that implicit in the BBC statement—involves preferential treatment of women, and may be successful. In the overwhelmingly male atmosphere of most media organizations, in practice it is difficult to carry through. Such potential overt discrimination against men is easier to decry than the actual but subtle forms of discrimination against women which find their roots in various beliefs about women, women's capabilities and motivations.

In Japan, reasons advanced for not recruiting women into the mass media revolve around women's domestic responsibilities (Nuita, 1979). It is this kind of belief—that women are primarily home-oriented, child-centred, emotional, intellectually inferior if not incompetent—which underlies the unease which employers around the world display in recruiting and employing women. Instances of women being asked at interviews about personal and family commitments, while men are not, are well documented. It is also important to bear in mind that interviews for media jobs are almost invariably carried out by men. The experience of one British woman at a selection board for the post of trainee film editor is certainly not unique. 'I was married but preferred to use my maiden name. One man there couldn't get over that. He wasn't interested in anything else. 'Why' he said 'don't you use your husband's name? Are you a bra burner then? And what will you call the babies when they come along? I was so mad I was in tears . . . I didn't get the job' (in Burnie, 1980).

Discriminatory beliefs and attitudes form part of a male occupational ideology which argues that many media jobs demand qualities which women do not have. In the United Kingdom, the ACTT found that the necessary qualities which women were most often said to lack were: physical strength, physical agility, being able to 'get on with machinery', willingness to work in dark or dirty surroundings, the ability to exercise authority, and a single-minded dedication to the job. There is plenty of research data to show that these presumed inadequacies have little basis in reality (for example, CBC, 1975). Even relative physical strength is becoming less important as light-weight equipment is introduced into industry.

Perhaps even more deep-rooted—and therefore more damaging—is the belief that the introduction of women into male-dominated job areas will disrupt working relationships. The fear that women will simply act as a sexual distraction to the serious work done by men underlies a good deal of the management unease about female recruitment, which has been found in studies carried out in the United States, Canada, United Kingdom and Australia (Isber and Cantor, 1975; CBC, 1975; ACTT, 1975; ABC, 1977).

Once women are in post, this prejudice can be carried over. One British film technician faced the problem. 'The whole crew used to slope off to the pub every lunch hour and they'd never ask me. It all came to a head at Christmas. They didn't invite me to the lunch for all the technicians.' In tears, she went to the editor's office. He hummed about a bit and said that the lads couldn't relax with me about and that their wives wouldn't like it. . . . 'And you'll get embarassed at the jokes', he said as a clincher. Paradoxically after this, the men did begin to accept her but, 'it wasn't until I did that dreadful feminine thing of weeping on the boss's shoulder that I got anywhere' (in Burnie, 1980).

Women attempting to 'swim against the tide' within the media must cope not only with the discriminatory beliefs and preconceptions of their male colleagues and superiors, but with their own feelings of inferiority and inadequacy too. One of the first camera operators in the United Kingdom found that 'the hardest task of all was just to feel that I was talented and courageous enough to persist. My self-doubts and struggle to break new ground often made me seem too radical and I was regarded with suspicion . . . I felt my struggles with the equipment were very public. I felt too closely observed for comfort' (Tammes, 1980). The complex context in which roles are defined, and challenged, makes women's 'intrusion' into male-dominated areas extremely threatening for both women and men:

'I am often the only woman on a technical crew and it is my responsibility as a camerawoman to lead the crew of sound recordist, sound assistant, camera assistant and electrician. When I arrive on location with a male assistant *he* is approached as the cameraperson. There is a belief commonly held by male technicians that if a woman can do the job it is not worth doing. A camera*man* is seen as a *macho* technical expert and this notion supports the egos of some directors. It is difficult for them to accept a woman behind the camera because it demeans their position' (Tammes, 1980).

Promotion criteria in the media

In 1976, the Australian Broadcasting Commission, in its official bulletin, stated that there was now evidence that women were being promoted to positions within the ABC which were once almost exclusively held by men. Yet a Task Force examining the position of women within the organization reported in 1977 that this statement was, at best, only partially correct. Just under two-thirds of women were promoted into 'women's' job, and about one-third were promoted into 'mixed' jobs

(ABC, 1977). The ABC Task Force found that women needed twice as much permanent service to achieve promotion to the same level as men, and that men were being promoted through the structure more rapidly than women. Similar differences between male and female promotion rates are reported from such countries as Canada, the United States, United Kingdom and Japan. In the *Asahi Shinbun* in Japan, for instance, it takes thirteen to fourteen years for men to reach the rank of assistant department head, and sixteen to seventeen years for women (Iwao, 1977).

Some of the reasons for this kind of discrepancy have already been mentioned—for example, the limited type of work performed in some women's jobs limits their scope for promotion and there is a reluctance to promote women to positions where they would be supervising men. Other factors, noted by several studies, are that women receive less in-service training than men and that the experience necessary for promotion (i.e. higher duties carried out in an 'acting' capacity) is more often given to men, whether or not they are the more senior. Other things being equal, preference is usually given to men: there is an assumption that women do not actually want the greater responsibility that comes with promotion. Yet, for instance, a Task Force in the United States Corporation for Public Broadcasting found, in 1975, that 63 per cent of women employed at the very lowest levels said that they wanted to be promoted within the next five years, and of these, 16 per cent aspired to the top managerial positions (Isber and Cantor, 1975).

The subtle persuasiveness of these factors is difficult for women to combat. Discrimination is hard to pin down and harder still to prove. Moreover, women often prefer not to pursue a complaint through fear of being branded as 'trouble makers' and jeopardizing future promotion opportunities. For example, commenting on a series of interviews with women working in British television which she carried out in 1980, Jean Burnie noted:

All the women I interviewed who had managed to 'make it' on television . . . were eager and willing to be named and quoted while all those who hadn't, but still hope to, demanded complete anonymity. . . . Women who haven't made it on television are terrified of victimisation (aware that, given TV's glamorous image, even their despised lowly positions can be filled, thrice over, at any time). (Burnie, 1980).

Still, discrimination suits can be proved, as in the *New York Times* dispute, where it was found that men were twice as likely as women to be hired into the six highest-paying job categories, even *after* correcting for differences in education, length of service and previous experience (*Media Report to Women*, 1978).

Standardized criteria for promotion are extremely rare in media organizations. In their absence, reliance is placed on factors such as personal associations and informal information networks. Social contacts, knowing the right people at the right time, can be all-important for certain types of work. Whatever may happen at interview boards, opinions about value and potential tend to be formed elsewhere. In some sectors

of the media industries, indeed, jobs and contracts are offered without going through formal procedures. Women, because of their relatively low visibility, often lose out on the jobs.

Then, too, despite official 'open competition' in many instances, perceptions of particular job areas as being male 'preserves' remain slow to alter, not least among women themselves. Various studies, for example, have found qualified and competent women reluctant to apply for promotion to jobs when the outgoing postholder is male, their assumption being that another man will be appointed. Rarely educated to believe that they can and ought to have authority, many women have such beliefs reinforced within media organizations which employ few women in senior positions. Given these perceptions, it is not surprising that most women avoid the obvious male ghettos and gravitate towards those areas—children's, educational, women's programmes and material—where they see the possibility of acceptance by virtue of their sex. Since in most cases senior staff are drawn from quite *other* areas—current affairs, documentary programming, economics and political reporting—it is little wonder that more women are not present in senior management.

Finally, cases of the application of double standards in the promotion of women and men are not hard to find. Media women in Jamaica, interviewed in 1979, felt that although the opportunities for promotion had improved since 1975, there was still discrimination—even if more subtly applied than previously. One reported that 'a man has been appointed to the job I've been acting in for two and a half years. I don't know what he's going to do—I'm doing everything'. Another commented that after an overseas training course she had been producing and directing programmes but 'all I get is praise—up until now, no promotion, no extra pay. Even though the head of my department knows I am capable of doing it, he is reluctant'. These double standards require contradictory attitudes and behaviours of women themselves. As one woman with ten years' media experience put it: 'A woman has to walk a very thin line. You have to act like a lady, think like a man and work like a dog.' (Cuthbert, 1979).

Chapter 3

Portrayal and participation: effects and relationships

A consistent picture emerges from those research studies which have investigated the media's portrayal of women. At the very best, that portrayal is narrow; at worst, it is unrealistic, demeaning and damaging. There are no notable differences between the mass media in this respect, although it is clear that small local media are more likely to present a positive picture. In terms of functional roles, although advertising has generally been found most reactionary, women's portrayal in news and entertainment has been little better. Even educational media have been found wanting. Certain cultural differences have been noted and media portrayals have been found to be most positive in those countries with a firm commitment to the social and economic integration of women. With few exceptions, however, research has shown that the media present women as a subordinate sex. Some of the most recent studies indicate the beginnings of changes, which, although slight, do provide some evidence that the mass media are not inescapably locked into a particular mode of presentation.

Extensive research in a fairly small number of countries has highlighted the severe under-representation of women in the upper echelons of all media organizations. Even when differences of educational level, length of service and range of experience are taken into account, women remain disproportionately excluded from key decision-making posts. Scattered data from other countries confirms this for most parts of the world. Occupational segregation has been seen to result in the growth of female ghettoes within media, making legislative measures, such as equal pay decrees, almost impossible to put into practice. Overall, media women continue to earn less, on average, than media men. Although cases of flagrant discrimination in recruitment, training and promotion have been noted, it has been found that discrimination against women works more subtly through the effect of sex-related beliefs and prejudices.

The fundamental questions which remain to be answered concern the effects and inter-relationships of these two patterns. What is the impact of the images of women found in the world's media on the formation of

attitudes and perceptions in both women and men? And what is the impact of media women themselves on the production of these images?

The impact of media portrayals of women

A great deal of effort has been directed towards examining the transmission of sex stereotypes and their influence on the behaviour of men and women. Despite recent research which shatters many assumptions about the actual existence of, for example, psychological sex differences (Maccoby and Jacklin, 1974) the old sex-role stereotypes persist and find their way into male and female self-perceptions and actions in a fundamental manner. Australian researchers, for example, as part of an experiment in open planning for telecommunications, found that compared with four other groups surveyed, women's world-views reflected feelings of pessimism and powerlessness (Albertson and Cutler, 1976). The ubiquity of the mass media in many parts of the world has led to propositions that they play an important role in the transmission of ideas and beliefs: considering the broadly negative way in which the media are seen to portray women, it is possible that damaging and misleading notions of female characteristics and capabilities are perpetuated in men and women alike.

But although the *assumption* that media images of women have a negative effect on female self-perceptions and behaviour, as well as on general social life, underlies the many statements which attest to the power and influence of the media, there is scant empirical evidence to bear out that assumption: very little indeed is known about how people digest and make use of the media information. The problem is basic to much media research. Attempts to establish a direct causal relationship between media exposure and specific effects—based on what is sometimes known as the hypodermic needle theory—have proved fruitless. Most studies indicate less direct links between media output and audience reaction, effects which are mediated by factors such as age, social class, educational level, ethnic background and religion (see, for instance, Halloran, 1970). To take an example from the most widely researched area in studies of media effects, that of violence; the exhaustive report of the American Surgeon General's Advisory Committee could only conclude that for some people, under some circumstances, exposure to televised violence *may* be harmful (Surgeon General, 1972). The question of what constitutes 'evidence' in the social sciences is itself deeply problematic. However, roughly speaking, what is 'known' about the effects of media portrayals of women derives from two broad research traditions. In North America research has tended to concentrate on the empirical testing of psychological theories, such as stimulus-response or modelling theory. European and Latin American research has been more concerned to describe the 'agenda setting' functions of the media: the hypothesis here is that by creating a common field of discourse, through a systematic pattern of inclusions and exclusions of themes and images, the media

may help shape an unquestioned consensus in society about the very nature of the world.

Experimental evidence

A number of experimental studies, for example in the United States (Cheles-Miller, 1975), Canada (Courtney and Whipple, 1978) and Australia (Pingree and Hawkins, 1978) have attempted to measure the impact of media imagery of women. Many findings have been replicated from one study to another (Tuchman, 1979). Briefly, it has been fairly well established that sex-stereotyped content leads children to describe women's roles in traditional ways; that content which contradicts sex-stereotyping leads to less traditional descriptions; that when watching television boys and girls pay particular attention to children of their own sex performing sex-typed tasks; that the more television girls and boys watch, the more traditional are their attitudes and aspirations. It would appear from such studies that girls and boys—and by extension women and men—do appear to model themselves along lines suggested by media imagery. Some studies of advertising suggest that this may be particularly insidious and powerful in providing modelling behaviour (Brown, 1979). For advertisements can present a complete—even if collapsed or telescoped—scenario or story, in which males and females accept their roles as natural. Sex-typing is usually implicit, rather than articulated. This implicitness may mean that while the explicit sales message is being discounted consciously, the subtle sex-typing can be absorbed unnoticed.

Identification, imitation and ideological control

Various surveys of women—in countries such as Brazil (Marques de Melo, 1971), Venezuela (Colomina de Rivera, 1968), the Netherlands (Berman, 1977) and Japan (Miyazaki, 1978)—suggest that women do identify themselves with media situations, and indeed that they may apply to their own problems solutions offered by the media. For instance, in Venezuela it was found that 50 per cent of a sample of housewives believed that radio and television soap-operas derived from real life; 53 per cent believed that the solutions offered in these soap-operas could help them solve their own problems; 30 per cent said that their children tended to imitate the characters in these programmes. In Japan, 28 per cent of housewives said that they watched television soap-operas because of a feeling that they dealt with real-life problems and were a good education. There were similar findings in Brazil, where a study of São Paulo housewives concluded that such programmes perform a specifically ideological function: 'The sufferings of the protagonists demonstrate that other people also suffer. And, a daily catharsis takes place. The tele-viewers relax, eliminate their accumulated aggressiveness, and gain a fictitious sensation of happiness' (Beltran, 1978).

Recent research—particularly in Europe, but also in Latin America—has been deliberately moving away from the narrow empiricism of most

North American work towards a broader attempt to analyse the power of the media in building up an ideology—a central system of practices, meanings and values. Such analyses are based on the proposition that with the increasing fragmentation of life in industrial society, the media can be said to orchestrate and bring together its selective representations into a relatively integrated and cohesive form, in which there is an acknowledged order. This order is complex, but in its emergence certain voices carry greater weight, defining and limiting power: in the male/female dimension, these voices are ineluctably male. Until lately, most analysis in this genre concentrated on the detailed examination of media output, which has been found to reinforce existing male/female economic and political patterns (for example, Quiroz, 1978; Butcher, 1974). But very recent studies, in an attempt to resolve the problems of inference attaching to this approach, have tried to link media output patterns with the perceptual patterns of audience members, finding, for instance, that women and girls do tend to take for granted a 'natural' order in their lives (McRobbie, 1978).

Although research of this last kind is still in its infancy, and is often approached at a high level of abstraction, it may prove more fruitful in explaining broad relationships between the media and social change than earlier studies, concentrating on individual or small group effects, have been able to do.

The relationship between media output and media women

Underlying much of the discussion and analysis of the media's portrayal of women and of women's participation in the media is the assumption that by increasing the number of women employees in the media organizations output will change so as to reflect more adequately women's interests and points of view, in such a way that negative or demeaning images of women will disappear or be minimized. Yet media women themselves have often been found to originate sexist content. There is little hard evidence to support the proposition that the portrayal of women in the media differs when a woman is producing the images.

However, one recent study—of Sri Lanka radio—did find that the higher the participation of women, the more positive was the imagery presented. The presentation of a positive (or at least a non-negative) image of women was highest in the English-language service, followed by the Tamil and then the Sinhala language services of the Sri Lanka Broadcasting Corporation (Goonatilake, 1980). This followed the pattern of female participation in radio—the highest being in English (where 50 per cent of staff are women), the next in Tamil (43 per cent) and the lowest in Sinhala programming (18 per cent): moreover, these figures refer only to the professional category of controllers, organizers, producers and announcers. The fact has to be emphasized that there is an unusually high representation of women in SLBC. For example, although there are no women on the Board of Management, women do hold 60 per cent of the positions at director and assistant director level. Women were

employed as news-readers as early as the 1940s in Sri Lanka radio, and now constitute about 40 per cent of all newsreaders. Of technical and clerical staff, 13 per cent and 60 per cent respectively were women in 1979—again, these are somewhat atypical proportions. It seems likely that women have achieved the 'critical mass'—at least in the English service—to allow them to work against certain dominant cultural and professional values which the scattered women in other media organizations find hard to resist, or which they even accept unconsciously.

Stereotyping and media women: cultural values

The fact that most research into media imagery has been limited to content analysis means that, overall, there have been virtually no attempts to establish links between the dominant images and the dominant values, beliefs or attitudes of media personnel. A few scattered studies, however, have managed to establish that, for instance, the female editors of women's pages are on the whole oriented by the same traditional concerns and priorities as their male counterparts, and that women's judgements about newsworthiness resemble those of men (Merritt and Gross, 1978). Another study, examining the news perceptions of journalism students, found that women students had the same stereotyped picture of women as male students: although they themselves were interested in politics and not 'traditional' women's concerns, they thought that they were unusual and that 'ordinary' women would be more interested in mundane matters (Orwant and Cantor, 1977).

It is also true that many instances can be found of individual women producers, journalists or decision-makers being associated with—or directly responsible for—anti-female material. For example, the most sexually explicit of a particular series of Venezuelan *fotonovelas* were almost all written by women (Flora, 1980). This underlines the simplistic nature of statements sometimes made about media output and male domination: the fact is that all women do not see the world differently from all men. Most women and most men *share* common cultural perspectives. The entire direction of 'consciousness-raising' efforts actually admits this communality. The problem, therefore, is not simply to open up media employment to women, but at the same time to work towards changing women's self-perceptions, evolving and directing measures against a cultural value system which at present not only accords women lower status but also frequently leaves them unaware of the fact.

Part of the same overall pattern is the fact that successful media women often deliberately disassociate themselves from their peers. A common belief among such women in the media is that most (unsuccessful) women just don't try hard enough. 'They give up too easily. And they expect the plums too quickly. Television is a craft job and it takes time to prove to others, and not simply to yourself, that you are capable of taking control,' commented a well-established British woman drama producer, interviewed in Burnie, 1980. Yet double standards make it more difficult for women to survive the trial period, as the same producer went on to admit: 'There is, too, the fact that they call a man a whizz

kid when he's into his thirties—yet a lot of people, including women themselves, see that as old for a woman.' Lower down the prestige ladder, perhaps sensing the need to be seen as 'different' from 'most women' if success is to come their way, ambitious women can be particularly tough on others. As one television floor-manager put it: 'They expect jobs like mine to be handed to them without any effort on their part. . . . Possibly I'm too involved and too busy to see any [discrimination]. I don't stand around and expect men to shift all the heavy stuff. I get in there and shift it myself. . . . I suppose I am a pioneer but I blame women themselves for that, just as much as men. You cannot blame a management for not promoting women if they don't apply in the first place. It's fine to preach women's lib, but nothing comes easy' (in Burnie, 1980).

Having struggled into elevated positions, these women may defend the existing structure with more conviction than any man. A woman current affairs analyst in the United Kingdom expressed the view that

My particular brand of current affairs, which is economic and technical, is a most sexless profession: people don't mind if you're a man, woman, or a chimpanzee. It doesn't particularly matter that many women aren't doing it, because if they were, it wouldn't alter the way in which it is done—you're simply not dealing with material where it matters, you're dealing with something analytic (in Karpf, 1980).

As her interviewer observes, 'she expresses a common notion (to some extent self-fulfilling: if she does it like men do, no one *will* be able to tell the difference) that there are various areas of life (especially the analytic—as opposed, it is implied, to the emotional) which have escaped masculinist ideology, that are somehow neutral'. This, in turn, relates to the widespread professional notion of 'objectivity' in media analysis and coverage, 'that there is a Truth that can be extracted from the morass of partiality by the acute pincers of the Corporation' (Karpf, 1980).

Ironically, as Tuchman (1978) has pointed out, even reporters who might associate themselves in spirit with women's or feminist concerns frequently ask hostile questions of feminists at news conferences in order to prove their reportorial neutrality. As one *New York Times* reporter explained, 'The hardest part of the job [of covering feminists] is not sounding like one of them. I have to be objective.' Yet, in practice, the concept of objectivity is difficult to uphold: editorial choice inevitably reflects the particular perceptions of those making the selection. The first woman to head a *New York Times* national bureau noted: 'There have been times when I found editors unaware of things happening, like the rape laws. Only women think in terms of rape laws; the men know about capital punishment' (in Tuchman, 1978).

Media control and professional attitudes

A further problem in focusing on individual media workers—whether male or female—is that they often have very much less control over media output than is commonly assumed. Many research studies have

documented, for example, the power of the American television networks in influencing both television station practices and the programmes produced by independent production companies (for example, Brown, 1971). Journalists' output has been found to be conditioned by the reward system and political preferences of their employers (for example, Tunstall, 1971). Various studies of organizational control in the media have highlighted the difficulties experienced by individual communicators in attempting to innovate or deviate from organizational norms and ground rules (for example, Cantor, 1971). In this context, it seems unlikely that women could or would have greater freedom than men within media organizations.

At another level, problems arise from the complicated system of attitudes and practices which constitute media professionalism. It is difficult for media women to resist ideas and attitudes associated with success in their profession, even if such ideas demean them as women in the audience. Professional beliefs may indeed undervalue women and women's interests—for instance, certain topics may be defined as uninteresting or unimportant—but professionally ambitious women are unlikely to go out on a limb and risk being identified with marginal or minority interests. The parameters of success are male-defined and women are not in a position to remake the rules. Thus, for example, one study found that both male *and* female members of a talk show encouraged sexist comments from guests during the 'warm-up' preparations for the show (Tuchman, 1974). Moreover, women in the media may be caught by a certain conflict between personal beliefs and professional aspirations. Allied to a real sense of powerlessness within the decision-making structure, and a need to satisfy perceived male attitudes, this may lead professional women deliberately to ignore what are personally important but professionally difficult issues, or even to distort them in order to be able to deal with them at all. For instance, one *New York Post* reporter described her coverage of a women's demonstration, with which she personally sympathized:

It didn't occur to me at the time that I should insist upon its being taken seriously. [Other demonstrators] were burning draft cards at the time and I featured overmuch the burning of bras, girdles, and curlers. I tried to be light and witty so it [the story] would get in [the paper]. I was afraid that if I reported it straight, it wouldn't get in at all (in Tuchman, 1978).

In the final analysis, the subtlety with which professional norms and procedures operate make them difficult to isolate. A Canadian study of advertising found that many of the television advertisements which were considered totally acceptable in story-board or draft form seemed much *less* acceptable in their final version (Task Force on Women and Advertising, 1977). In other words, the bias crept through in the course of detailed execution—stereotyped acting, tone of voice, general 'style'—consequently making the application of any formative evaluation or monitoring principles extraordinarily difficult.

The impact of media women

Despite the problems, women working in the media clearly can have a positive impact on imagery and overall output. For instance, the growth in women-oriented programmes, pages and journals has been substantial in many countries (even Japan has recently introduced a television news programme for women, produced and directed by women). Although often criticized for merely underlining women's marginality, in singling them out for special attention, these ventures have certainly had the effect of highlighting some of the specific problems which exist and which need to be solved. The very sensitivity of the women and media issue bears witness to their impact.

In terms of the integration of treatment of women's specific problems or concerns into general media coverage, women can also be successful. For instance, 'committed' women who are recognized by their male colleagues as subscribing to professional ideologies can bring women's stories into focus for the general public. One very well-established woman journalist in the United States could say:

I have never, well very rarely, done a piece that didn't run pretty much as I wrote it and the length I wrote it. [The national editor] is happy to have me telling him, 'This is good, we have to cover this'. My ability to define stories is because of professionalism.

She explained how she instituted national *New York Times* coverage of the fight for the Equal Rights Amendment.

In 1971, the first time ERA was in the House, I became aware of it, and I became aware that no one else was interested in covering it and they thought it peculiar that I was interested. If you volunteer for work, you're allowed to do it. I created a national women's rights beat here. (in Tuchman, 1978).

Another experienced professional, who became editor of the *New York Times* women's page in 1975, began to cover the American women's movement without referring to her managing editor: she 'just started to do it'. Moreover, stories were not confined to the women's page alone: in 1975 she noted that each month three or four 'women's page' stories were actually *starting* on page one of the paper. This was said to be at least in part because coverage of women's stories was having an impact on male editors, who were realizing the importance of previously ignored topics (Tuchman, 1978).

However, despite such instances, the potential impact of media women is fundamentally limited. As long as they work within structures in which final editorial decisions are made by men, their interests are likely to be judged as secondary or peripheral. As one woman professional suggests, 'Half of where a story goes has to do with the kind of news day it is. If it's slow, the story [one of her feminist stories] may be on page one.' But 'if it's heavy [if the story must compete with many others], it goes inside and may be offered to the women's page'. She continues, 'Perhaps it's unconscious discrimination' (in Tuchman, 1978).

Part III

What has been done so far?

Part III

What has been done so far?

Introduction

Action programmes in the field of women and the communication media present a more sketchy picture—at least in quantitative terms—than that mapped out by the substantial number of research studies which have emerged over the past decade. This can be partly explained by a natural and inevitable lag between the execution of research and any possible implementation of its recommendations. Time is needed to evaluate research findings, before their implications can become clear—perhaps only after repeated replication—and before they can be translated into positive action. On the other hand, action often occurs without any real or explicit recourse to research data. There is no doubt, for example, that International Women's Year in 1975 acted as a catalyst and resulted in activities in many spheres, including that of media.

The World Plan of Action adopted by the World Conference of International Women's Year recognized the potential of the mass communication media in promoting social and attitudinal changes, in accelerating women's participation in society and in encouraging their equal integration in development. The plan called for research into the portrayal of women by the media and suggested that the media should be urged to reflect the changing roles of both sexes, the diversity of women's roles and the actual and potential contribution of women to society. It also emphasized that women should be employed in greater numbers in decision-making, professional and creative capacities within media organizations.

During International Women's Year itself one of the most important activities concerning the communication media was the Media Workshop for Journalists and Broadcasters organized by Unesco in Mexico City immediately after the World Conference. The workshop formulated a series of recommendations to media and non-governmental organizations, professional communicators, governments and intergovernmental bodies on the more effective use of media and the increased participation of women as mass media professionals (Unesco, 1975). An exceptionally far-reaching and practical outcome of the workshop was the creation of regional networks for the production and dissemination of news and

information concerning women, an initiative which will be considered in the final part of this section. Since that workshop in 1975 a worldwide series of expert meetings and workshops has considered how the media might better reflect and support the changing roles and aspirations of women. Regional media seminars for broadcasters and journalists have been organized in Asia (by the Asian Broadcasting Union in 1975), in the Arab States (by the Arab States Broadcasting Union and Tunisian Television in 1975), in Europe (by the Association of Hungarian Journalists and the International Association of Women and Home Page Journalists in 1975). Other seminars, also at the regional level, have brought together researchers, media practitioners and decision-makers to consider existing practices and future priorities. In Latin America, such a seminar organized by the Inter-American Commission of Women (CIM) in 1977 was followed by national workshops on the same theme in Bolivia, Guatemala, Nicaragua, Peru and the Dominican Republic. The World Association for Christian Communication (WACC) has sponsored or organized meetings since 1975 in the Caribbean, Asia, Africa, the Middle East and Latin America; these have often resulted in the formation of smaller in-country work groups to formulate research needs, organize training courses and so on.

If International Women's Year served to stimulate research and discussion, the World Conference of the United Nations Decade for Women held in Copenhagen in 1980 provided a further focal point. The six months leading up to the World Conference saw the publication of three global reports on the image and role of women in the media. Two of these had been commissioned by Unesco, from the Catholic University of Louvain in Belgium (Ceulemans and Fauconnier, 1979) and the Open University in the United Kingdom (Gallagher, 1979); the third was the report of the Special Rapporteur to the Economic and Social Council of the United Nations (Cuevas, 1980). In addition, reports from Canada, Jamaica, Japan and Senegal on the impact of cultural (media) industries on the socio-cultural behaviour of women were considered at an expert meeting organized by Unesco and the Finnish National Commission for Unesco at the end of 1979. In the mid-decade year itself, regional meetings to review and plan activities concerned with women and the media were held in Africa (organized by the magazine *Africa Woman*) and in Asia (organized by the Asia-Pacific Institute for Broadcasting Development). At the inter-regional level, the United States National Commission for Unesco in co-operation with the National Commissions of Canada, the Dominican Republic, Jamaica and Mexico, sponsored a seminar on Women, Communications and Community Development which was hosted by the Department of State of Puerto Rico. Finally, in direct preparation for the World Conference in Copenhagen, Unesco collaborated with the Conference Secretariat in the organization of an international Seminar on Women and Media. The report and recommendations of this seminar were included among the Mid-decade Conference documents (WCUNDW, 1980*d*). (A list of reports and proceedings of seminars and meetings on women and the media since 1975 is given in Appendix 3.)

What has been done so far?

Literally hundreds of conclusions and recommendations have emerged from the impressive amount of research, information-gathering and discussion which has proliferated in recent years. To some extent there has been duplication of effort and a similarity in the thrust of conclusions and recommendations between one world region and another. But the need for specific applications and variations has also become clear. In practice, two broad lines of activity have resulted, one stressing the developmental use of mass media in support of women's struggle for equality, the other emphasizing the need to improve the day-to-day reflections of women flowing from the media so that a changing social reality is more conscientiously echoed.

Chapter 1

Using mass media for women in development

Much has been said and written, particularly since International Women's Year in 1975, of the tremendous potential of the mass media to promote the integration of women in the process of national development, through education, skills training and the provision of information on fundamental issues such as nutrition, health, family planning, employment possibilities and so on. Indeed, the media have been used—with varying success—in a large variety of development support projects for women over the years. An early and successful example was the Unesco project in Senegal using television for the social education of women (Fougeyrollas, 1967). Some recent examples can be briefly mentioned, to illustrate the range of possibilities in this area.

Some regional level projects

A far-reaching project based at the Inter-American Institute for Agricultural Sciences (IICA), a Latin American organization with executive offices in Costa Rica and with twenty-four member countries throughout the region, has set out to develop guidelines for the integration of women into rural development programmes, by using appropriate educational media to communicate agricultural and related information. The guidelines will be developed out of approaches tried and replicated in several countries in the region, and should be ready for dissemination by 1981 (AID, 1978).

Also in Latin America, an ambitious multi-media project is being prepared by the Latin American Evangelical Centre for Pastoral Studies (CELEP) based in Costa Rica. The project is designed to develop leadership in women and to initiate discussion of social, political and economic problems in the region. A series of forty-eight radio programmes, to be used in conjunction with other media such as seminars, publications and filmstrips, is to be produced in Costa Rica for weekly transmission to Central American states (Salazar de García, 1979).

The relative scarcity of projects at the regional level is perhaps explained

by the immense and inevitable problems of co-ordination which occur when working across national boundaries. Operational projects which require the co-operation of several bodies or institutions in different countries are notoriously difficult to manage, and more than one ambitious regional beginning has splintered into precipitate and untidy fragmentation. Work at the national or country level naturally has a much higher success rate.

National media development for women

Numerous projects at the national level have used radio, television, print and film in various combinations for the development of women. For instance, the Colombia Food and Nutrition Plan (PAN) uses radio, posters and booklets reinforced by interpersonal communication to improve nutritional status, with an emphasis on pregnant women, new mothers and young children. Begun as a pilot project in one state in 1976, the programme quickly expanded to cover eleven states and will eventually be fully national. Media effort focuses primarily on radio (both 'spots' and more elaborate programmes), but posters and booklets reinforce all messages. Extension agents disseminate additional information and advise local radio stations on nutrition programming (DNP, 1977).

This combination of media and interpersonal communication has often been notably more successful than the use of mass media alone. While broadcasts can lend authority and reach large audiences, field-workers can provide the detailed back-up service that is needed at the group or individual level in order to make implementation or take-up a practical possibility. A CARE project in India in 1977 used a radio soap-opera to illustrate such problems as malnutrition, sanitation and immunization. In answer to requests generated by the programme, CARE provided food and medical services. This was important: if they had not, many women listeners would have been unable to act on the advice they received, and the project would simply have led to frustration. As it was, some were impeded by their husbands' lack of co-operation and understanding, which at times was a considerable obstruction (Moss, 1978).

The multi-media approach was also highly successful in a television-focused project in the United Kingdom in 1977/78 in a weekly series of twenty-six drama programmes entitled *Parosi*, designed to encourage immigrant Asian women to seek help in learning English: the series was backed up by a telephone referral service for women's inquiries, educational facilities at the local level, and a tutor's handbook. The goal of the project was not simply to give Asian women in the United Kingdom —60 per cent of whom speak little or no English—a chance to start learning the language; it was also to enable them to take a wider interest in activities outside the home and to show them the value of teaching their pre-school children to speak English. The serial drama format, developing a story of two Asian families, was specially chosen to allow for identification and because of the importance of drama in Asian

culture. The project had many spin-offs at both the local and the national level: for example, the provision of a mobile classroom to serve Asian women in different parts of the city of Bradford, and the formation of a National Association for Teaching English as a Second Language to Adults (Matthews, 1978).

In Spain in 1978 a different use was made of television as part of a multi-media approach in a six-month campaign launched to improve the status of women. Eight television spots, 45 to 60 seconds in length, dealt with such topics as the sexual division of labour, women's political participation and the value of women's economic contribution. They were designed by advertising agencies, in collaboration with media and government administration, and were supplemented by other advertising media—periodicals, magazines and cinema. The campaign created a climate for positive discussion which led to a better appreciation of women's changing roles (Ministerio de Cultura, 1978).

Collaboration between different organizations and the pooling of various kinds of expertise has been essential in the successful implementation of a family planning information, education and communication project in Portugal. Since 1978, members of the Commission on the Status of Women have worked together with a woman journalist, a woman social worker and communication experts to design a comprehensive multi-media campaign to inform women about family planning and the services available. Press, radio and television are all used to relay practical information. For example, weekly articles are published in the most popular women's magazine; regional newspapers, trade union and agricultural press are supplied with two articles monthly; documentation folders are supplied to selected journalists in the national press as well as to television producers; radio 'spots', interviews and round-tables give information, while radio phone-ins allow regular audience feedback. An extensive range of print and audio-visual material, including brochures, posters, slide-tapes and a travelling photographic exhibition, all extensively pre-tested, provides detailed information at the local level. This formidable project is due to end in 1981, but already by 1979 an interim evaluation had demonstrated considerable practical benefits for women as well as a significantly higher informational level among the Portuguese population (WCUNDW, 1980*e*).

Weekly or monthly television or radio programmes aimed at aspects of women's development are broadcast in a number of countries—for example, the Dominican Republic, Portugal, Mexico, Indonesia and Puerto Rico. In the Dominican Republic, the weekly television series *Diferentes pero iguales*, begun in 1977, is particularly interesting since it not only deals with topics such as women's jobs, nutrition, family planning and education but also seeks to train women as technicians to record, edit and produce programmes. The idea is that once trained, the women will themselves produce programmes with an emphasis on women's development problems (Human Resources Management, 1978). The question of training is also given particular emphasis in an Indonesian project for Women in Development broadcasting. A special course for radio and television scriptwriters and for producers of women's

programmes was held, stressing the changing and expanding role of women in development. The trainees are expected to apply their new knowledge to actual radio or television production, and an evaluation team periodically checks programmes produced under the project and makes recommendations for further improvement (WCUNDW, 1980*f*).

Turning to format, one of the most popular and attractive seems to be the radio soap-opera, particularly in Latin America, although other countries such as the Philippines have also made extensive use of this type of programming for development purposes. An exceptionally well-researched and designed series in Mexico used a common street-vendors' cry to title its programmes: *Pásele, pásele, aquí no lé cuesta nada* . . . was a series of ninety-nine twenty-minute soap-operas broadcast by Radio Educacion (Acevedo, 1979). The programmes provided basic information in the areas of work, education, health, organization, urban problems, and the family, as well as analysing causes and reasons for class-based and sex-based domination. A system of formative research allowed each programme to be developed on the basis of the felt experiences of ordinary people. A research team went to village and urban groups to collect their views on the topic to be treated. A scriptwriter then dramatized the programme, incorporating the idioms, ideas and problems expressed by the target group itself. Each programme, or set of programmes (they tended to be grouped in threes), contained a number of options which could be used by listeners to improve their situation in relation to the problem in question. The programmes proved extremely popular and Radio Educacion has subsequently developed plans to provide them on audio cassette, with back-up print material, for group listening and discussion.

At an altogether different technological level, the Indian Satellite Instructional Television Experiment (SITE) linked over 2,000 villages in a social development programme in which four hours of television were broadcast daily between 1975 and 1976. Although, overall, only about 10 per cent of women watched the programmes regularly, compared with almost 40 per cent of men (mainly because of lack of time, and reticence to go to the public viewing places), it was found that those women who *did* watch benefited more from the family planning, health and nutrition programmes than did male viewers. Another important spin-off was the fact that communal viewing gave women a chance to meet each other more frequently, leading to changes in their interpersonal relationships (Gore, 1980).

Satellite communication is an exceptional luxury. At the other end of the scale interpersonal communication is accessible to all. Moreover, it is a particularly important medium of information exchange among women. For example, a study carried out by the Indonesian Institute of Sciences found that women were twice as likely as men to rely on interpersonal sources of information (WCUNDW, 1980*f*). Women in many countries use various forms of personal communication in an organized way, to provide and exchange information. One example is the Sistren Theatre Collective in Jamaica, which uses drama to depict and communicate the role of Jamaican women in the development of

their society. The eleven women who form the collective are all mothers in the age range 20 to 40 years, and most of them were illiterate at the start of the project (WCUNDW, 1980g). After a training programme which included drama, dance, reading skills and co-operative management, given by various government and quasi-government bodies, Sistren's first commercial production, *Belly-woman Bangarang*, was performed in 1978. The play was developed from the life stories of the women in the collective. The group's second major production, *Bandoolu Version*, based on personal experiences in Kingston, was toured in 1979. Sistren has also designed a series of short documentary dramas for community education, which are performed at workshops organized by the Jamaican Women's Bureau. The group has also planned and collaborated in two documentary films, one of which was televised at the end of 1978; the second was completed in 1980. Sistren, which began as a small experiment under the government's Special Employment Programme, has developed into a far-reaching and highly successful project. Apart from the direct benefits to members of the collective themselves, in terms of skills, income and self-confidence, benefits to women in the wider society have also been considerable. The group has provided an accessible role model to other women; its productions have helped to make women, and society at large, more supportive of women's struggles; they have also helped to develop communication between different socio-economic groups. Perhaps most importantly the success of the Sistren Theatre Collective demonstrates that women without formal education can function effectively as teachers and communicators by analysing and sharing their experiences.

Development projects at the local level

It is probably at the local level that the largest number of women's development projects have been initiated. Among the 'small' media, audio cassettes have been used in a huge variety of ways. Apart from their low cost, they can be particularly valuable in encouraging participation. For instance, in Kenya, what began as a functional numeracy and literacy course in 1977 turned into a project on women's participation, illustrating how, through control of the media, women can voice their needs and problems to the point where they can organize themselves to solve these problems. Cassettes issued to the Chebilat Women's Group, a small handicrafts' co-operative, enabled women unaccustomed to public speaking to voice their concerns in private before eventually reaching the stage of group discussions of solutions (Lundeen and Lundeen, 1977). In the 1975 Pila project in Guatemala, audio cassettes were used to give women health and agricultural information, mixed with entertainment in the form of music and *radionovelas*, as they washed their clothes at the communal facilities (Colle and Fernandez de Colle, 1977). In 1978, a project in the United Republic of Tanzania used cassettes to provide information, followed by group discussion, which enabled village women to recognize the importance of their role and led them to

take action on health and nutrition problems which they themselves had identified (Stanley and Lundeen, 1978).

'Bigger' media have often been used to motivate or advertise local development efforts. For example, an ambitious project in the Limón zone of Costa Rica uses a monthly magazine, pamphlets, radio and classes to encourage women to take up income-producing activities through vocational training, family planning education and creation of new jobs (Ligia Chang, 1970). Begun in 1977, the project is training women in various skills: courses in tailoring, for instance, cover not just sewing but also management, marketing and accounting. Twice-weekly radio programmes are used to discuss the activities and to advertise the training classes.

A variety of media, including film or slide-tape, are commonly used to promote discussion or to act as a catalyst for future action. For example, in Bolivia film and slide-tape presentations are used as part of an orientation and motivation programme for training courses on the integration of *campesinas* into community development programmes (Human Resources Management, 1978). In 1979 the Argentinian Federation of University Women prepared an audio-visual presentation, to be shown to groups of women throughout the country, dealing with issues such as the need for legislation, marital rights and family allowances. The idea is to generate action and pressure at the local level (IFUW, 1978). An information project for village women in Indonesia, aimed at the improvement of life conditions of women in rural areas, stresses the need to create 'mobility multipliers' from among the local women themselves (WCUNDW, 1980*f*).

The project used printed material (mainly posters), film shows, rural radio broadcasts, face-to-face communication, as well as traditional communication such as *wayang* and *ludruk* performances to disseminate national development messages. 'Information cadres', including members of local women's organizations, are given special training in an effort to intensify the flow of information relevant to the needs of rural women.

Numerous projects in North America and a few in Europe have made use of local video and television cable systems to promote discussion of women's problems. In the United Kingdom, for example, the Worker's Educational Association co-operated with women near Glasgow to produce six programmes, which were broadcast over a local commercial cable network in 1976 under the title *Women in Focus*. Originally conceived as one programme, the project expanded to cover issues including child care, work, legislation and images of women. Local viewing groups formed to discuss the programmes as they were broadcast (WEA, 1977). The project illustrates how far-reaching even local efforts can be: started as a small adult education effort, this grew into something much wider. Local women's support groups were formed for mutual help and in order to involve isolated women. The experience of making the tapes was said to have a dramatic consciousness-raising effect on the women involved, while the tapes themselves are in constant demand by groups throughout the country.

In a similar project carried out in 1979 in the new city of Milton Keynes, also in the United Kingdom, women described the opportunity to make their own video programmes as 'one of the most important things that ever happened to us' (Hemmings, 1979). About a hundred women were involved in the production of twenty videos, from six to forty minutes in length, which were transmitted over the local cable network. The overall series title was *Things That Mother Never Told Us*, and it gave women the chance to voice their concerns and needs in coping with life in the new city. The fact that the problems of these ordinary women are typically ignored by the national media is strongly felt:

National television's rubbish. A typical programme for women is that *Houseparty*. There's your middle class, loads of money, round for coffee.... My husband doesn't want stupid vol-au-vents, cordon bleu. There must be more to it than that. We're working-class people. And I think we're more interesting than that lot.

Given the chance to express themselves, the women found the challenge both frightening and exhilarating, leading to important shifts in self-perception:

Before we all got involved . . . we saw ourselves as basically ordinary housewives.... Confidence has been the hardest thing to build up.... But our brains are living again. We went from being involved in all these areas of discussion, learning to support people, learning filming and editing techniques—it did surprise us.

The women's husbands were also surprised—'they thought we didn't have any brains'—and temporarily threatened, 'but they've had to accept that we've become more independent people'. Many of the women have gone on to make more tapes, and friendships built up among them have strengthened, generating new ideas about how women might help and support each other in the city (Hemmings, 1979).

Chapter 2

Media and the social reality of women

Challenged by critics of the way in which the media portray women, a common response of media personnel is that the media simply show life as it is, however unpalatable this may be, and that they therefore reflect the *reality* of women's legal, political, economic and social subordination. Extensive systematic longitudinal studies of the relationship of media to social change would be needed in order to validate or challenge this argument, and so far few have been carried out. However, one recent piece of Swedish research has indicated that the media tend to lag behind social change rather than to keep pace with it. In its detailed analysis of magazine advertising over a twenty-five-year period, the study concluded that advertising at least reflected conservative rather than liberal attitudes, and that it also actively encouraged conformity in a culturally oppressive fashion (Andren and Nowak, 1978).

There is plenty of evidence that the mass media under-represent women in terms of numbers, as a proportion of the work-force, in various age and class categories, in all parts of the world. That they misrepresent the majority of women in terms of characteristics, attitudes and behaviour is less easy to establish, since little research has so far been carried out into social perceptions and their congruence with media images. However, research findings in the Philippines (National Commission on the Role of Filipino Women, 1978c), the United States (Foote, Cone and Belding, 1972) and Canada (Aaron, 1975), report that women are enormously dissatisfied with their portrayal by the media. Not surprisingly, women are more critical than men. One of the largest surveys of public attitudes to television in the United States, carried out by the Screen Actors' Guild in 1974, asked the question 'Do you like the women you see on TV?' While 52 per cent of men replied in the affirmative, only 28 per cent of women did so (Screen Actors' Guild, 1974). In another American study, only 8 per cent of housewives thought the advertising image of women was an accurate one (quoted in Newland, 1979).

Other research indicates that the media do respond to changes in the broader socio-economic fabric, and that the mainstream mass media are beginning to reflect or recognize greater diversity in images for women

(although usually in the sense of accepting ideas which have become common currency rather than in terms of an active exploration of alternatives). But changes cannot always be accepted at face value. Some analyses argue that the media have often simply succeeded in transforming certain new ideas into old ideas in new trappings: for example, their emphasis on sexual liberation may have diverted attention away from social or political liberation while giving some well-worn images a modern appeal. On the other hand, there is indisputable evidence of the growth of a feminist press in every world region, and of an active body of feminist film-makers in certain countries.

Content and policies in the mainstream mass media

In the past five years some established women's television and radio programmes have been revised and some newer ones have appeared. In Canada, for example, changes have been noted in the long-running women's programme *Femme d'aujourd'hui*. Since its inception as a 'housewife's aid' in 1964, it has moved to include regular items on women at work, social problems, politics and so on (Legaré, 1979). In the United Kingdom, too, the long-established BBC radio programme *Woman's Hour* found that women wanted better coverage of current affairs, consumer affairs, legal problems and other advisory matters; this was in sharp contrast to a 1965 survey, which showed that listeners wanted more about hobbies and cooking, and less about health and sex (BBC, 1965 and 1972). The BBC's *Afternoon Theatre*, the daily drama slot with over twice as many female as male listeners, has begun to broadcast the work of feminist playwrights on issues such as rape, mastectomy, alcoholism and return to work. In Italy, RAI has been transmitting a cultural-political television programme called *Si dice donna* since 1977. Its initial success has resulted in its being allocated increasingly more favourable transmission slots until in the 1979/80 season it was broadcast at 9.30 p.m. during midweek, and was attracting an audience of 8 million viewers—higher than any other cultural programme. At the same time RAI's morning radio programme *Noi, voi, loro, donna* has been running daily since 1977 and deals with topics such as politics, education and the women's movement in Italy. It also provides the public with a means of feedback on *Si dice donna* through a phone-in programme on the morning after the television broadcast. Even Japan has introduced a television news programme for women, directed by women themselves (Nuita, 1979).

The range of expertise called on for such programmes is increasingly non-traditional. For instance, *Si dice donna*, although produced by a RAI staff member (and a feminist), has a production team which includes the editors of the best-known feminist journals in Italy. RAI has also financed a much-acclaimed video production, *Processo per stupro* (about a rape trial), made by an independent feminist collective. The programme won the Premio Italia in 1979, has been transmitted twice on national television and is used on cassette by feminist groups for discussion and workshops. The Australian Broadcasting Commission's *Coming Out*,

Ready or Not, a weekly radio programme produced since 1975 by a women's co-operative within the organization, gives *all* women (including, for example, typing and clerical staff) the chance to produce. In some countries, women's groups outside the media organization may also be given regular access to radio and/or television slots. For instance, Radio Televisão Portuguesa collaborates with the Commission on the Status of Women to produce weekly radio programmes such as *Ser mulher* (since 1977) and a fortnightly television programme, *Condicão mulher* (since 1979).

In print, too, there have been some notable developments. Traditional women's magazines, often spurred on by competition from the fast-growing alternative feminist press, have increasingly published articles which project a new perception of the woman's sphere. Magazines such as *Woman's Own* in the United Kingdom, *Marie-Claire* in France and *McCalls* in the United States now regularly carry material which assumes and even approves widened scope in life-choices for women. In fact, *Woman's Own* played a very important part in focusing attention on inequalities in the British tax laws (since revised). Following this success, in 1979 it began a campaign to obtain better child-care facilities in the United Kingdom. Newspapers have instituted columns on women and social issues, such as 'Omen' in the British *Guardian*, 'Women's View' in the *Ceylon Daily News* or 'Feminist Viewpoint' in the *Indian Express*, which tackle quite different problems from those covered in the traditional woman's page or life-style column.

So there is some evidence that changing social patterns and values find a response in main-stream media. Yet the survival of such ventures is by no means assured. For example, in the case of *Femme d'aujourd'hui* and *Coming Out, Ready or Not* it has had to be *won* through the continual effort of producers and audience, who defend it against successive management threats. Economy cuts tend to affect women's programmes or columns first: so the *Indian Express*'s 'Feminist Viewpoint' was one of the first items to be axed when the paper faced economic difficulties in 1980. Too often, they depend on the presence, goodwill and persistence of a single individual rather than being integrated within an overall programming or editorial policy. For despite all the criticism which has been levelled at media organizations in recent years *vis-à-vis* their treatment of women, almost none—beyond those under government control, notably in planned societies such as the Soviet Union or Cuba—has yet developed any *policy* in this area. Of course, this is an extremely delicate issue which immediately raises fundamental problems touching on jealously guarded freedoms and rights in the media. In the arena of international debate, in particular, the whole question of communication policy and planning has become an extremely touchy subject. It was notable that at the World Conference of the United Nations Decade for Women, despite several attempts to introduce resolutions or amendments to strengthen the scanty proposals concerning the media, no government or group of governments was prepared to support such moves. The entire question of communication policy and its implications for women went undebated at the Copenhagen Conference: perhaps not surpris-

ing in a year in which the political context of communication had been highlighted by the publication of the controversial report of the International Commission for the Study of Communications Problems (the 'MacBride Commission'), *Many Voices, One World,* and by the Unesco Intergovernmental Conference on Communication Development.

Yet policy development, seen in the context of the protection of basic human rights and freedoms, need not be restrictive. Two media organizations which have attempted to devise comprehensive proposals and policies on the portrayal and participation of women are the Canadian and the Swedish Broadcasting Corporations.

The CBC initiatives date back to a commitment made at the 1978 Canadian Radio-Television and Telecommunications Commission (CRTC) licence renewal hearing, to which seven Canadian women's organizations had submitted documented complaints of sexist imagery and practices on the part of the CBC. Four months later, in February 1979, a two-day seminar was organized at CBC headquarters to bring together representatives of the women's organizations and senior CBC staff; specialists in fields such as communication, psychology and sociology were also invited to give presentations on the problem of women and the media. The CBC then committed itself to a series of eight objectives, including the development of a programme policy, programme evaluation and monitoring, and the development of 'social affairs specialists' in television news, for both the English and French networks, to ensure comprehensive coverage of issues of concern to women. It also promised a **follow-up meeting a year later to assess progress (CBC, 1979). By the end** of 1979 a programme policy statement had been issued in which the CBC stated its belief that programming should contribute to the understanding of issues affecting women. Language guidelines were also developed, and by June 1980 two 'social affairs specialists' were in post. None of this had been easy to achieve (in particular, the appointment of the social affairs specialists had met with some opposition) and by the time of the promised follow-up meeting, in June 1980, at which yet more criticisms were directed at the organization, there was a certain 'tiredness' about the whole issue: on the one hand, a management feeling that they had fulfilled their commitment, on the other the criticism of tokenism and complacency in a situation which had not visibly changed.

The problem is not peculiar to the debate within CBC. There is an immense and widely reported difficulty in keeping continued discussion of this deeply rooted and multi-faceted problem 'alive'. Typically, those who honour their initial commitments to action feel that once *something* has been done their obligations have been met: it is now, they suggest, a matter of time before the results become clear. Typically, their critics are frustrated by a visible ebbing of interest in or exasperation with a problem not quickly or simply solved. Is the issue being deliberately 'defused'? Or is it that its fundamental resolution lies outside the capacity of any organization or group, however well-intentioned? Or is the attempt to resolve it within existing organizational structures actually a contradiction in terms? Some of these questions will be taken up in

Part IV of the book. It seems relevant at least to mention them here since they touch on any interim evaluation prompted by consideration of the scope or effects of what has been done so far. For to examine almost any action taken until now in this field is to confront a record of limitations.

In 1976, for example, Sveriges Radio (now the Swedish Broadcasting Corporation) launched an equality project. One-sexed work areas were identified, new guidelines for announcing vacant jobs were introduced, and affirmative action experiments were started. A basic technical course for women was mounted, as well as a typing course for men. Under the direction of the head of programme policy, a seminar for female writers was held, a card file on women 'experts' on specialized subjects was set up, and an attempt made to analyse sex roles in the programmes. The project culminated in an action programme which covered personnel and programme policy. The action programme contained sixty-nine specific points (Sveriges Radio, 1978). Yet in a review carried out in 1979 the Swedish National Committee on Equality had to conclude that 'no major change in the mass media treatment of equality issues can be borne out with examples' (National Committee on Equality, 1979). Nevertheless, the committee conceded, the fact that debate and discussion—both internal and public—had started and was continuing was perhaps the most significant fact. Given the implications of the equality issue for the balance in personal relationships, slow progress and even 'active opposition' must be expected. The important thing should be to create a climate in which critical awareness and self-questioning could flourish, and in this respect, admitted the committee, the Swedish mass media had contributed—although in fits and starts. Questions such as advertising, working conditions, part-time work, legislation, child care, the male role, housewives, women and media, women and technology, rape and prostitution, and the quota-allocation principle had all received extensive coverage in press and broadcasting.

One development which, although not always part of a fully-fledged policy, does have certain policy implications is the appearance in recent years of various sets of guidelines. Aimed at advertisers, journalists and broadcasters, these aim to help media personnel avoid the most obvious—but frequently unnoticed—sorts of verbal or visual bias against women. The status of such guidelines may be official, advisory or informal. For example, in Norway a preliminary set of advertising guidelines has been prepared for the Ministry of Consumer Affairs (Berg, Kallerud and Melby, 1979): it is intended that these will eventually have official status. In Canada, on the other hand, the Ontario Status of Women Council's guidelines are directed informally both at interested consumers —advising them on how they can help eliminate offensive advertising— and advertisers (Aaron, 1975).

As far as journalism is concerned, numerous sets of guidelines are beginning to appear in the United States. Some are independently produced by interested women who have monitored the media. Others are the product of groups, such as those issued by the International Association of Business Communicators (IABC, 1977) or Chicago Women in Publishing (Chicago Women in Publishing, 1978). A task force of

the Swedish Journalists' Union has taken a slightly different approach by publishing a folder called *Testa din Tidning* (Test Your Newspaper). The McGraw-Hill publishing company has issued its own guidelines for equal treatment of the sexes in its publications (McGraw-Hill, n.d.). Although stressing that these are not rigid or mandatory, the company offers them as a step towards developing a particular attitude. The same point is made by the British National Union of Journalists, who published their guidelines in 1977 (NUJ Equality Working Party, 1977). Covering topics such as under-representation, images, character and occupational stereotyping, social stereotyping, women as activists and the refutation of myths, the publication is studded with telling examples and clever cartoons which illustrate graphically the nonsensical way in which women are often presented.

Such guidelines do not always have an easy ride when issued to media personnel. Particularly subject to criticism or parody are attempts to revise common uses of language. Jokes about 'chairpeople', 'Mr Johnsperson' or '*Ecce persona*' illustrate the unease which is aroused by attempts to uncover the discriminatory roots which pattern our words and ideas. The London *Times* still refuses to use the title 'Ms', preferring to distinguish between married and unmarried women. Yet the symbolic —and subordinate—significance attributed to women in language has been well documented (for example, Lakoff, 1975; Miller and Swift, 1977; Thorne and Henley, 1975). The point is recognized in the language guidelines developed by CBC: 'Words', they state, 'can be the symbols, of deeply rooted cultural assumptions. The way language is now used tends to relegate women to secondary status in our society.'

Of course, guidelines need not be in the form of a written check-list in order to be effective. Indeed, other forms which imply more flexibility in application or freedom of choice in adoption may find a more sympathetic response. In Norway, for instance, the Head of the Norwegian Broadcasting Corporation periodically circulates staff with reminders of the need to ensure fair treatment of women in programmes. This kind of personal approach may strike chords where the typed multi-point guide gathers dust or becomes buried under other, more recent notices on the pin-board. Financial incentives, where possible, can also bring results. Again in Norway, the government gives subsidies or grants to many newspapers and press agencies so as to assure a wide spectrum of viewpoints in the press: in fact one such grant holder is the Press Service of the Norwegian National Council of Women (Vaerno, 1978).

Organizing to monitor the media

In the United States, two major attempts have been made to monitor changes over time in the portrayal and participation of women in the media. The United States Commission on Civil Rights reported on commercial television in 1977 and 1979. Public broadcasting was systematically monitored in 1975 and 1978. The overall conclusion of both sets of studies was that the picture had not improved in the interim

period—indeed, in some respects, it appeared to have deteriorated (Signorielli and Gerbner, 1978; United States Commission on Civil Rights, 1979). Yet increasingly women have been organizing to monitor media content and to act as pressure groups, and their efforts have not been completely unsuccessful.

Still in the United States, groups such as the American Association of University Women, the National Organization for Women and the United Methodist Church have played an extremely active monitoring role since the mid-1970s. Quite apart from the general climate of discussion which such groups help sustain through the continual publication of reports and papers, they have been instrumental in supporting or indeed initiating particular actions such as the challenge to WRC:TV's licence mounted by the National Organization of Women (NOW, 1972). Part of the United Methodist Church's thinking on this issue is that involvement in the process of monitoring leads women to be more aware and critical of media content in the longer term. Their television monitoring project, carried out in 1975/76, trained twenty-three co-ordinators in the use of a simple analysis form. Each co-ordinator was then expected to recruit and train ten monitors in her local area. A total of 187 monitors was eventually involved in the project. A quite vast consciousness-raising effect was thus achieved, characterized by comments such as: 'We learned not to drink it all in, assuming it had no effect on us'; 'I became more aware and angry'; 'I had never actually analysed what I was seeing. Now I have a more critical eye' (United Methodist Church, 1976).

On a smaller scale and with a quite different mandate, in the United Kingdom AFFIRM (Alliance for Fair Images and Representation in the Media) acts as a central body through which British women can channel complaints about or to the media. AFFIRM—like many of the American organizations—issues a newsletter and provides information on the particular agencies to which complaints on media imagery should be addressed. It also provides advice on how to lodge such complaints. Its resources are pitifully small and it makes little of the public impact achieved by some of the North American groups; yet it has had some significant success: for instance, it was instrumental in bringing about the redesign of a particularly offensive popular book cover in 1979 (AFFIRM, 1979).

At the international level, groups such as the International Federation of University Women and the Association Internationale des Journalistes de la Presse Feminine et Familiale (AIJPF) have become involved. The 1978 congress of the AIJPF, for instance, had as its theme 'How the Press Treats Women', and reports from eight countries were presented. Women's International Information and Communication Service (ISIS) bulletins have covered related questions such as the advertising techniques used in the international marketing of dried baby milk to women in the developing world. Some national governments—for example, in Norway, Denmark and Sweden—have set up groups to examine women's imagery in various media: the Norwegian project has already produced several reports (for example, Flick, 1977 and 1978),

and one report of images in advertising has gone to the Danish Ombudsman (Sepstrup, 1978). National women's organizations—for instance in Pakistan, Argentina, Sri Lanka, Federal Republic of Germany—are also often involved in monitoring or in sponsoring monitoring work. For example, the Sri Lankan women's organization Kantha Handa (Voice of Women) has, since its inception in 1978, conducted a campaign against sexist advertising. The group sent letters to all firms which were using women as sex symbols, copying the letters to all advertising agents in the country, and indicating that copies were also being sent to the President. Although they received no replies to the letters, many of the advertisements were subsequently withdrawn. The campaign is ongoing.

At the local level, countless women have come together—either in existing groups, or in groups formed expressly for the purpose to monitor the media's portrayal of women. In Austria, the Federal Republic of Germany, the United Kingdom and elsewhere, groups have organized to study film, broadcasting or press material and to produce reports —sometimes even published books—on the results of their work. Many of these groups are actively involved in spreading information to other women, through newsletters, seminars, slide-shows and so on. For example, a group of housewives formed in 1975 in the Federal Republic of Germany issues its own paper, *Modern Housewife*. It puts pressure on media for more realistic treatment of 'houseworkers' conditions, and for discussion of questions such as the economic value of housework and the sharing of family roles. A United States group, Women against Violence in Pornography and Media, formed in 1976, has been successful in persuading Max Factor to redesign an advertising campaign which exploited women's fears of rape and mugging in big cities.

However, a major problem for these small local groups is the enormous amount of time, effort and money which is usually needed to make an impact on the monolithic media industries. For example, in the United States, in 1974, the Los Angeles Coalition for Better Broadcasting went to every television station in Los Angeles and attempted to negotiate with them on questions of their programming and employment in relation to women. Agreements were reached with two network-owned stations, and the licences of the others were successfully challenged by the women's group. However, the entire process took over five years and eventually went to the United States Court of Appeals. It was estimated that the television stations spent over a million dollars fighting the cases (Margulies, 1978). In France, it took over a year for women—working through a Member of Parliament and eventually a government committee—to have a ban placed on *Detective*, whose publicity posters and contents seriously degraded women. The women activists came into conflict with various levels of interest in the media. They were opposed not only by the owner of the magazine—whose weekly circulation of 380,000 made it a money-making enterprise—but by a body of journalists who contested the ban in the name of freedom of the press and who, according to one analysis, used the event in order to scapegoat the women's movement by simplistically associating it with a repressive and conservative morality (Kandel, 1979).

Yet there are other instances in which the media actively encourage and support women who wish to monitor output. An important example is the 'Schema for Programme Analysis' developed by the Swedish Broadcasting Corporation as part of its Equality Project. This analysis sheet (reproduced in Appendix 6) is designed to be used by any group or individual concerned to study the norms and values associated with men and women in television. It has been well tested, is simple to use, and yet provides quite detailed information. It could quite easily be adapted for use on other media such as radio or magazines. It demonstrates, as did the television monitoring project of the United Methodist Church, that effective and systematic media monitoring is well within the scope of the amateur: no esoteric research skills are needed to generate a mass of powerful information. Used as part of a group project, the analysis should stimulate discussion and focus action.

Although now made available to women in the audience, the Swedish Broadcasting Corporation's schema for analysis was initially designed for use within the organization itself. A considerable number of monitoring and other pressure groups now exist to bring together women within or across media organizations. Some of these groups—such as Women in Communications, Inc., in the United States—are particularly concerned with improving their members' working conditions. Others are just as interested in acting as pressure groups to change media portrayal of women. For example, Women in Media has united British media women since 1970 in a wide range of activities, including a successful campaign in 1972 to ban advertising for vaginal deodorants on commercial television. In 1976, it organized a workshop on advertising, bringing together leading advertisers, media women and political figures to discuss this particular problem; their report, entitled *The Packaging of Women*, has been widely circulated in the United Kingdom (Women in Media, 1976). Members of the group have also published a book containing their analyses of images of women as they are presented in the media (King and Stott, 1977). More recently, in 1979, some of the Women and Media group helped to form a second 'Women and Television' group, with the aim of bringing together women from both inside *and* outside the medium. This in turn launched the Women's Broadcasting and Film Lobby, formed to represent women's interests during the development of policy for Britain's new fourth television channel. The WBFL, for instance, has called for a programme of affirmative action and the allocation of a budget for training and retraining for women in all technical, production and executive grades. They want to see at least three women on the board of the new channel, one of them specifically to look after women's interests (Baehr, 1980b). The extent of the success of the WBFL in obtaining such demands remains to be seen. Whatever happens, the significant fact for the future may be that women have, as a group, developed the political acumen to sense the strength of organization and the importance of timing.

Other very active groups of this kind can be found in, for example, Norway, Australia, Sweden, and the Federal Republic of Germany; in the United States, they are almost as numerous as the media themselves.

Results of their work can be impressive. For instance, at the end of 1977 women journalists on the Swedish evening paper *Aftonbladet* produced a document describing their experience of discrimination at work. This led to debate within the newspaper and to the eventual formation of a woman's desk. This is staffed by four journalists who have three pages in each Monday edition and can also publish material in other parts of the paper. In Norway, the work of the Engebret Movement, started by a group of women journalists in 1974, led to the placement of a number of women in leading positions in trade unions.

One of the most interesting examples of women's organizations in the media is the Women's Broadcasting Co-operative, formed within the Australian Broadcasting Commission in 1974. Its original purpose was to provide better opportunities for women staff to participate in programme-making. But in the six years during which it has both struggled for and consolidated its position it has, while remaining within the established media structure, succeeded in challenging that structure at a number of different levels (Fell, 1980). At the ideological level, its feminist radio programme *Coming Out, Ready or Not* has been a persistent weekly national presence, presenting new themes and radical ideas in contradiction to the many established myths which dominate other types of programming. At the organizational level, the creation of a co-operative structure within a hierarchical setting has been a major achievement. The co-operative has an autonomous Women's Unit with three full-time radio production positions selected by and responsible to the co-operative. Pursuing its aims of attaining gains for *all* women, the co-operative has tried to create non-competitive, egalitarian, supportive work conditions: skills, knowledge and experience are shared; policies are discussed co-operatively; programme/production positions are selected by the co-operative and rotated annually; struggles with management are pursued independently of the union, through direct action and collective bargaining. At the industrial level, the co-operative has fought, with some success, to change job structures, redistribute incomes and improve work conditions. One important proposal, originally rejected by management, was the provision of work-based child care. A hard and persistent struggle to press for this eventually won through: facilities are expected to be in operation in the ABC in 1981. The co-operative believes this provision to be profoundly important: by starting to break down the sexual division of labour in the work place (by removing some of women's dual burden) they expect the sexual division of labour in the family itself to be challenged in some degree.

Widening opportunities for media women

The ABC Women's Co-operative was founded on an initial recognition of the lack of career openings available to the vast majority of media women, who are found in a small number of traditionally female secretarial-type occupations. The co-operative began by providing some training in production skills for secretarial and clerical staff through lunch-

time or evening training sessions and workshops. The title of their weekly programme, *Coming Out, Ready or Not*, reflects their philosophy towards programme production: relatively untrained women, who had spent most of their working lives at the typewriter, were thrown in at the deep end of programme-making. For all the rough edges that showed in their initial efforts, the women in general found that there was nothing mystical or magical about production. Their programmes were broadcast and their self-confidence grew. Several of them have subsequently taken up full-time production positions elsewhere. Sveriges Radio's equality project in Sweden has also drawn up detailed plans for the training of its secretarial staff—in areas such as administration, production and technical work. The objective is to increase these women's self-confidence, involvement and employment potential (Sveriges Radio, 1978).

A different kind of scheme is operating in the United States. Since 1976, the Corporation for Public Broadcasting has operated a Women's Training Grant Programme, which is designed not simply to improve the employment prospects of women already working in the media, but also to open up the range of jobs potentially available to new recruits. The scheme is aimed at encouraging the employment of women in important areas now staffed by very low percentages of women. The types of position mentioned as being particularly likely to attract CPB grants include station manager, producer/director, operations manager, film editor, supervisory engineer, and so on. Under the scheme, grants are awarded for one or two years to public broadcasting stations who either designate internal candidates for training or specify a position to which they will appoint and train a woman after receipt of the grant. Almost a million dollars had been spent or committed to the scheme by the end of 1977, and seventy-two grants had been awarded (CPB, 1978).

Since 1977 the Australian Film and Television School has also been organizing innovative courses for women who already work in the media. Run in the evenings and at weekends, the courses—lasting from three to thirteen weeks—are designed to provide women working in dead-end occupations, such as make-up, continuity or production secretary, with some practical experience in technical and production jobs traditionally associated with men. Between March 1977 and October 1978 four courses were held. Each course had five major components, covering studio work, film work, information areas (detail of production), consciousness raising and individual projects. Extremely detailed evaluations of all four courses were made, and in general terms they were found to be extraordinarily successful. Specifically, of forty-two participants who returned follow-up questionnaires, nine had been promoted, eighteen had changed work direction and nineteen had increased job satisfaction. Women from the courses had set up twenty-one production projects and many had become involved in a variety of other work-related projects, such as research, writing and publicity. Nineteen of the women said that the courses had a great deal of effect in bringing about the changes and developments which they described in their lives (Alexander, 1979).

Paradoxically perhaps, in the developing world, where training is so crucial, much less has so far been done. In Asia, the Asia-Pacific Institute for Broadcasting Development hopes to begin a programme of training courses and workshops. In Africa, the Africa Training and Research Centre for Women has held study tours for women journalists to underline the importance of the integration of women in development. It also plans a seminar for senior producers of radio programmes, to sensitize them to women in development issues. Despite these few cases—and even these remain, for the most part, at the planning stage—and some scattered initiatives by Unesco at the national level, the problem has barely been approached. Perhaps more promising, in Africa at least, is the involvement of the World Council of Churches in the establishment of training centres for women communicators in Kitwe and Dakar. The World Association of Christian Communication (WACC) has been operating a fellowship scheme in media training for a number of years. One of its major problems has been in finding women applicants, even though it is prepared to favour women in awarding grants. In the end, however, a comprehensive programme of affirmative action may be needed if developing country women are to overcome the already considerable barriers imposed by poor educational opportunities as well as by social and cultural factors.

Chapter 3

Alternative strategies for media change

Most of the activity described so far rests on the belief that the existing media systems and structures which at present disadvantage women are in the long run responsive and amenable to change. In a broad sense, effort is focused on reform, amendment and sensitization, while accepting the basic political and ideological assumptions of the present systems. An exception to this would be the Australian Women's Broadcasting Co-operative, which aims to bring about radical change by developing a new organizational base strong enough to challenge the established structure within which it is located. Nevertheless, even here the strategy adopted has been to struggle from *within*. Other approaches, however, are based on the belief that true change can only be achieved by working *outside* existing structures. Alternative, radically different views and voices, according to this view, will inevitably be stifled or —perhaps worse—transformed and incorporated by the dominant system if they try to work within it. The only possibility, then, is to maintain an independent stance, creating new, purposeful media for distribution through self-sufficient channels. Initially these may be no more than isolated pockets of dissent but over time they will weld together to form a wave of critical consciousness solid enough to challenge, undermine or even destroy existing discriminatory systems.

Growth of the feminist media

The basic tension between these two approaches is clear in the rapidly growing area of what is often broadly called 'the feminist media'. Magazines, films, radio, even video: all forms must resolve the dilemma provoked by the intention to deliver a fundamentally different *type* of information to as many people as possible. While some solve the problem by directing their work at a small well-defined public, and accepting these limits, others prefer to make a more general appeal to a bigger, heterogeneous audience, consequently losing much of their radical force. Economics also play a part. To be effective, the alternative media must

survive. The costs of production and distribution can rarely be covered by sales or subscriptions. Advertising revenue may be tempting but will almost certainly require compromising the premises on which the venture has been founded.

Certainly the most notable development in recent years has been the immense growth in new types of magazine for women. Taking a fairly strict definition of the term 'feminist', ISIS listed 129 publications in eighteen countries in their 1980 survey of the feminist press in Western Europe (ISIS, 1980). But if the definition is expanded to include other less radical publications, the range becomes enormous, and covers all world regions. At one extreme there are publications such as *Viva* in Kenya, which started out in 1974 as a traditional women's magazine, but has moved in a feminist direction through changes in editorial policy. Still commercially supported, *Viva* has tried to combine an appeal to middle-class Kenyan women's conventional tastes with a policy of publishing regular, comprehensive articles on issues such as prostitution, birth control, female circumcision, polygamy and sex education. But dependence on advertising revenue imposes enormous limitations on what a magazine like *Viva* can publish. Opposition to its policy of including controversial material gradually built up. Eventually, after publication of an investigative article on the conditions of seisal workers early in 1980, the editor was told by the owners of the magazine to drop such issues in future: the journal's existence was in the balance because of the threatened withdrawal of advertisements. In Kenya, as in most other countries, whether industrialized or developing, there is little choice when advertisers' support is necessary to survival, since about 90 per cent of all advertisements are channelled through a handful of advertising agencies. Subsequent editions of *Viva* show a noticeable response to the warning with a much 'lighter' approach to any equality issues which do remain, but overall more reliance on the old themes of beauty, family and sexual relationships.

Moving along the scale, there are several large-circulation feminist publications—such as *Ms* in the United States (started in 1973, circulation about half a million) and *Emma* in the Federal Republic of Germany (started in 1977, circulation 300,000)—which have won readerships broad enough to be described as mass media, though their commercially palatable brand of feminism is subject to some criticism. Here, too, advertising plays an important role in their success: more than a third of the space in *Ms*, for instance, is taken up with full-page colour advertisements. And although these magazines reject advertising which is obviously exploitative of women (*Ms* invites readers to submit examples of such advertisements for publication in its feature 'No Comment') they nevertheless print advertisements which other less market-oriented magazines would find quite unacceptable. For example, in its June 1979 issue *Ms* published an 'objectionable' advertisement in its 'No Comment' column. It pictured a glamorous model, seated legs crossed, dress pulled back to reveal her thighs. A man's hand rested on the model's knee (only the arm of the man was visible). The caption read: 'I get ideas.' The sexual association was unabashed and explicit. Yet eight pages away, a full-page 'accept-

able' advertisement (for exercise sandals) appeared showing two women, both seated with legs drawn up and apart, dresses pulled back to show their thighs. There was no male hand, and no caption. The sexual reference was more subtle, delivered at the subliminal level through a now well-known technique: the dress of one of the models, pulled high between her thighs, was arranged in folds to form the clear outline of the female sex organ (this particular publicity technique is extensively analysed in Key, 1976; specific instances are illustrated in, for example, Santa Cruz and Erazo, 1980).

To avoid such paradoxes, many feminist magazines reject all advertising except perhaps for some feminist-produced items. There are numerous magazines in this category, mainly established in the early or mid-seventies, most with circulations around 20,000 although some sell more. For example *Spare Rib* in the United Kingdom, *Ideal Woman* in Ghana, *Effe* in Italy, *Mother Jones* in the United States, *Courage* in the Federal Republic of Germany, *Famille et développement* in Senegal, *Kvinder* in Denmark, *Fem* in Mexico, *Hertha* in Sweden, *Des femmes en mouvement* in France, *Vindicación feminista* in Spain—the list could go on and on—all are attractively and professionally produced, but also willing to allow occasional rough edges to show. Their priority is substantive quality rather than commercial polish.

Run on a mainly voluntary basis, or foundation-supported, these magazines address serious problems and can influence not only their comparatively small audiences but can help shape policies affecting women. For instance, *Ideal Woman* is said to have been largely instrumental in the establishment of a government committee to review the laws on succession. Recently established and radical feminist journals, such as *Manushi* in India, *Feminist* in Japan or *Voice of Women* in Sri Lanka, appeal to similar markets. Many are produced on a co-operative basis, by broadly based social groups including working-class and rural women. This helps to ensure that they avoid charges of 'middle-class' or 'educated' élitism in the subjects tackled, although many are still written in such a way as to put them outside the linguistic or conceptual grasp of less educated women.

Most countries with developed media markets now support at least a few small feminist magazines and newspapers. The Federal Republic of Germany and the United Kingdom have at least twenty each; in the United States, there are hundreds. The Soviet Union too saw the brief appearance of a feminist magazine in late 1979. The first edition, entitled *Almanac: For Women and About Women* and dated 10 December 1979, was circulated unofficially as a *samizdat* (self-published paper) within the Soviet Union, and found its way to France where it was translated and reproduced in successive issues of *Des femmes en mouvement* in early 1980. From there, it was picked up by other European feminist magazines such as *Emma* and *Spare Rib*. Produced by an editorial collective, the *Almanac* echoed many concerns of feminists in other parts of the world, particularly the problems and double burdens of working mothers in a society whose values are still masculine; indeed a major problem for Soviet women was said to be sheer 'masculinization'. A

second edition was never published: one of the founders of the collective, Natalya Malachovskaya, was reportedly forced to leave her country in July 1980. At a press conference given at the Copenhagen Conference, however, she affirmed her plans to edit the journal abroad in Russian, and to create a new feminist publishing house for Soviet authors (Jones, 1980).

Such feminist publishing houses are a new though rapidly increasing phenomenon, particularly in Europe and North America. Publishers such as Éditions des Femmes in France, Virago in the United Kingdom, The Feminist Press in the United States, Ediciones de Feminismo in Spain, Das Mulheres in Portugal, Sara in the Netherlands, Frauenoffensive in the Federal Republic of Germany, all have an impressive number of feminist titles to their credit. Their publication of creative writing, academic works, school and college textbooks, all prepared from a feminist perspective, intends to break down the almost monolithic male-generated structure of knowledge and ideas which is common in all societies.

A sizeable body of feminist film-makers (and videotape-makers) has also grown up in the last decade. Sometimes working independently, sometimes in groups or co-operatives, almost always on a shoestring budget, such women set out to make statements about those aspects of women's lives, image and place in society not touched by conventional media. Again, the problem of distribution is a nagging one. Showings at specialized cinema clubs and workshops tend to reach only the already 'converted': the mass audience remains untouched. Yet to achieve wide, even semi-commercial, distribution the film must fulfil certain basic audience expectations, of length, structure and so on. Independently produced films which see even limited commercial success—such as the well-known *Take It like a Man, Ma'am* produced by the Danish group Røde Søster, or the Belgian *Les Rendez-vous d'Anna* by Chantal Ackerman—do tend to conform to such expectations, while still challenging accepted viewpoints.

But there are countless feminist films—many lasting no more than a few minutes—which will never be widely circulated, if only because the listing and cataloguing of such work is grossly inadequate. This problem was recognized at a Unesco-sponsored symposium on women and cinema held in 1975 and the establishment of an association, Film Women International, was proposed. The association, to be based in Stockholm, was intended to create an international research and information centre on women's films, establish an archive, assist in the publication of material on women in cinema, foster the production of films made by women, and find new ways to develop the distribution of women's films. As yet, however, the proposal has not been put into effect. Film-makers do sometimes group together locally to catalogue and distribute their (and others') films. One of the most organized groups is the Sydney Film-makers Co-operative, which has been together since 1971. In 1979 they published a major annotated catalogue of women's films independently produced in Australia, as well as some North American and European titles. In the United Kingdom, Cinema of Women (COW) provide a

briefer annotated listing. They distribute films which they consider to be particularly suitable as starting-points for discussion to schools, women's groups, community centres, trade unions and youth clubs as well as to independent cinemas.

The major problem for independent film-makers, however, remains that of funding. Some national cultural organizations, such as the British Film Institute or the National Film Board of Canada, do provide grants for independent production. However, rarely do women receive special consideration. One exception is in Australia, where a Women's Film Fund was set up in 1976. The fund is administered by the Australian Film Commission and was established with a grant of $100,000. Grants and investments generally range from $2,000 to $5,000, but the fund's survival is largely dependent on returns from its investments, so any major project must show a strong possibility of some commercial success if it is to receive substantial support. However, up to 1980 the investment had been made in twenty-seven projects, including an award-winning film about a young woman with multiple sclerosis and documentaries on child care, sexism in education, women in non-traditional work, hysterectomy and menopause. The fund also provides grants for small projects such as script development or training; it invested in the preparation of the catalogue produced by the Sydney Film-makers Co-operative.

Alternative radio provides women with a further outlet. Probably the best-known feminist radio station is—or was—Radio Donna, in Italy. This was a daily two-hour opt-out from Radio Città Futura, a private left-wing station in a working-class district in Rome. Each morning, various groups of women took the air on subjects such as contraception and wife-battering. On 9 January 1979 five women from the Housewives Collective were in the studio, making a broadcast about abortion, when the station was attacked by members of a Fascist group. They set fire to the studio and seriously injured the women. Big demonstrations were held to support the women and condemn the violence, but Radio Donna is now defunct, although radical feminists have subsequently started a new station called Radio Lillith. Other European groups, such as Les Kleteuses in Belgium, have organized similar programmes.

Numerous alternatives have been tried in the United States, particularly among community radio stations. But the first 'women's' station was a commercial venture, WOMN/1220 in Connecticut, launched by a man. A 'feminist' tone is not encouraged on the station, which attracts a great deal of advertising. On the other hand it does carry news stories about women which other stations might not and also screens advertisements. The Feminist Radio Network, formed in Washington in 1974, distributes radio and audio tapes to radio stations, schools and libraries. Their aim is to provide an alternative for women working in radio, as well as to inform and educate the public about women. In 1979 the FRN organized a conference attended by 150 women working in public service broadcasting, university radio and commercial stations from all over the United States. The conference expressed a strong commitment to information sharing and to the demystification of radio.

In the United Kingdom, the women's Radio Workshop was formed in 1979 with very similar aims to those of the American FRN (Karpf, 1980). The British group offers independently produced programmes to local radio stations and hopes to acquire regular broadcast time on these stations, so that rarely heard points of view can reach women who have not thought about feminist issues or the women's movement. However, each programme is also prepared on cassette, with an accompanying leaflet, since WRW also considers non-broadcast distribution essential. When people can listen in groups, with follow-up discussion and perhaps action, the relationship between programme-maker and audience-member changes, so that the listener is not simply a passive consumer of a transient product.

Media networking for women

One of the most important discoveries made by women during the past few years has been the value of 'networking'—establishing and maintaining contacts, sharing information, exchanging ideas, providing and receiving support. Women began to realize the necessity for large-scale organization and the strength of numbers and the power of information. Undoubtedly, an important event in advancing the notion of solidarity and the value of shared experience and information was the International Women's Year Conference and Tribune in Mexico City in 1975. For the first time in history thousands of women from around the world met in one place, realized that many problems were common to them all and saw that the momentum generated in Mexico City should be continued. As a direct result of International Women's Year, the International Women's Tribune Centre was set up in New York. An important part of the Tribune Centre's work has been to promote communication and the sharing of information among women—particularly those involved in development work—around the world. It acts as a resource centre and a liaison service and provides technical assistance and training. Through its newsletters, workshops and regional activities it promotes further the importance of information sharing through the creation of networks at regional, national and local levels.

Even before International Women's Year, the Women's International Information and Communication Service (ISIS) was in operation. Formed in 1974 after the first International Feminist Congress at Frankfurt, ISIS acts as an information and liaison centre for women activists throughout the world. Since 1976, *ISIS International Bulletin* has been published quarterly. Each bulletin has a single theme—for example, women and the daily press, women and work, women and health—and reproduces theoretical and practical information and documentation from women's groups and the women's movement around the world. It includes resource listings, reports and notices to help pass on information and to help on the exchange of ideas, contacts, experiences and resources among women and feminist groups. In addition, ISIS aims to provide a more balanced flow of information on women's issues and activities be-

tween the developing and the industrialized world and to present an alternative picture of the women's movement, in contrast to that provided by the regular mass media. By 1979 ISIS had over 5,000 contracts in 130 countries.

A further ISIS activity is the co-ordination of the International Feminist Network (IFN), a communication channel through which women can mobilize support for each other. National contacts in twenty-four countries disseminate information, organize action and obtain publicity for women who need help in cases such as sterilization abuse, kidnapping, rape, struggles for rights, self-defence against rape or battering. For example, one case taken up in 1978/9 was that of a Portuguese woman journalist, accused of 'moral offences' and of 'encouraging crime' because she was responsible for a 1976 television programme which dealt with abortion. A steady build-up of national and international pressure led to her acquittal in June 1979.

Journals such as *Women's International Network News (WIN News)* and *Media Report to Women*, both based in the United States, also play an important role internationally. Founded in 1975, *WIN News* appears quarterly and covers significant news about women from all major areas of the world. Its information has become a unique resource for those concerned with women's development. *Media Report to Women*, a monthly which began in 1974, is specifically concerned with media issues; although broadly oriented towards North American groups and concerns, it is an invaluable source of information on international media-related activities.

At the regional level, organizations like the Women and Development Unit (WAND), established in 1978 to help implement the regional plan of action for women in the Caribbean, are founded on the notion of information networking and the principle of liaison. WAND publishes a quarterly newsletter called *Womanspeak* and a series of occasional features *Concerning Women and Development*. It serves as a clearing-house/resource centre on issues concerning women in development in the English-speaking Caribbean. The Asian and Pacific Centre for Women in Development (merged in the Asia Pacific Development Centre from 1980) and the African Training and Research Centre for Women have similar functions to those of WAND. In Europe the bimonthly bulletin *Women of Europe* acts as an information resource on and for women in the nine countries in the European Economic Community. Established in 1978 at Brussels, the bulletin collects news and features from national correspondents and brings them together in a country-by-country round-up of facts, activities, studies, meetings and so on, publishing with each item an address to which readers can write for further information.

Information sharing is of course most common at the national level, and many of the existing organizations and networks have already been described. One additional, and unusual, case which may be mentioned is the French organization Agence Femmes Information. Founded in 1978 by a group of journalists, later joined by other women, AFI offers a telephone information service on all questions which concern or preoccupy women. It also serves as a documentation centre, building up files on a

wide variety of topics: these can be consulted centrally, or photocopies can be provided at low charges. Research on specific subjects can also be carried out, on request. Finally, AFI functions as a small national press agency channelling information concerning women to and from media, groups and individuals. It also compiles dossiers on particular themes, containing unedited documents, detailed analyses and critical commentaries. The triple role of AFI, then, is to search out information useful to women, to report it and to promote its reflection in public opinion.

Chapter 4

Mainstream media and alternative distribution channels: case-study of a women's communication network

'Mainstream' and 'alternative' approaches to media are by no means mutually exclusive. Indeed, the most comprehensive attempt so far to develop an information network on women's issues is founded on a balance between the two. The network, known as the Women's Features Services, attempts to integrate the concept of alternative information with the dominant structures of mainstream information management. The history and development of the Features Services illustrate many recurring problems in the establishment of women's action programmes and their relationship to the overall media fabric.

Genesis and establishment of the Women's Features Services

Immediately after the 1975 World Conference, a Media Workshop for Journalists and Broadcasters was organized by Unesco in co-operation with the United Nations Centre for Economic and Social Information (CESI, now DESI). The purpose of the workshop was to examine ways in which the media could help implement the World Plan of Action. One of its major problems was to devise a realistic framework within which the laudable but at times somewhat idealistic recommendations concerning the mass media could be set. For the concepts of access, participation and self-determination underlying the plan are almost the antithesis of the centralized systems of control characteristic of mass media throughout the world.

The Media Workshop concentrated its discussion on strengthening co-operation and exchange between women in and through the communication system. A number of ideas, which were later to come to fruition in the establishment of the Women's Features Services, emerged from this debate. For example, there was considerable interest in the development of network facilities to further the exchange of information (news, features, etc.) of particular concern to women. It was suggested that media professionals should seek closer contact with women leaders, professionals and action groups so that media material became more

relevant to actual situations. It was also felt that the media could provide information on development goals and services so that women could derive the greatest possible benefit in terms of their own perceived needs. In particular, one recommendation called for the United Nations and its Specialized Agencies to 'collect data and undertake studies of existing information networks and systems, which might co-operate in promoting a regular service of news, information and background on women's issues'.

The genesis of the Features Services, then, was based on a perception of the importance of communication and information in promoting the development goals of the United Nations Decade for Women. There was an understanding, perhaps more implicit than explicit, of the pattern of interrelationships connecting the communication process and the development process—through an information system embodying the concepts of access, participation and self-determination. The problem now was to identify 'existing information networks and systems' which actually did espouse those concepts, especially in relation to the integration of women in development. For various reasons this did not prove completely straightforward.

In 1976, when the original project document on the Features Services was prepared by Unesco for submission to the prospective funding agency, the United Nations Fund for Population Activity (UNFPA), international discussion of North-South news and information flows had barely begun. However, the progress of the project from conceptualization to implementation was soon to echo some of the problems raised in that wider debate on communication and development; ultimately the project was to find its direction firmly within the framework of the New International Information Order (NIIO), and in the spirit of the Technical Co-operation and Developing Centre (TCDC).

It was not until the beginning of 1978 that a consultant was appointed to carry out the necessary exploratory work in preparation for the project. But it soon became clear that the major established international press agencies, located in North America and Europe, were not really interested or prepared to co-operate in the project in a way which would have helped to get it off the ground. With their own established networks of correspondents (mainly male), a primarily Western orientation in coverage, and an emphasis on 'spot' news rather than feature or background information, there was no real perception of a need for the kind of material called for by the project. (In fact, a study carried out by the research office of the news agency, Inter Press Service, has found that between only 1 per cent and 1.5 per cent of news carried by transnational news agencies is related to women's issues.) The fundamental incompatibility of the project's underlying concepts of access, participation and self-determination with the interests vested in established media structures were clear.

From the outset it had been recognized that the success of the Features Services would largely depend on the co-operation of regional and alternative media associations and networks. Their role now became central and crucial. In fact, all of the distribution agencies eventually contracted

to the project—Inter Press Service (IPS) in Latin America and subsequently Africa, Christian Action for Development in the Caribbean (CADEC) working with the Caribbean News Agency (CANA), and the Press Foundation of Asia (PFA)—had been established to provide alternatives to the information distributed by transnational agencies. IPS and PFA in particular had fostered a new kind of information which put the emphasis on analysis, commentary and synthesis. This was important, since in the discussions on the need for an NIIO it had soon been recognized that the basic problem was not just one of a quantitative imbalance in the North-South and South-South flows of information: perhaps more important was the quality of the information itself. A further realization was that the vertical communication structures which resulted in information being produced and distributed by a limited number of countries in the world were actually reproduced *within* developing countries so that certain needs and interests—primarily male, urban, élite—were given priority. An alternative information order would have to encourage broader participation in the communication process so that the needs of other groups—for example, female, rural, poor—were reflected in the information system. Again, this argument found a response in the agencies contracted to the project: notions of access and participation formed part, at least, of their guiding philosophies. Finally, all of the distribution agencies which were contracted had already established outlets within traditional (and alternative) media markets.

This fusion of traditional media markets and alternative media distribution structures gave the women who were eventually to become features correspondents a means to communicate in their own way, from their own perspective, on questions which they saw as important. This promised a substantive shift in the structure of information in society. For by providing access to the communication process to this new group of 'actors', as IPS would put it, the Features Services could fulfil at least three functions. In the first place, by bringing attention to the specific difficulties faced by women—for example, in the work place, the family, the educational, economic, legal and political systems, in matters of health, nutrition and fertility—the feature articles could work towards increased public awareness and an improvement in women's immediate conditions. Secondly, by publicizing women's experiences, by suggesting possible solutions to particular problems, by stressing women's positive contributions, they could begin to provide women themselves with the knowledge and the confidence to confront and question their own possibilities in life and their own capabilities and rights to participate in the process of social and economic development. Thirdly, by interpreting and reporting events from a new and distinct woman's perspective, the features could promote understanding of the impact on and implications *for women* (and thus a better understanding of the *total social* implications than would emerge from male interpretations alone) of developments in economic, legal, political, medical, technological and other spheres. This is the kernel of the idea behind the Features Services, and the fundamental element in the relationship between the project and concepts such as the NIIO and TCDC: that the 'women's viewpoint'

has the potential to bring about a different kind of evaluation of, and a different ordering of priorities in, the process of development.

Ideas into practice

So much for the principles. How, in practice, do the Features Services work? The first point to be made is that although all four of the existing regional services are based on the principle of a network of correspondents who channel articles to a central regional co-ordinator for editing and distribution, each is constituted and operated along somewhat different lines according to available local resources, priorities and possibilities.

The Latin American service, Oficina Informative de la Mujer (OIM), was the first to be set up, in May 1978. By May 1980 400 features had been received and edited by the co-ordinator—based in Rome, at IPS headquarters—and distributed by IPS to all subscribers to its normal service. From the very start of the service, however, the correspondents themselves played an active part in finding other outlets for the material than those provided by IPS subscribers. This individual approach to distribution, which would be inadmissible within any of the 'established' news agencies, was actually encouraged by IPS and undoubtedly contributed to the very high pick-up of the features by media in the region. It is not unusual, for instance, for individual articles to be published by three or four different newspapers and indeed one particular feature appeared as many as seven times. In the early stages of the service, articles were published in only four countries in the region, but by 1980 they appeared regularly in thirteen, while the total number of correspondents had grown to forty-nine. In countries with many correspondents (in Mexico, for example, there are eighteen) a national co-ordinator provides a focal point for contact and liaison.

If OIM has a major problem, it is one associated with growth and development. Each of the services is contracted by Unesco to produce a certain number of features per year. In the case of OIM the number is 190, and 40 of these are to be written by the regional co-ordinator herself. Correspondents are paid by the piece. Clearly, however, as the number of contributing correspondents and countries has increased, it has become necessary to restrict the total number of features produced by any individual. A strict balance would allow for only three articles annually per correspondent, and seven per country in the region. However, as the regional co-ordinator pointed out at a consultation held in Paris in April 1980 to review and assess the development of the Features Services, restrictions of this kind are artificial and indeed endanger the natural growth of the network and its output. This problem raises some basic questions about the organization and future development of the Features Services as a whole: they will be returned to later.

The Caribbean Women's Features Syndicate (CWFS), Depthnews Asian Women's Features Service (DNWFS) and the Africa Women's Features Service (AWFS) are at different stages of development: AWFS in particular was, in 1980, in the process of initial establishment, a regional

co-ordinator having been appointed only in March of that year. However, the service is contracted to produce 100 features annually. DNWFS, which was set up in July 1979, also produces 100 articles a year, and by 1980 features had been written by correspondents in eleven Asian countries and had been published in papers and journals subscribing to PFA's regular Depthnews Feature Services, in twelve different countries in the region. As in the case of the OIM-IPS relationship, DNWFS benefits from the existing facilities of PFA—particularly in terms of its Depthnews distribution—and here also there has been some flexibility in the arrangements between the two. A Depthnews agreement with the Asian Features Association, based in Delhi, has meant that DNWFS material gets extensive distribution in India's state capitals; the Thai and Indonesian language editions of Depthnews have brought the women's features to non-English-speaking readers; Depthnews Radio has carried some of the features to radio audiences in the region; negotiations with Depthnews subscribers have enabled separate distribution of DNWFS material to certain non-subscribing magazines; existing Depthnews correspondents and stringers have produced many of the women's feature articles. Nevertheless, at the Paris Consultation the regional co-ordinator reported difficulty in building up an independent network of women correspondents who were both committed to the goals of DNWFS and prepared to write regularly for it. In part, this is a problem relating to the planning time-scales for the original establishment of the service and to its relative youth. However, it is a problem shared by the Caribbean service, which was still constantly searching for the right kind of correspondents and the right kind of articles almost two years after its inception.

CWFS started operations in July 1978 and is contracted to produce fifty-two features annually. Its organizational base is quite different from that of the other three services, all of which are most closely associated with their distributing agencies. In the case of CWFS, although the articles are distributed by the regional news agency (CANA), the operational base of the service was originally within the communication wing of Christian Action for Development in the Caribbean (CADEC). It recently transferred to the Women and Development Unit (WAND) at the University of the West Indies. From the beginning, an advisory group with representatives from CADEC, CANA, WAND and the Caribbean Women's Association (CARIWA) has met from time to time to assist the co-ordinator with particular problems, to advise on priorities and developments and so on. Again, there has been considerable flexibility in terms of distribution of the material which has gone to CANA subscribers, to CADEC's publication *Caribbean Contact* and its *Radio Contact* programme. It has also been mailed directly to radio stations, women's groups and others by the co-ordinator herself.

Apart from the problem of developing a strong network of correspondents, which has continued to prove difficult, one constraint which CWFS has faced since its establishment is that—relatively speaking—the Caribbean public is not a reading public. This made reliance on the print medium particularly problematic for CWFS (it does, of course, apply in one way or another to all of the women's features services)

and led to attempts, even in the earliest days of the service, to use other media. The printed features were mailed to local radio stations, some of which adapted the material for their own use, mainly in women's programmes; a small number of specially prepared tapes were made for *Radio Contact*, and distributed to fifteen radio stations in the region. Interpersonal communication was also exploited, and features were mailed to women's groups with the intention that they should be used as discussion starters and catalysts for action. The success of these early efforts was limited, but the lessons learnt from them convinced the co-ordinator of the need for some reorientation of CWFS in the direction of a multi-media approach, rather than reliance on any single medium, with an emphasis on personal contact and follow-up action.

Learning by experience

So far little has been said about the content of the features themselves. A glance at just a few titles will give some idea of the range of topics treated by the correspondents. Among the OIM features are 'Premature Birth: A Dramatic Problem for Working-class Mothers'; 'Women and Human Rights'; 'Some Causes of Female Illiteracy'; 'Women, Rural Technology and Migration'; 'Women and Self-management'; 'Illegal Abortion and Its Risks'. From the CWFS come 'Credit Service for Low-income Women'; 'Evoking a New Spirit among Caribbean Women'; 'Problems of Nutrition in Maternal and Child Health'; 'What Choice Do Girls Have?'. DNWFS titles include 'Setting Up a Women's Group? Indonesian Book Shows You How'; 'Rural Women Find It Much Tougher to Improve Far-from-ideal Status'; 'Shoddy Coverage of Women's Roles and Interests by Asian Press Assailed'; 'Breast-feeding: Original, Safe Convenience Food for Babies'; 'Working Ma's Dilemma: Who's to Keep House, Tend Children?'. The selection of titles is random and does scant justice to the eclecticism of the full output, but it should give some hint of the general orientation of the material and indicate the nature of the difference between it and the kind of copy normally carried by the mass media under the rubric of women's interests.

As far as substance is concerned, all of the co-ordinators at the Paris Consultation were critical—perhaps unduly so—of the output of the service in their own region. There was general agreement that the ideal feature should contain a balance between abstract analysis and concrete cases, probably moving from the description of a particular problem to an analysis of its general underlying causes and its relationship to the wider situation; it was also suggested that the features should, where possible, indicate some lines of action which could be taken to help solve the problem. However, the co-ordinators felt that the majority of articles fell short of this ideal, remaining at the level of problem exposition and often lacking analytical cogency, leaving the reader with a rather negative feel. But it would be wrong, at this stage in the development of the Features Services, to concentrate unduly on the shortcomings of the material, which was admittedly uneven in quality. As one of the

co-ordinators at the consultation pointed out, this was a new venture for women and they needed to be *encouraged* to write. Moreover, provided that criticism was offered in a constructive spirit, women would learn and develop. This was clearly illustrated by a particular case in the Caribbean, where early in 1979 one of the correspondents produced a feature on women in calypso. During a workshop organized by CWFS almost a year later, this was just one of a number of articles dissected and subjected to detailed constructive criticism. As a result the same correspondent wrote a new feature on the same topic, but this time taking account of the comments and suggestions made at the workshop. The outcome was one of the most successful articles yet produced by CWFS, analysing not just the images of women found in the calypso, but relating these images to accepted social practices and values, and finally suggesting how Caribbean women themselves could use the calypso as a medium of protest. The feature was widely published in the Caribbean itself and also has found its way into the British feminist media.

A different kind of learning and exchange is exemplified by a case from OIM. A correspondent in Ecuador wrote a feature about Manuelita Saenz, the lover of Simón Bolívar. She had played an important part in the independence movement of several Latin American countries but her role had never been acknowledged in official historical accounts, which described her simply as *'la mujer del liberador'*. On the other hand, Bolívar the *liberador* was accorded a prestigious place in the history of Ecuador, Colombia, Peru, Venezuela and Bolivia. After reading the original article from Ecuador, the regional co-ordinator asked correspondents in each of the other countries to evaluate the role of Manuelita Saenz from their particular national perspective. The result was more than a series of articles which built up a comprehensive regional picture of the contribution of a single woman: it was also a first-hand and dramatic realization of the extent to which woman's actual work and achievements in society have been historically ignored or denied. This learning experience is as important for the correspondents themselves as for the readers of the articles which they produce.

A third and fundamental type of learning promoted by the features material is in the area of what has been called 'information literacy'. This relates back to the argument made, in the context of the search for an NIIO, that a new *kind* of information is needed if that information is to work in the interests of a group wider than the élite and if it is to foster a development based on self-determination. A common criticism of the established information order is that it presents 'pictures of the world' in incoherent fragments or in predigested explanations which can only be passively filed away. Consequently it is argued that in this sense information functions in an oppressive way, since by the very manner of its presentation it precludes the holistic perspective necessary to an understanding of the interrelationships between events and their causes. Without such an understanding, it is impossible for people to see where action—and ultimately change—is within their control.

The features material works against this situation in at least three

ways. In the first place, by setting particular events or problems in their historical and/or contemporary context, by striving for an analytical approach and by searching for commonality and root causes rather than adopting the conflict-orientation of much media output, the Features Services provide the background material which encourages understanding of issues and which should promote action and change. Secondly, by setting out to reflect the needs and interests of the mass of women in society (by requesting correspondents to seek out actively the views and demands of ordinary women, or by involving women's groups in the generation and dissemination of the features content), the features pursue a user-orientation which attempts to strike chords among the audience and promote solidarity between individuals and groups. Thirdly, by producing articles which analyse and comment on the output of the established communication system itself the Features Services encourage the development of a critical awareness in their public. To take one example among many which could be cited, one of the most widely published OIM features in 1978/9 was entitled 'Women's Magazines are Women's Enemies'. The article related the content of women's magazines to dominant structures of national and transnational control of the media, and highlighted the way in which such magazines manipulate both the women who help produce them and those who read them. The arguments of the feature were pitched at various levels of sophistication; but at the very least a reader of the article when next opening a women's magazine would be led to ask whose interests were being served through the advertisements, fashion spreads, agony columns and horoscopes which filled its pages.

Finally it should be pointed out that the regional and interregional basis on which the Features Services are organized encourages a further kind of learning by experience through the exchange of material within and between regions. The regional networks through which the features are distributed mean that it has become commonplace to find articles about Indian women in Manila's *Daily Express*, about Trinidadian women in the *Advocate News* of Barbados, or about Peruvian women in *El Correo* of Bogotá. Cross-regional exchanges have been less common: for example, features about Malaysian women in the *Jamaica Daily News*. But the interregional exchange procedures have been strengthened and the number of cross-regional publications should gradually increase. This kind of exchange is crucial in breaking down the isolation experienced by women as a group and in highlighting common interests, problems and prospects which unite them across national and even regional boundaries.

Problems and prospects

The establishment of the regional Features Services was almost complete by 1980, although setbacks delayed the plans for a service in the Arab states. The project, which had been a sketchy idea, born of the World Conference for International Women's Year in 1975, was very much a

reality by the time of the Mid-decade Conference. Nevertheless, some major problems which arose as the services developed—within the rough categories of correspondents, audiences, organization and funding, and structure—point to several basic difficulties which must be confronted and resolved in the general area of media and development for women.

Although many excellent women have contributed regularly to the Features Services, a constant problem has been identification of the right kind of correspondent. Professionalism does not, in the experience of the Features Services, necessarily accord with the ability to produce articles which are sensitive to the issues and problems concerning women: indeed at times there may be a conflict involved for professionally ambitious journalists. This problem is linked to the need for training of a special kind in the context of media for women in development. For the most part, such training should be less focused on training skills (although these are naturally important) and should be more concerned with what could be called orientation: the encouragement in journalists of a deeper sensitivity towards and awareness of women in development issues. This is largely uncharted ground in development journalism training, but it is crucial if women are to learn to analyse and interpret the world from their own distinct perspective rather than from that taught to them by men. Two elements are basic to the development of this orientation: one is the need for consciousness-raising sessions which encourage women journalists to think and talk about their state and status as women; the second is the need for more information among journalists about what is going on in their region and elsewhere in the way of women and development projects. They need to travel, to discuss, to exchange ideas, to learn what has been successful and what has failed. Moreover, correspondents need to come together from time to time, at least within their own regions, in order to break down feelings of isolation and to promote a sense of cohesion and identity with a larger network.

In relation to the audience for the features material, much remains to be done. Needs assessment and evaluation on a national as well as a regional basis has yet to be carried out in any systematic way by any of the services. Yet these are recognized as important in ensuring an output which matches the interests and concerns of women in the audience. It is also clear that the potential audience is severely restricted by the use of print as the primary medium of communication, and the need to reach new audiences through other media has high priority. In Asia and Africa particularly, the adaptation of material into vernacular languages is crucial, and the use of alternative print media and radio is being fully explored. Furthermore, it is not just enough to distribute the material, it is equally important to try to ensure that something happens as a result. In this respect the role of women's groups and non-governmental organizations is seen to be of the utmost potential value. The experience of the Features Services indicates that it is important that such groups be given some specific advice on how the features might be used, if they are to be truly drawn into the arena of action and follow-up. Finally, a completely new audience, which has not yet been approached,

exists in the industrialized countries. There are two basic reasons for trying to extend the outreach of the features material to these countries. The first is based on the tenets of development education, which argue that if the principles of the NIIO are to become practice, issues of concern to the South must be recognized as problems for the North.

The second reason relates to the question of the organization and funding of the services. Markets which almost certainly exist in the North—along with those which have already been or could be tapped in the South—are essential to the development of a more secure financial footing for the services in the longer term—which provide a 'set' contractual amount but supply the material to media free of charge. Existing financial arrangements actually endanger the development of services which prove unexpectedly successful. On the other hand a subscription service—at least in those regions where a market has clearly been created—would help to match production more squarely to demand. The creation of markets in the industrialized countries, through the initial distribution of the features material on a trial basis, could eventually provide a parallel source of revenue for the Features Services as a whole. Such an entry into commercial markets in the North, however, has implications for the structure of the overall features network, since a consortium rather than piecemeal approach in this direction might be more likely to yield results. But whatever steps are taken in the development of self-financing arrangements, at least for the foreseeable future the services will need additional financial support at some level.

Finally, there is the question of structure. During the Paris Consultation, attention was repeatedly drawn to the problems caused by the fragmentation and isolation of much of the effort in the field of women and communication. This problem was recognized in the very establishment of the Features Services project, which was intended to correct some of the imbalances in the flow of information and to encourage a new ordering of priorities in society. However, the point was made at the consultation that if the Features Services remained at the level of an association of women who wrote for the media it would not live up to its potential as a base for the development of a network of information exchange for women themselves.

This suggested the development of a structure or network of a permanent kind which would serve as a meeting point for all women involved in communication. It might include, as associates, other kinds of women's groups or organizations not directly involved in the communication process as such, but which would want to share information with other women. However, the basic operational body of the new network would be quite small, and its running costs would be low. IPS would be ready to support such a body in the sense of providing it with telecommunications facilities, if the OIM/AWFS arms of IPS were to become part of this new entity. Initially, the organizations might be little more than a conglomerate of the existing Features Services, each retaining its separate identity and each continuing to work through its existing facilitating and distribution agencies, although with the additional support of key women working in the communication and information field. Event-

ually, it might evolve into something more organic, with shared correspondents who would cover world events.

The idea was exciting, though clearly embryonic, and awaited a good deal of further elaboration and discussion. It reflected, however, the beginnings of a sense of cohesion in a sphere normally characterized by fragmentation. If the Features Services contributed in some way to that spirit of solidarity, if they helped inspire in women a sense of the *possibility* of change in the information and communication order, they had gone a considerable way towards launching women into a world where their voices have previously gone largely unheard, and where the concerns of others have long had priority.

Part IV

What remains to be done?

Fundamental change, of course, is not the result of paperwork but part of a historical process, of what is developing or foreshadowed in people's minds. . . . Privileged groups have seldom changed their attitudes wholly voluntarily. Arguments do play a role; words can be weapons. Nevertheless, a higher degree of intercommunication does not necessarily lead to better understanding.

Independent Commission on International Development Issues, *North-South: A Programme for Survival* [The Brandt Report], 1980: 11, 23.

Part IV

What remains to be done?

Chapter 1

Setting the agenda: some lessons in politics

The events leading up to the World Conference of the United Nations Decade for Women, held in Copenhagen in July 1980, suggested that the issue of communication would feature reasonably prominently in the conference discussions. The World Plan of Action adopted at the World Conference of International Women's Year in 1975 had recognized the significance of the communication process and of the mass communication media in a series of specific action proposals. Subsequently an extensive series of international and regional meetings had examined the question of women and the mass media and had developed yet other recommendations and proposals. The regional meetings held in 1979 in Asia and the Pacific, Latin America and the Caribbean, Africa, and western Asia in preparation for the Copenhagen Conference had all stressed the importance of the mass media. In March 1980 the United Nations Economic and Social Council's Commission on the Status of Women had recommended that the report on mass media prepared by its Special Rapporteur should be submitted as a background document to the conference. This recommendation had been adopted by the Preparatory Committee for the World Conference at its April session. At the same time the committee had requested the Conference Secretariat to prepare an official conference document on the topic of information and communication as development resources for women. In May, just two months before the conference, an international seminar on women and the media had been held at the United Nations Headquarters in New York. This had been described as a sectoral meeting for the World Conference and the report and recommendations of the seminar were also submitted as a conference background document. Yet in the event there was little or no discussion on communication at the Intergovernmental Conference in Copenhagen.

This was in part a consequence of the structure of the conference agenda, which was intended to concentrate on the three 'sub-themes' of the decade—employment, health and education. Only a handful of paragraphs in the Draft Programme of Action concerned proposals for communication at either the national or the international level. But

the proposals themselves were weak. In the debate, Committee Two (which dealt with proposals at the international level) covered the seven paragraphs dealing with communication in less than twenty minutes. At a conference where it was not unusual to spend an entire day debating two paragraphs—without reaching agreement—this was less an indication of consensus than of lack of substance in the proposals.

But there was another, more fundamental problem. By 1980 the entire communication issue had become highly controversial in international debate. The much-debated report of the International Commission for the Study of Communication Problems (the MacBride Report), which had appeared in early 1980, and the Unesco Intergovernmental Conference on Communication Development held in April had already focused a great deal of international attention on sensitive questions such as freedom of the press, the protection of journalists, the limits to communication policies and planning, and the new international information and communication order. All of these questions, and perhaps the last in particular (because of its clearly stated relationship with that other highly disputed notion, the new international economic order), had already caused rifts and the hardening of positions which amounted to virtual political *impasse* between North and South. By the time of the Copenhagen Conference communication had become an extremely contentious issue. At least two attempts to strengthen the wording and orientation of the proposals concerning communication in the Draft Programme of Action ran aground because of governmental reluctance to become embroiled with the question.

Perhaps, too, in a year in which communication had already been subject to much international discussion, the issue was a little 'tired' by this point. It was certainly not on the delegations' agenda for debate, although other topics were, and these were not the sub-themes of employment, health and education. The Conference President Lise Ostergaard was speaking on behalf of many women at Copenhagen when she said, 'I get the strong feeling that the Conference is being politicised' (Hall, 1980a). She was referring to the focus on apartheid and the Middle East, arguing that these questions had been debated at the expense of a broader focus on the oppression of women everywhere. For if there was relatively little discussion of the 'issues' of employment, health, education, environment, family and culture, there was also little real effort to address and understand the root causes of women's oppression. This particular problem is important to further consideration of the question of women and communication—what progress has been made, what remains to be done—since it is illustrative of some basic dilemmas which remain to be resolved by women, concerning, for example, the nature of problem definition, the relevance of existing political and organizational structures and the basis of social change. What Copenhagen revealed clearly was that, despite all the preparatory meetings and the detailed documentation, the agenda was being revised and re-set by men—not so much in an obvious sense (for instance, only 20 of the 145 governmental delegations were actually headed by men), but in the sense that decisions had been made well in advance about which issues could be dwelt on to obtain

political mileage at the conference, irrespective of their relevance to the specific problems of women.

In defence of what was happening, some women at Copenhagen argued that women must take their place in the political world, that political issues were women's issues. But, in the now accepted manner of international debate, the discussion was not so much about issues as about positions. Had women come to Copenhagen to play men's political games, or to question what relevance well-worn political dogma had to them and their situation? Had they come to imitate, or to improvise—or perhaps even create? The problem was not that the conference became politicized, but that in its politicization it lacked a specific women's perspective. The prepared speeches and interventions of many of the women delegates reflected the same ordering of priorities as those of their male counterparts in other fora. It must be said: there was little creativity at the Copenhagen Conference.

Some of these problems can be illustrated with reference to the debates which took place in the conference's Committee of the Whole, set up to consider the Introduction, Historical Perspective and Conceptual Framework of the Draft Programme of Action (paragraphs 1 to 37). The contentious nature of a number of the issues dealt with in these early paragraphs was manifested by the large number of amendments before the committee. Seventeen separate sets of amendments were put forward, many of these sets proposing changes to multiple paragraphs: one set, for instance, proposed amendments to twenty-six separate paragraphs. But the political thrust and the North-South tension in the amendments was clear. The Group of 77 wanted to stress the importance of the new international economic order; the United States wanted to remove all existing references to the new international order and to subdue references to the effects of transnational corporations. These opposing positions occupied the committee for two full weeks. After four public sessions, at least fourteen private meetings and countless informal consultations, two paragraphs on which there was no agreement whatever had to be put to the vote in the final plenary session.

Where was the 'women's perspective' in the Committee of the Whole? In the plethora of amendments condemning colonialism, imperialism, racism, Zionism and every other '-ism', where were the women's voices? The attempt of the Australian delegation to introduce the concept of sexism as a cause of underdevelopment and women's inequality was, after very lengthy debate, relegated to a footnote. Delegates could not accept that it was 'on the same level' as the other '-isms'. Another attempt, by the New Zealand delegation, to introduce a paragraph dealing with the discrimination suffered by women because of their being the reproductive force, encountered similar difficulties. The problem, the delegate submitted, was not just one of inequalities in the world economic system: there was a specific 'subjection, exploitation, oppression and domination of women by men' which was not 'sufficiently explained in history'. Objections to the paragraph were again based on the belief that political or economic domination could not be conceived of or understood in the same terms as the relationship between men and women.

The Indian delegate said that as a national of a country which had been subject to colonization he was in a position to understand that experience; he could not accept this as equal or parallel to the colonization of women by men. The lack of logic in his position—on the one hand, claiming the knowledge of first-hand experience; on the other, discounting the experience of those in the 'parallel' situation—escaped him, at least at that time.

The nature of the debate on the Australian and New Zealand amendments, which can be only touched on here, is important in that it indicates something of the extent to which the roots of the problem supposedly addressed by the conference are still insufficiently understood. The continued reluctance in the committees to grasp the *specific* issues at the heart of women's oppression was striking. The insistence on world economic and political structures and patterns as causal or explanatory factors in the inequalities suffered by women was more than a strategy related to the internal and external politics of the conference. It was also an indication of the lack of detailed study of the subject on the part of the majority of those present. This was as true of many of the women delegates as it was of the men. It was notable, for example, that one delegate described the Australian and New Zealand amendments as containing the only new ideas on women to be introduced at the conference. This may have been true for the conference itself, but these ideas had long been familiar to any reader of a mildly feminist publication; they would be dealt with in the first week of any introductory women's studies course.

A comment must be made, however, on the nature of some of the interventions of male delegates in the Committee of the Whole. There was an apparent lack of awareness among particular representatives of the extent to which the tone of their remarks vividly illustrated the very phenomena or concepts which they sought to deny. The Russian delegate's comment on 'the *charming* delegate . . . whose instability' (because she had apparently changed her mind on previously agreed wording) 'is also charming; because instability is a charming characteristic in women', or the remark that 'sexism' was clearly 'dear to the hearts' of some representatives, must be seen and examined as the most serious of matters. Finally, it was also notable that at the only public meeting of the Committee of the Whole to deal with substantive matters, half of the speakers were men—a proportion well in excess of the overall proportion of male delegates at the conference.

On several occasions the conference stressed a point made in its documentation (WCUNDW, 1980*h*): that the impetus to research given by the 1975 conference had vastly improved the knowledge base on the objective existence of women's subordination. This is true, but only at a certain level. A great deal of straightforward research has been carried out, charting the quantifiable disparities. But the fundamental questions have hardly been asked, much less answered. How was it possible, for instance, for the Copenhagen delegates to be so unaware, apparently, of basic work in the field which has already been done? Would the same be true of a conference on economic issues, on techno-

logical questions, on agrarian reform problems? How was it possible that certain delegates could take an outright patronizing or dismissive stance towards women's specific concerns? How was it possible that others, apparently 'on the side of women', could yet be drawn into the hierarchical gamesmanship of the committee room while the time slipped by and the basic problems became obscured in ambiguously worded consensus statements?

In truth, the basis, structure and transmission of attitudes in this area has barely begun to be explored. The relationships between cultural values, communication processes, language and concept formation, political and economic ideologies, all in regard to male-female domination, are virtually unknown. Yet they need to be examined and understood if real change is to be effected. Much of what has so far been proposed in relation to strategies for change—for example, in the Draft Programme of Action itself—is based on a reading of symptoms, rather than on an analysis of fundamental causes. Increase employment opportunities, upgrade health, improve access to education? Yes, but only to add some new rungs to the existing ladder? After Copenhagen, women must find themselves searching for new definitions of the problem, going beyond the 'band-aid mentality', as Elizabeth Reid of the Conference Secretariat described it (Rowley, 1980), suggesting that effective strategies would have to 'undermine the culture that creates the subordinate position of women'. For one thing the conference did show clearly: new constituents in old hierarchies do not promise real equality or genuine participation.

Chapter 2

Redefinition and revitalization of the issue

At a seminar on 'Women's Issues in Television' held in London in May 1979, the organizer, Helen Baehr, admitted that since the previous seminar on the same topic two years earlier she had had less trouble finding television programmes made by women about women to show as examples of work in the area. However, a new difficulty had surfaced. Feminist concerns—once difficult to get on the screen—were now in danger of being defused by the television companies, who treated them as a token series of single issues devised to pacify women working in the media as well as women in the audience. As one producer pointed out, the most depressing thing she had heard recently was an executive from her company describing programmes on women as 'a new growth industry' (Valentine, 1979). In the United States a television writer, interviewed as part of an analysis of programmes planned for network transmission in 1978, commented that this was 'supposed to be a time for women's projects on TV', and that what the networks wanted were girls who were 'good looking, well-endowed and running towards the camera' (Farley and Knoedelseder, 1978).

An editorial in the Italian feminist magazine *Effe* (May/June 1980) explained the publication's new, economical format. In its eighth year now, *Effe* had had to cut costs because of a falling off in subscriptions. Noting a certain crisis in the politics of the women's movement, the editorial set *Effe*'s particular problems in the context of that general crisis of confusion which had apparently overtaken women. *Effe*'s dilemma was the need to maintain its rationale as an autonomous cultural 'space' for women who, at the same time, did not wish to and could not deny their relationship to that wider cultural space predominantly defined as 'male'. After ten years of struggle, many women had fallen back on the old institutions and structures, frustrated by their powerlessness in 'marginal' groups. Their problem now was to maintain the sense and reality of their specificity within such structures. *Effe*, created and existing outside them, also had to come to terms now with a new relationship to these institutions.

An article in the British *Observer* in August 1980 began by asking:

'Can it be the backlash starting to bite, or is there some kind of collective nervous breakdown going on among the unstable and disparate sisterhood of women journalists? (Lowry, 1980). She reported that a feeling of exhaustion was overtaking even the hardiest of feminist journalists in the United Kingdom after 'ten years of being angry in the face of ridicule and determined in the face of grim resistance'. One of the journalists, Anna Coote, in an article in the *New Statesman*, had announced that she felt the need to start a 'Refresher Course for Clapped-out Feminists' to avert a decline in the women's movement such as that which occurred during the 1920s. This loss of heart was paralleled by a decline in general media interest in serious women's concerns and an resurgence of jibes and anti-woman jokes. Feminist optimism—and anger— seemed to have languished at the same time as and 'along with the media mileage; the bad jokes were just the other side of a good story which editors (usually male) had gone along with while it was pulling readers. Articles about breasts and menstruation were, at first, adventurous and instructive —and, in some papers, another way to get sex into the paper. Now such items are greeted by yawns and moans' (Lowry, 1980).

Finally, in the same *Observer* article, the media were charged with having eagerly pounced on the self-admitted problems of women struggling for equal rights, to suggest that the whole thing should be taken more slowly. As the *Daily Express* put it: 'This quest for equality —has it been too much too soon?' The author of the *Observer* piece, Suzanne Lowry, used an example from the American cartoon series *Superfriends* to make her point. *Superfriends* is a series in which Batman, Robin and Wonderwoman (all characters from other American comic strips) unite to fight the forces of evil.

In this episode the forces were represented by a monstress bent on world domination by women. To this end she had 'dematerialised' brigades of Mid-West housewives and reconstructed them as obedient, blank-eyed robots, ready for the kill. Needless to relate, the Superfriends foiled her scheme, with the final blow allowed to Wonderwoman. The robots returned to twittering normal, and the world was saved. Bat- (or was it Super-?) man then delivered a neat homily to remind us that 'only gradually, and step by step, can social change be achieved'.

The media are inevitably fashion- and trend-conscious. But to what extent do they follow the social trend or deliberately exploit and co-opt it for their own purposes? Is it inevitable that a journalist, after reporting on women's issues—mainly employment—for years, must say, 'I'm sick of handbag journalism'? (quoted in Lowry, 1980). Her reason was that she had become 'type-cast' as a women's writer, and could not obtain recognition for her expertise on other subjects—'everything from medicine to trade to the problems of the developing world'. But are these not 'women's subjects' too? What makes Margaret Drabble, one of the United Kingdom's most respected women novelists, write a book (*The Middle Ground*, published in 1980) whose central character, a top media woman, confesses on page 2 that she is 'bloody sick of bloody women... I wish I'd never invented them'?

Of course, as Butler and Paisley point out in their review of research and action in the field of women and the mass media in the United States (1980), we are well into the age of the FW2 ('first woman to . . . '). One American writer, pronouncing the death of the women's movement in the United States (Geng, 1976), commented that she had a portfolio of FW2 clippings from the *New York Times* which were 'boring because they falsify the reader's experience'. By glossing over the continuing struggle of women and by minimizing the distance from FW2 to HW2 ('hundredth woman to . . . '), such articles create an illusion of progress. But how can real progress be achieved and enduring change be brought about? Butler and Paisley believe that it is the functioning of organizations and bureaucracies which usually needs to be worked on, which up to a point makes sense: women working within male-dominated structures will make little impact. They quote a report in the magazine *Advertising Age* of interviews conducted with five female advertising copywriters. Each described problems in influencing advertising campaigns, in working with men who believed that 'sexism sells', and in having no other role models. Ideas for non-stereotyped portrayals of women were ignored; campaigns showing equality in relationships were changed so that the woman became sexy but passive and the man became adventurous; reactions were gathered from male, never female, creative supervisors. The conclusion of the report was that it was difficult for women to change sexist advertising if they were not in decision-making positions. And Butler and Paisley themselves see this as the key: 'most of us believe that media sexism will wane as women occupy key management and production positions' (Butler and Paisley, 1980).

However, such an analysis, although admirable in its optimism, ignores some fundamental problems in history which continue today and which allied to some contemporary questions make women's struggle for equality or equity a more complex task than the simple quest for a share in media management. It ignores the big business interests in media ownership and the relative lack of control over output at the managerial level, whether this be peopled by women or men. It ignores the transnational structure of communication and the massive agenda-setting power of a small number of major conglomerates in terms of information provided, values promoted and range of alternatives available. It ignores the problem of maintaining specificity within male-defined and dominated institutional structures. It ignores women's weakness in the face of the continuing burden of their reproductive role. Perhaps most important it accepts the given (male) world as it is: it accepts a certain view of the structure of communication, of hierarchical organization, of power and control. Women's task, in this definition, is to take their rightful place in this world. Small wonder that women are exhausted in the struggle to pursue a masculine destiny in a world where men make the rules, when at the same time they are thrown back on a feminine destiny in the home and actually live a different personal, professional and political experience from that lived by men. If women are struggling to keep the issue alive, it is perhaps because they—and society in general—have wrongly diagnosed the problem

Redefinition and revitalization of the issue

to begin with. Adoption of the 'male' model of development has led to an emphasis on the improvement of working conditions and opportunities, at the expense of conditions in the home. Acceptance of the 'male' model of communication directs women to the duplication of the vertical structures which typify the modern communication media. In the fashion of any oppressed group, women have sought to usurp the power of their oppressors without considering fully its implications, either for themselves as individuals or for women as a group.

But new definitions and alternatives are already emerging. At the United Nations/Unesco seminar on women and the mass media in May 1980, for example, women from developing countries pushed the point that power should not be seen in terms of a struggle between women and men, since most men—as well as most women—are oppressed, in the sense that in most societies power is monopolized by a very small group which usually includes a small group of women. Liberation thus becomes a quest in which society as a whole is involved and in which the needs and capacities of both women and men are recognized. Similarly, in most societies, communication and information are the monopoly of a small élite of whom some, again, are women. Democratization of media structures will not be achieved by admitting more women into the hierarchy. Such views introduce some new priorities into the women and communication debate in that they lay stress on the notions of access and participation, while emphasizing the need to recognize and build on women's particular capacities and experiences rather than forcing them into male perceptions and definitions of communication skills and contents. The orientation also poses some problems. For instance, by placing the initial stress on participation, rather than on women, it runs the risk of being seen to imply that there is no specific set of problems which attach to the condition of being a woman. This is not an interpretation which the proponents of the approach would support. Nor is it one which could be upheld on the basis of available international statistical data: as the Brandt Report made clear, 'As long as women have unequal access to education, technology and other assets affecting their productivity, the "unequal exchange" which many commentators see as characteristic of North-South relations will in a not wholly dissimilar way obtain between men and women But women cannot do much to improve their lot while authority and information remain in the hands of men.'

The approach does not at all deny women's particular oppression; it simply seeks to set it in a specific political context. As such, it is a truly feminist approach, although paradoxically it is often not recognized as such: for example, one United States reporter at the United Nations/Unesco seminar reacted to the debate with the remark, 'There must be *some* feminists in the Third World' (Lone, 1980). Reflecting on the seminar later, one of the African participants was to speak of the gap between the 'extremist feminism' of the Western women and the 'militant feminism of development' (Aw, 1980). And there *was* a gap, at times leading to confrontation, between women from the South and those from the North in their perception of the media problem. In part, this reflected

real differences in the objective situations in different parts of the world. Could the lack of women in decision-making positions in the media stimulate much discussion among women from countries where only a tiny number of women even dream of entering the media to work? Could the notion of legal suits to prove sex discrimination fire the imaginations of women in whose countries such legal procedures are quite impossible? But more fundamentally, the gap reflected basic differences of intellectual approach in which the tension was between the expressed need to reform existing structures and contents and the belief that the limits to reform now being clear, an alternative and more radical approach was called for, based on another model of communication and of development.

The impetus to reject the unquestioned assumptions in the 'male' model is already evident to some degree in changing social policies. The Scandinavian countries, Sweden in particular, have been attempting to redefine the family role. This is reflected in the equality project of the Swedish Broadcasting Corporation, where it is recognized that there is a need for a change in the *general* labour conditions (not just those of women) and that the male sex role must also be redefined if the female role is to change. It is acknowledged, too, that the experiences of both men and women are important in their potential contribution to every situation. But others are becoming aware of the inadequacies of the approach to equality in which women must be more efficient, more competitive, more aggressive than men in order to prove their worth. At the non-governmental forum at Copenhagen Betty Friedan, author of the influential *Feminine Mystique*, founder of the National Organization of Women and doyenne of the United States equal rights movement, led a workshop in which she suggested that some of the basic assumptions of the movement needed to be re-examined, particularly those relating to nurturing and family roles. Certainly one of the most chilling testimonies to the failure of the male model has come from the Russian women who produced the journal *Almanac: For Women and About Women*. Here the problems faced by women who are expected to internalize a man's world-view in every aspect of life while still carrying complete responsibility for child care and household management are said to have resulted in a profound alienation in many women (Malakhovskaya, 1980). In an interview given at the non-governmental forum at Copenhagen, one of the women involved stated that in her country women were not actually allowed to develop as women. The attempt to create a unisex model had led to a society peopled by hermaphrodites (*Spare Rib*, 1980).

The current drive to re-examine previously accepted frameworks and the search for new models may represent a new stage in the emergence of women's own consciousness. To take an analogy from the field of development, the Brandt Report reminds us that 'a refusal to accept alien models unquestioningly is in fact a second phase of decolonisation'. Just as many developing countries have come to reject the growth models of highly industrialized countries, so many women have begun to question the adequacy of the dominant male model of life. And just as the growth in awareness among many developing countries of their specific cultural

identities has helped them to adopt and adapt elements of particular models to their best advantage, so may the development of women's self-knowledge have helped them to do the same. However, in the final analysis, just as the developing countries exist in a world in which dominance and economic control is in the hands of the industrialized nations, so women exist in a world in which control rests with men. How can any subordinate group insist on the acceptance of its model of development?

Writing over twenty years ago, Herbert Kelman described three basic processes involved in attitude change (Kelman, 1958). The first he called 'compliance'. This is relatively easy to achieve and does not represent anything lasting. It is basically the kind of response which media organizations have tended to make to legislative measures or pressure groups. The second change process Kelman called 'identification'. This is more durable and is illustrated perhaps by what happens when a feminist, or a person who understands and identifies with women's concerns, takes up the cause within the media organization. However, this process is also at risk since it depends on the presence of transitory individuals. The third process is 'internalization', when the need for change is fully understood and integrated into organizational policy and practice. The Brandt Report itself is an attempt to work for fundamental change through this third process, by demonstrating on the basis of an empirical-rational approach that the self-interests of individual nations can and must merge with common interests. The Brandt Report has not, at least initially, been enthusiastically received by those to whom it was intended to appeal. Women can expect no less resistance—and they have barely begun to prepare their case.

Chapter 3

Developing new structures

If communication was barely discussed at the Intergovernmental Conference at Copenhagen, at the non-governmental forum there was prolonged and heated debate on communication issues, in terms of existing shortcomings and future potential of communication and information systems. In particular, enthusiastic support was given to the idea of an international women's information or press service, which might build on—or grow out of—existing information networks such as the Unesco/UNFPA Women's Features Services. The proposal was explored at a series of six meetings attended by almost a hundred journalists, non-governmental organizations and members of United Nations agencies. The amount of interest in the notion reflected in part a concern with what became almost a sub-title for the forum—networking. There were feminist networks, development networks, women's studies networks. The whole idea of organized exchange came to be seen as crucially important in breaking down women's experience of isolation and in creating a source of solidarity and strength. Information networking was seen as part of this development. But it was seen as something more, in the sense that information is such a basic locus of power and yet something to which women as a group have so little access.

A curious characteristic of much media output is its almost paradoxical capacity simultaneously to standardize and to isolate. The presentation of fragmented, unrelated issues and the almost total absence of appeal to group or community solutions are well-known aspects of media content. Even a 'progressive' programme like the Canadian *Femme d'aujourd'hui* follows this tendency: only about a quarter of the problems which it dealt with over a twelve-year period were treated in group or collective terms (Legaré, 1979); the remainder appeared as isolated, individual cases. Yet the privatizing trends of media communication are set within a field of discourse which constantly suggests a framework as broad as the world itself—witness the titles of magazines such as *Woman's Realm* (United Kingdom) or *Cosmopolitan* (United States). It is perhaps in relation to their role in advertising and the cult of consumerism that this reference to the 'world' framework is most obvious in the

media. Discussing the growth of consumerism in the United States in the 1920s as the development of a 'world view', or a 'philosophy of life', Stuart Ewen makes clear the *political* dimension of advertising. 'Only in the instance of an individual ad was consumption a question of *what to buy*. In the broader context of a burgeoning commercial culture, the foremost political imperative was *what to dream*' (Ewen, 1976).

How is such a paradox contained within the media? In the first place, by adopting an approach in which 'the product becomes a way of fighting against isolation and the unknown' (Mattelart, 1978), media advertising in fact reinforces the sense of *actual* isolation which people experience. Moreover, as Dorothy Hobson has pointed out in relation to the important role played by radio in the lives of housewives, programmes 'not only provide a contact with the "outside" world; they also reinforce the privatised isolation by reaffirming the consensual position—there are thousands of other women in the same situation, a sort of "collective isolation" ' (Hobson, 1978). In their study of United States advertising, Gunnar Andren and his colleagues have discussed its characteristic 'perspective displacement', both in terms of the reality of the lives of individuals ('Life is leisure time. Work is an unimportant detail') and of the relationship of individuals to one another ('It is you—you alone or you and your family—who should enjoy life, have a good time, live comfortably. How others fare is none of your business') (Andren et al., 1978).

The public inertia or complacency engendered by this development of individualistic values within a reassuring collective context is pushed even further by the extent to which the media have been noted to actually incorporate or even colonize those oppositional forces or resistances which do arise. How is it possible to register dissent when 'as we are confronted with the mass culture, we are offered the idiom of our own criticism as well as its negation' (Ewen, 1976). The fundamental importance of these points becomes clear in terms of any consideration of change or development. For instance, Eugenie Aw in her study of Senegalese women found that 'there is no connection between what women see as the feudal, unfavourable picture of themselves presented by the audio-visual media, and the response that image evokes'. As she points out, 'their resentment does not prompt them to draw conclusions about a new appoach to the audio-visual media' (Aw, 1979).

It was in recognition of this kind of problem, endemic to most established media structures and systems, that the idea of a women's international press service found a response at the Copenhagen Forum. What was called for was a new kind of structure, developed for and by women, in which their concerns could be squarely addressed and their voices clearly heard. What was needed, too, was a new kind of communication in which all women had the right and the opportunity to participate, and not just those who were part of the élite or even the meritocracy: this system would have to be predicated on the commitment to seek out and reflect the experiences, problems, words, ideas of the poor, the

illiterate, the rural, the working, the invisible woman. It would have to rely on a sense of professionalism which was altogether different from that typified by the conventional media man or woman. It would have to get away from the idea that there are people who are uniquely qualified to define 'knowledge' and 'information', and who are uniquely privileged to impose those definitions, that knowledge, that information on the mass of the population. It would have to provide a type of information which responded to people's experienced reality, so that the receiver became a creative critic, rather than remaining a passive absorber in the process of communication.

Idealistic? Unrealistic? Certainly difficult to sustain within the limits of the political realities of certain countries; and clearly impossible even to begin in others. For example, at the United Nations/Unesco seminar on women and the media, where the question of challenging existing media structures and creating alternatives was discussed, the case of the socialization of the press in Peru was cited by way of illustration of the difficulties. As part of a programme of social reforms, the press was expropriated in 1974 and each newspaper assigned to a particular social sector, for example, the farmers, the workers and so on. This did not mean that the farmers or the workers were actually writing the articles, but that they were involved in the management and direction of the papers. Consequently, their demands, complaints and points of view were publicly heard for the first time. However, this rapidly became a clear threat to the system of power which had granted access to the public, and within a year the experiment was stopped. (However, the government also fell shortly afterwards).

Idealistic it may seem, and yet it is not so different, in terms of the principles which it invokes, from the organization and philosophy of at least one existing sub-system within an establishment media service. The Women's Broadcasting Co-operative within the Australian Broadcasting Commission is founded on the belief that all women within the organization have the right and the capacity to create, to communicate; that all have the same right to be considered important; that all have the right to an equitable distribution of resources. With six years of life behind it, the co-operative has proved the viability of a non-competitive, thus challenging, structure within a system whose overall approach to management and production is altogether different. This seems to be one of the most important initiatives taken by media women in developing a structure to meet their own needs and priorities. But it has not been achieved without cost. Inevitably within such a structure certain women have had to give up the prestige and authority which would have been theirs had they pursued their careers along the traditional lines. When there is a redistribution of salaries, certain women suffer a real financial loss. It is not always easy to eschew the hierarchy in which you are well set for success in order to improve the overall position of others who would not get beyond the first rung of the ladder. It is, in the end, an act of political commitment.

And if the ideas behind the formation of an international women's press service are unrealistic, yet some of them have already been put into

practice. The Women's Features Services form the skeleton. At Copenhagen itself Interpress Service, through which two of the Features Services operate and which has offered its telecommunications facilities for a women's venture on the international scale (IPS, 1980), provided those facilities so that a team of women journalists could cover the conference and the forum. Five features each day were filed to IPS headquarters in Rome and thence to distribution outlets around the world. This represented an opportunity to provide regular and solid coverage of the event, coverage which was assured of international circulation. And yet at the same time some of the very problems that had been discussed in the abstract when women met to consider the prospects for an international information service of their own were brought into the open as *real* problems and not just abstract conundrums. For in the first days at Copenhagen, the women were taken to task by the IPS editorial desk in Rome for being too opinionated, using too many adjectives, not respecting the canons of good journalism. In reply the women maintained that they did not adhere to the male definition of 'objective' journalism; that they were in the process of 'no less than a redefinition of journalism . . . in which opinion, passion and reason are all inseparable elements in reporting and analysis'. Yes, came the reply, but 'it is a question of carrying news and information which other media will print' (Hall, 1980*b*).

That, of course, is the crucial point for women who fear that an international press which aims to place its material in the —male-dominated— mass circulation press (among other outlets) would have to make too many compromises in terms of form, style and content to be able to retain its specificity as a distinctive women's service. It would thus lack the power to carry out its mandate to challenge and to undercut the established information structure. It is a real problem and a source of endless debate among feminists. Is it more effective to work for change at the margins, or can real change be brought about by trying to hit the centre even with an arrow which has to be somewhat blunted? The dilemma is the reverse side of that other perennial question which asks whether women should set up separate institutions and media or integrate themselves within those which already exist. The arguments on either side of both questions are by now well known and need not be rehearsed again.

What is clear is that women need and want structures which more directly address their concerns and within which they can operate more effectively than is now possible. The logic of what has been argued earlier points to eventual structures within which there will be integration, but suggests that in order to achieve them women must take themselves and their own situation as the starting-point in their analysis of possibilities. Whether that development takes place within existing institutions (as in the case of the ABC Women's Broadcasting Co-operative) or outside them (as in the establishment of independent feminist media), or whether it is something which tries to straddle the division (such as the Women's Features Services or the proposed international women's press service), is probably less important than that it arises from a careful assessment of needs and priorities, a realistic appraisal of organizational, economic and

political possibilities, and a clear and continuous consciousness of the conditions which originally demanded to be changed.

This discussion has not been concerned to list again those many possibilities which exist for improving what is there already. Examples of these have been illustrated in the preceding pages, and the various measures are quite exhaustively listed in the reports and proceedings of many meetings which have already been held on the subject of women and the media (see Appendix 3 for details of these). It is assumed that these various possibilities will continue to be followed up and that some victories will continue to be won. It is assumed also that the victories will continue to be relatively small unless action is related to a more developed analysis of causes and a more comprehensive strategy for change. As the Brandt Report reminds us, 'privileged groups have seldom changed their attitudes wholly voluntarily. . . . A higher degree of intercommunication does not necessarily lead to better understanding'.

The promise of communication structures and information services created by and designed to serve women along the lines discussed above is that they would allow and encourage the emergence of specific regional, national and group needs, priorities and differences. This seems all-important since at times these differences do seem to separate women in various world regions more clearly than they separate them from other men. Sometimes the differences are imaginary, or are no more than a question of semantics. At Copenhagen, for instance, responses to the words 'sexism' and 'feminism' reflected misunderstandings rather than really basic differences. At the non-governmental forum, at least, some of these misunderstandings began to be resolved through dialogue. For example, a quote carried in the daily newspaper *Forum 80*—'To talk feminism to a woman who has no water, no food and no home is to talk nonsense'—led feminists to prepare a leaflet in which they responded:

For too long the patriarchal media have presented an image of feminism as a luxury that is peripheral to women's lives, especially to the lives of Third World women. . . . We must counter that image and assert that feminism is a political perspective on all issues of concern to human life. It does and must address itself to issues of water, food, and home as well as to the issues of sexual inequality and violence against women, to economic exploitation and racism and to all institutions and attitudes in both industrialized and developing countries that create and perpetrate domination and inequality. . . . To separate feminism and politics is to limit the meaning and potential of feminism to offer new approaches to development and social change (Feminist Theory and Activism Committee, 1980).

Subsequently a workshop was organized on the topic of feminism, and this broke down into small groups which tried to understand what feminism did actually mean to women in different parts of the world.

However, there remain very real differences. There is no relation between the resources, facilities and range of alternatives in the field of communication media in the North and those existing in the South. The experience of cultural domination resulting from the transnational structure of communication, although it exists in the North, is of little

significance compared with its acute effect in the South. It is an experience which clouds all international discussion, not least that among women. At the United Nations/Unesco seminar on women and the media held in May 1980 the North-South division was clear, although each group made concessions in a spirit of mutual respect. Yet there remained an undercurrent and a feeling that a different world of problems was being discussed in each case. More seriously, there was a continual tension caused by the belief—openly stated on several occasions—that the women from the developing countries were having interpretations and inappropriate solutions imposed on them.

The anthropologist Eleanor Leacock has suggested that a basic obstacle to our true understanding of the role and situation of women in their various cultures has been the tendency to impose concepts from Western sex-role patterns on other societies (Leacock, 1978). As she points out, this is partly because many questions about women have just not been asked in the history of research. The activities, social relationships and attitudes of women have seldom been as extensively investigated as those of men in any society at any time. It is also because many of those questions about women which *have* been asked have been asked from a male perspective, often of male informants. If this 'basic obstacle' to understanding is to be removed, it is time that the voices of women themselves be heard. If this is to happen, new and developing communication structures must be built on a realization of the existing absences and partial representations of women in mass media practices and products. They must admit women as autonomous and central characters in the process of communication. But if that is to be possible, women must themselves imagine and create the structures.

Appendices

Sources of reference

This section brings together documentary and individual sources from around the world which should be helpful to anyone interested or working in the field of women and communication, whether as researcher, practitioner or activist. Information on various types of resource is provided. There is a regional listing of feminist publications, including magazines, newsletters and journals; relevant directories and guidebooks are also cited. Reports and proceedings of meetings, seminars and workshops on women and communication held since 1975 are fully referenced. A short list of catalogues of audiovisual material is included, as are the complete addresses of some of the most important groups and organizations involved with women and media questions. Finally, to assist in specific media analyses or monitoring activities, a format is suggested: the analysis sheet which is reprinted here can be used as it stands or adapted as necessary.

Both well-known and more fugitive sources are included, in the hope that the collection will be of use to both beginners and experienced students of women and the media. Although the intention is to provide a global inventory of resources, there are inevitable gaps. The sources listed, although based on a global review, and provided by a worldwide network of contacts, reflect the information available to a European-based author. The listings were made in September 1980. But the field is fast changing and it is to be expected that by the time of publication some details may already be out of date. Addresses may have changed, some publications may have ceased, other important ones may have become established. However, at the present time no similar inventory exists. This one is offered as a limited beginning, which others may update, build on and refine.

Appendix 1

Feminist publications

The listing of publications is divided into two parts. The first covers feminist magazines and newsletters; the second includes journals of a more scholarly nature. Clearly, the criteria for the inclusion of 'feminist' publications were extremely difficult to define. Broadly, such publications encourage women's freedom of choice; the concepts of participation, equality and self-determination are written into their basic philosophies. In some cases, however, particularly in parts of the world where a feminist press is just now emerging, a rather more loose definition has been used: a few publications have squeezed in on the grounds that they do regularly print a goodly number of feminist articles, although other aspects of their content may be at odds with these. As far as possible, only publications which have been in existence for at least a year have been included. Feminist magazines and newsletters appear and disappear constantly. It is not unusual for birth and death to be represented in a single issue. Although this does not necessarily reflect on the substantive significance of the short-lived publication, it has to be considered in compiling a listing intended to be useful over a period of time. Finally, the publications listed are all produced by independent non-governmental groups; no governmental or party-affiliated journals have been included.

Magazines and newsletters

International

AIJPF News
Association Internationale des Journalistes de la Presse Féminine et Familiale,
Boulevard Charlemagne 1-Bke 54,
1040 Brussels,
Belgium

International Women's Tribune Centre Newsletter
305 East 46th Street, 6th floor,
New York,
NY 10017,
United States of America

ISIS Bulletin
C.P. 301,
1227 Carouge,
Geneva,
Switzerland

WIN News
Women's International Network,
187 Grant Street,
Lexington,
MA 02173,
United States of America

Women's Organisation for Equality Newsletter
29 rue Blanche,
1060 Brussels,
Belgium

Africa

Update
African Training and Research Centre for Women,
PO Box 3001,
Economic Commission for Africa,
Addis Ababa,
Ethiopia

Obaa Sima (Ideal Woman)
PO Box 5737,
Accra North,
House No. F. 800/1 Cantonments Road,
Accra,
Ghana

Viva Magazine
PO Box 46319,
Nairobi,
Kenya

Famille et développement
BP 11007,
CD Annexe,
Dakar,
Senegal

Africa Woman
Kirkman House,
54A Tottenham Court Road,
London W1P 0BT,
United Kingdom

Asia and the Pacific

Refractory Girl
62 Regent Street,
Chippendale,
NSW 2007,
Australia

Sybil
PO Box 198,
Nedlands,
Western Australia 6009,
Australia

Womanspeak
PO Box 103,
Spit Junction 2085,
NSW,
Australia

Feminist Network Newsletter
Gayatri Singh,
c/o H.V. Shukla,
Bhavna Apartments, 1st floor,
No. 5/6 S.V. Road,
Viteparle (West),
Bombay 400 056,
India

Manushi
C1/202 Lajpat Nagar,
New Delhi 110024,
India

Rashtra Gaurar
c/o Ajeevika Press,
B.M. Das Road,
Patna,
Bihar,
India

Asian Women's Liberation Newsletter
c/o Goto Masako,
147 Kenju-Kosha,
112 Sakuragaska,
Hodogaya-ku,
Yokonami-shi,
Kanagaura-ken,
Japan

Feminist Forum
CPO Box 1780,
Tokyo,
Japan

Feminist Japan
Seien Building No. 502,
1-3-2 Kita-Aoyama,
Minato-ku,
Tokyo,
Japan

Broadsheet
PO Box 47201,
Auckland,
New Zealand

Voice of Women
16/1 Don Carolis Road,
Colombo 5,
Sri Lanka

Europe

AUF—Eine Frauenzeitschrift
Esslinggasse 17/11,
1010 Vienna,
Austria

Rotsrumpf 1
Rechte Wienzeile 81/21,
1050 Vienna,
Austria

Les Cahiers du grif
Groupe de Recherche et d'Information Féministes,
14, rue du Musée,
B-1000 Brussels,
Belgium

Women of Europe
Rue de la Loi 200,
B-1049 Brussels,
Belgium

Kvinder
Rodstromperne,

Feminist publications

Kvindehuset,
Gothersgada 37,
1123 Copenhagen-K,
Denmark

Choisir
102 rue Saint-Dominique,
75007 Paris,
France

Des femmes en mouvement
70 rue des Saints-Pères,
75007 Paris,
France

F magazine
26 rue de Poncelet,
75017 Paris,
France

Le mercure des femmes
12 rue du Quatre-Septembre,
75002 Paris,
France
(links French and francophone African groups)

Courage
Bleibtreustrasse 48,
1 Berlin 12,
Federal Republic of Germany

Emma
Kolpingplatz 1a,
5000 Koln 1,
Federal Republic of Germany

Der Feminist
Christrosenweg 5,
8000 Munich 70,
Federal Republic of Germany

Informationen für die Frau
Augustastrasse 42,
5300 Bonn 2,
Federal Republic of Germany

Donneoggi
Via Silvio Pellico 6,
Milan,
Italy

Effe
Piazza Campo Marzio 7,
Rome,
Italy

Noi Donne
Via Trinita dei Pellegrini 12,
00186 Rome,
Italy

Quotidiano Donna
Via del Governo Vecchio 5,
Rome,
Italy

Mulher d'Abril
Escaddinas de São Cristovao 13, 2°,
1100 Lisbon,
Portugal

Vindicación Feminista
Roger de Flor,
96, 2°, 2ª,
Barcelona 13
Spain

Hertha
Biblioteksgaten 12,
S-11146 Stockholm,
Sweden

Fraue-Zitig
Postfach 648,
8025 Zurich,
Switzerland

Fowaad
Newsletter of the Organisation of Women of Asian and African Descent,
10 Cambridge Terrace Mews,
London NW1,
United Kingdom

Media Action Bulletin
AFFIRM,
10 Cambridge Terrace Mews,
London NW1,
United Kingdom

Revolutionary and Radical Feminist Newsletter
17 Kensington Terrace,
Leeds 6,
United Kingdom

Spare Rib
27 Clerkenwell Close,
London EC1,
United Kingdom

Women's Report
14 Aberdeen Road,
Wealdstone,
Middlesex,
United Kingdom

Women's Research and Resources Newsletter
190 Upper Street,
London N1,
United Kingdom

Women's Voice
Box 82,
London E2,
United Kingdom

Latin America and the Caribbean

Womanspeak
Women and Development Unit,
University of the West Indies,
Extra-mural Department,
Cave Hill Campus,
Barbados

Boletín documental sobre las mujeres
Comunicación Intercambio y Desarrollo Humano en América Latina (CIDHAL),
Apartado 579,
Cuernavaca, Morales,
Mexico

Fem
Nueva Cultura Feminista, A.C.,
Av. Universidad No. 1855,
Desp. 401,
Mexico 20 D.F.,
Mexico

La Tribuna
Latin American Newsletter
of International Women's Tribune Centre,
305 East 46th Street, 6th floor,
New York,
NY 10017,
United States of America

North America

Broadside
PO Box 494,
Station P,
Toronto,
Ontario M5S 2T1,
Canada

Match Newsletter
323 Chapel Street,
Ottawa,
Ontario K1N 7Z2,
Canada

Status of Women News
40 St Clair Avenue East,
No. 306,
Toronto,
Ontario M4T 1M9,
Canada

Calliope
Feminist Radio Network,
PO Box 5537,
Washington,
DC 20016,
United States of America

Chrysalis
Women's Building,
Dept 4150,
1727 North Spring Street,
Los Angeles,
CA 90012,
United States of America

Heresies
Box 766,
Canal St Station,
New York,
NY 10013,
United States of America

Media Report to Women
3306 Ross Place NW,
Washington,
DC 20008,
United States of America

Ms Magazine
370 Lexington Avenue,
New York,
NY 10017,
United States of America

New Directions for Women
223 Old Hook Road,
Westwood,
NJ 07675,
United States of America

Newspage
Women Against Violence in Pornography and Media,
PO Box 14614,
San Francisco,
CA 94114,
United States of America

Off Our Backs
1724 20th St NW,
Washington,
DC 20009,
United States of America

Quest
Box 8843,
Washington,
DC 20003,
United States of America

Spinning Off
Newsletter of Women's Culture,
Dept 7,
1727 N. Spring St,
Los Angeles,
CA 90012,
United States of America

The Spokeswoman
5464 South Shore Drive,
Chicago,
IL 60615,
United States of America

Women: A Journal of Liberation
3028 Greenmount Avenue,
Baltimore,
MD 21218,
United States of America

Journals and research bulletins

Al-Raida
Institute for Women's
Studies in the Arab World,
PO Box 11-4080,

Beirut University College,
Beirut,
Lebanon

Atlantis
Acadia University,
Wolfville,
Nova Scotia,
Canada

*Bulletin: Women's Studies
in Communication*
ORWAC,
Dept of Speech Communication,
California State University,
5151 State University Drive,
Los Angeles,
CA 90032,
United States of America

*Canadian Women's Studies:
An Educational Forum*
651 Warden Avenue,
Scarborough,
Ontario MIL 326,
Canada

Feminist Review
14 Sumner Buildings,
Sumner Street,
London SE1,
United Kingdom

Feminist Studies
Women's Studies Program,
University of Maryland,
College Park,
MD 20742,
United States of America

Frontiers: A Journal of Women's Studies
Hillside Court 104,
University of Colorado,
Boulder,
CO 80309,
United States of America

Hecate
English Department,
University of Queensland,
St Lucia,
Brisbane 4067,
Queensland,
Australia

*International Journal
of Women's Studies*
Eden Press Women's Publications Inc.,
245 Victoria Avenue, Suite 12,
Montreal,
Quebec H32 2M6,
Canada

Newsletter
Research Unit on Women's Studies,
SNDT Women's University,
1 Nathibai Thackersey Road,
Bombay 400020,
India

Pénélope
Centre de Recherches Historiques,
54 Boulevard Raspail,
75006 Paris,
France

Questions féministes
Éditions Tierce,
1 rue des Fosses Saint-Jacques,
75005 Paris,
France

Resources for Feminist Research
Department of Sociology,
Ontario Institute
for Studies in Education,
252 Bloor Street West,
Toronto,
Ontario M5S IV6,
Canada

*Signs: Journal of Women
in Culture and Society*
307 Barnard Hall,
Barnard College,
New York,
NY 10027,
United States of America

Women's Studies International Quarterly
Institute of Education,
University of London,
20 Bedford Way,
London WC1H 0AL,
United Kingdom

Zena
Vlaska 70a/111,
Zagreb,
Yugoslavia

Appendix 2

Directories and guidebooks

The following are some particularly useful sources of information, guidance and advice, related in one way or another to the broad area of women and communication.

Asia Pacific Centre for Women and Development: Women's Resource Book, 1979. Produced by APCWD, Kuala Lumpur, and International Women's Tribune Centre, New York. (See Appendix 5 for addresses.)

Broadcast Media Kit. Prepared by NOW Media Task Force, 425 13th St NW, Suite 1001, Washington, DC 20004, United States of America.

Caribbean Resource Book on Women in Development, 1978. Produced by Women and Development Unit (WAND), Barbados, and International Women's Tribune Centre, New York. (See Appendix 5 for addresses.)

Index/Directory of Women's Media. Women's Institute for Freedom of the Press, 3306 Ross Place NW, Washington, DC 2008, United States of America.

Implementation Guide for Media. American Association of University Women, 2401 Virginia Avenue NW, Washington, DC 20037, United States of America. (Produced in 1973, but still useful.)

ISIS International Bulletin No. 16, 1980. The Feminist Press in Western Europe. Lists 129 publications in 18 countries. ISIS, C.P. 301, 1227 Carouge, Geneva, Switzerland.

Media: A Workshop Guide, 1977. National Commission on the Observance of International Women's Year, Department of State, Washington, DC 20520, United States of America. (Guide and resources for organization of a one-day workshop on women and media; prepared 1977.)

Women's Action Almanac. Women's Action Alliance Inc., 370 Lexington Avenue, New York, NY 10017, United States of America.

Bibliofem. City of London Polytechnic, Fawcett Library, Old Castle Street, London E17 NT, United Kingdom. (Comprehensive bibliographic resource on women.)

Appendix 3

Seminar proceedings and reports

This is a quick guide to seminars, workshops and meetings on women and the media, held since 1975, for which written reports are available. The meetings are listed chronologically, starting with the earliest.

1975, 13–15 June. *Workshop on Caribbean Women in Communication for Development*, held at Jamaica. Sponsored by Caribbean Church Women, Institute of Mass Communication, UWI, and Women's Bureau, Jamaica. Marlene Cuthbert (ed.). Barbados, Cedar Press, 1975.

1975, 3–4 July. *Media Workshop for Journalists and Broadcasters*, held Mexico City. Sponsored by Unesco and the United Nations Department of Economic and Social Information. Report: Paris, Unesco, 1975. (COM-75/WS/29.)

1975, 23–27 July. *International Symposium on Women in Cinema*, held in St Vincent, Valley of Aosta, Italy. Sponsored by Unesco and Italian National Commission for Unesco. Report in *Women in the Media*, Part II. Paris, Unesco.

1975, 8–12 September. Seminar on the *Role of Broadcasting* in *International Women's Year*, held in Bangkok. Sponsored by the Asian Broadcasting Union (ABU) and Unesco. Report: Kuala Lumpur, ABU.

1975. Seminar on *Women's Programmes on Radio and Television*, held in Tunis. Sponsored by the Arab States Broadcasting Union (ASBU) and Tunisian Television. Report in *ASBU Review*, January 1976.

1976, 23–25 January. Seminar on the *Role of the Mass Media in Changing Social Attitudes and Practices Towards Women*, held in New Delhi. Sponsored by the Indian Institute for Mass Communication Research. Report in *Vidura*, Vol. 13, No. 1, 1976.

1976, 29 January. Meeting of United Kingdom Organizations on the *Audio Visual Media and the International Women's Year*, held in London. Sponsored by the International Film and Television Council (IFTC) and Unesco. Report: London, IFTC, 1976.

1976, 27 March. Seminar on *How Women are Portrayed in Advertisements*, held in London. Sponsored by Women in Media (WIM). Report: *The Packaging of Women*. London, WIM, 1976.

1976, 6–9 April. Consultation on *Women and Media*, held in Hong Kong. Sponsored by the Centre for Communication Studies, Chinese University of Hong Kong with the World Association for Christian Communication (WACC) and the United Methodist Church. Proceedings: Timothy Yu and Leonard Chu (eds.), *Women and Media in Asia*. Hong Kong, Centre for Communication Studies, CUHK, 1977.

1976, September. Meeting on *Women in the Mass Media*, held in Leicester. Sponsored by the Centre for Mass Communication Research, University of Leicester with Unesco. Report: Paris, Unesco, 1976.

1977, 1–5 August. Inter-American seminar on *Mass Communication: Media and Its Influence on the Image of Women*, held in Santo Domingo. Sponsored by the

Inter-American Commission of Women (CIM) with Unesco and the Government of the Dominican Republic. Provisional report: Washington, D.C., CIM, 1977. (CIM/CD/doc. 39/77.)

1977, 18–21 November. *International Media Workshop*, held in Houston, Texas. Sponsored by the United States National Commission for Unesco. Report: Washington, D.C., United States National Commission for Unesco, 1978.

1978, 19–24 February. Consultation on *Women in the Media*, held in Beirut. Sponsored by the World Association for Christian Communication (WACC), the World YWCA and World Council of Churches. Report: London, WACC, 1978.

1978, 3–5 April. Seminar on *Women in Danish Broadcasting*, held in Copenhagen. Sponsored by Danmarks Radio. Report: *Danmarks Radio Kvindeseminar*. Copenhagen, Danmarks Radio, 1978.

1978, 24–30 September. *Study Visit of Women Journalists*, held at ATRCW, Addis Ababa. Sponsored by UNECA/Unicef/Unesco/Government of Belgium/Government of Ethiopia. Report: Addis Ababa, African Training and Research Centre for Women, 1979. (ECA/SDD/ATRCW/STJ/79.)

1978, 18–24 October. Congress on *Women and the Press*, held in Montreal. Sponsored by the Association Internationale des Journalistes de la Presse Féminine et Familiale. Report: *AIJPF Newsletter*, No. 16, December 1978.

1978, November. Meeting on *Women and the Mass Media*, held in Bogotá. Sponsored by the Centro de Estudios Sobre Desarrollo Económico (CEDE), Universidad de los Andes. Report: Elssy Bonilla de Ramos (ed.), *Memorias del encuentro sobre la mujer y los medias massivas de comunicación*. Bogotá, CEDE, 1979. (Documento 058.)

1979, 22–23 February. Seminar on *The Portrayal of Women in CBC Programs*, held in Ottawa. Sponsored by the Canadian Broadcasting Corporation. Transcript report: Ottawa, CBC, 1979.

1979, 11–14 December. Expert meeting on *The Impact of Cultural Industries in the Field of Audio-visual Media on the Socio-cultural Behaviour of Youth and Women*, held in Hanasaari. Sponsored by the Finnish National Commission for Unesco, and Unesco. Report: Paris, Unesco, 1980. (CC-80/WS/9.)

1980, 31 March–3 April. Consultation of *Regional Co-ordinators of the Features Services on Women and Population*, held in Paris. Sponsored by Unesco. Report: Paris, Unesco, 1980. (SS.80/WS.10.)

1980, 28 April–2 May. Seminar on *Women, Communications and Community Development*, held in San Juan. Sponsored by the United States National Commission for Unesco in co-operation with the National Commissions of Canada, Dominican Republic, Jamaica and Mexico, and hosted by the Department of State of Puerto Rico. Summary report: Washington, D.C., United States National Commission for Unesco, 1980.

1980, 20–23 May. International seminar on *Women and the Mass Media* held in New York. Sponsored by Conference Secretariat, World Conference of the United Nations Decade for Women, with Unesco and UNFPA. Report: New York, Secretariat WCUNDW, 1980. (A/CONF.94/BP/10.)

Appendix 4

Catalogues of women's media

Audio-visual materials made by and for women are scattered and difficult to locate. Listed here are some sources from which catalogues of material can be obtained.

Films and video tapes

Cinema of Women (COW Films)
156 Swaton Road,
London E3,
United Kingdom

Insight Exchange
Box 42584,
San Francisco,
CA 94101,
United States of America

Liberation Films
2 Chichelle Road,
London NW2,
United Kingdom

Moonforce Media
PO Box 2934,
Main City Station,
Washington,
DC 20013,
United States of America

Sydney Film-makers Co-operative Ltd,
PO Box 217,
Kings Cross,
NSW 2011,
Australia

Women and Film Group
Educational Advisory Service,
British Film Institute,
81 Dean Street,
London W1V 6AA,
United Kingdom

Women in Focus
6–45 Kingsway,
Vancouver,
B.C. V5T 3H7,
Canada

Women Make Movies Inc.
257 West 19th Street,
New York,
NY 10011,
United States of America

Radio and audiotapes

Feminist Radio Network
PO Box 5537,
Washington,
DC 20016,
United States of America

Women's Audio Exchange
Natalie Slohm Associations Inc.,
49 W. Main Street,
Cambridge,
NY 12816,
United States of America

Music on disc or tape

Women's Revolutions Per Minute
c/o Women's Arts Alliance,
10 Cambridge Terrace Mews,
London NW1,
United Kingdom

Appendix 5

Groups and organizations

The problem of selection has been particularly acute here. Given the enormous number of existing groups and organizations involved in action or research, or both, any attempt at a comprehensive listing is impossible. Some of the more important are included below; each resource can then be used to locate additional sources within a particular country or region. Two basic categories are used. Action and information groups comprise media women's groups and associations, women's pressure groups with a particular focus on media, women's information services and feminist media groups, as well as a few official departmental groups within media organizations.

Research and training organizations are just that. However, the selection has attempted to provide an international picture and to concentrate on institutions known to emphasize the relationship of women to culture and communication, if not specifically to the mass media. Consequently, no mention is made of the many university and college departments, particularly in Europe and North America, which carry out research in the general area of 'women's studies'. Information on these may be found in publications such as *Centers for Research on Women*, prepared in 1979 for the Project on the Status and Education of Women, Association of American Colleges, 1818 R Street NW, Washington, DC 20009, United States, and available from them; *Women's Studies in the United Kingdom*, edited by Oonagh Hartnett and published in 1975 by London Seminars, 71 Clifton Hill, London NW8 0JN, United Kingdom, is another source; Unesco (Division of Human Rights, Social Sciences Sector) has a project for the development of Women's Studies and can provide additional information, particularly on research in developing countries.

Action and information groups

ABC: Women's
Broadcasting Co-operative,
Australian Broadcasting Commission,
GPO Box 487,
Sydney,
NSW,
Australia

AFFIRM
(Alliance for Fair Images and Representation in the Media),
c/o Women's Arts Alliance,
10 Cambridge Terrace Mews,
London NW1,
United Kingdom

Agences Femmes Information,
104 Boulevard Saint-Germain,
75006 Paris,
France

Aktion Klartext (AKT),
Gleichstellung der Frauen in der Medien,
Am Ehrenkamp 15,

4800 Bielefeld 12,
Federal Republic of Germany

American Women in Radio
and Television Inc.,
1321 Connecticut Ave NW,
Washington,
DC 20016,
United States of America

Arbeitsgruppe Frauenmaul,
Wolfgang Hemel,
Schonbrunnerstrasse 188/23,
1120 Vienna,
Austria

ARD: Frauengruppe
(Helga Dierichs),
Hessischer Rundfunk,
6200 Wiesbaden,
Federal Republic of Germany

CBC: Office of Equal Opportunity,
Canadian Broadcasting Corporation,
Corporate Programme Services,
1500 Bronson Avenue,
PO Box 8478,
Ottawa,
Ontario K1G 3J5
Canada

CPB: Office of Women's Activities,
Corporation for Public Broadcasting,
1111 16th Street NW,
Washington,
DC 20036,
United States of America

Danmarks Radio: Kvindegruppen,
Danmarks Radio,
Rosenorns Allé,
DK-1970 Copenhagen 5,
Denmark

Feminist Network,
Gayatri Singh,
C/O H.V. Shukla,
Bhavna Apartments, 1st floor,
No. 5/6 S.V. Road,
Viteparle (West),
Bombay 40056,
India

Feminist Radio Network,
PO Box 5537,
Washington,
DC 20016,
United States of America

FUMAG (Arbeitsgemeinschaft
Frau und Medien),
Journalistengewerkschaft, OGB Haus,
Maria-Theresienstrasse 11,
1090 Vienna,
Austria

Groupe de Recherche
et d'Information Féministes,
14 rue du Musée,
B-1000 Brussels,
Belgium

Her Say: Women's News Service,
Zodiac News Service,
950 Howard Street,
San Francisco,
CA 94103,
United States of America

International Archives
of the Women's Movement,
PO Box 19315,
100 G.H. Amsterdam,
Netherlands

International Women's Tribune Centre,
305 East 46th Street, 6th floor,
New York,
NY 10017,
United States of America

International Women's Video Network,
HKW Video Workshop,
27-10-3 Chome,
Matsunoki,
Suginami-ku,
Tokyo,
Japan 166

ISIS: Women's International
Information and Communication Service,
C.P. 301,
1227 Carouge,
Geneva,
Switzerland

Kantha Handa,
16/1 Don Carolis Road,
Colombo 5,
Sri Lanka

Los Angeles Women's Coalition
for Better Broadcasting,
3514 Cody Road,
Sherman Oaks,
CA 91403
United States of America

Manushi Collective,
C1/202 Lajpat Nagar,
New Delhi 110024,
India

Media-Vrouwen,
Vrouwenhuis,
Nieuwe Herengracht 95,
Amsterdam,
Netherlands

Moonforce Media,
PO Box 2934,
Main City Station,
Washington,

DC 20013,
United States of America

National Association of Media Women,
157 West 126th Street,
New York,
NY 10027,
United States of America

New Zealand Radio Media Women
(Karen Barnsley),
Radio New Zealand,
Private Bag,
Wellington,
New Zealand

NOW: Media Task Force,
National Organization of Women,
National NOW Action Center,
425 13th St NW, Suite 1001,
Washington,
DC 20004,
United States of America

NUJ: Equality Working Party,
National Union of Journalists,
Acorn House,
314/320 Gray's Inn Road,
London WC1
United Kingdom

ORF: Frauen und Medien—Arbeitskreis
(FUMAK),
Osterreichischen Rundfunk,
Abteilung Kultur,
Argentinierstrasse 30a,
1040 Vienna,
Austria

Pertama
(Women's Journalist Association),
46M Jalan Chan Sow Lin,
Kuala Lumpur 07-04,
Malaysia

SBC: Equality Project,
Swedish Broadcasting Corporation,
S-105 10 Stockholm,
Sweden

Sydney Film-makers Co-operative Ltd.,
PO Box 217,
Kings Cross,
NSW 2011,
Australia

Unabhangiges Frauenkollektiv,
Laubenweg 2,
A-4210 Gallneukirchen,
Austria

Workgroep Vrouw, Taal en Media,
p/a Wijngaardenstraat 40,
Zoetermeer,
Netherlands

Wires (Women's Information Referral
and Enquiry Service),
32a Parliament Street,
York,
United Kingdom

Women against Violence
in Pornography and Media,
PO Box 14614,
San Francisco,
CA 94114,
United States of America

Women in Communications Inc.,
PO Box 9561,
Austin,
Texas 78766,
United States of America

Women in Media,
12 St John's Wood Road,
London NW1,
United Kingdom

Women Media Workers,
PO Box 193,
Kings Cross,
NSW,
Australia

Women's Action Alliance,
370 Lexington Avenue,
New York,
NY 10017,
United States of America

Women's Arts Alliance,
10 Cambridge Terrace Mews,
London NW1,
United Kingdom

Women's Broadcasting and Film Lobby,
28 Torbay Road,
London NW6,
United Kingdom

Women's Educational Equity
Communications Network,
1855 Folsom Street,
San Francisco,
CA 94103,
United States of America

The Women's Group,
5 Professors' Colony,
St Xavier's High School Road,
Navrangpura,
Ahmedabad 380009,
India

Women's Institute for Freedom
of the Press,
3306 Ross Place NW,
Washington,
DC 20008,
United States of America

Women's Research and Resource
Centre,

Ontario Institute for Studies
in Education,
252 Bloor St West,
Toronto,
Ontario M5S LV6,
Canada

Women's Research and Resources
Centre,
27 Clerkenwell Close,
London EC1,
United Kingdom

Women's Video Project,
The Women's Building,
1727 North Spring Street,
Los Angeles,
CA 90012,
United States of America

ZDF: Frauengruppe
(Elisabeth Seiffert),
Zweites Deutsches Fernsehen,
Postfach 4040,
6500 Mainz,
Federal Republic of Germany

Research and training organizations

African Training and Research
Centre for Women (ATRCW),
PO Box 3001,
Economic Commission for Africa,
Addis Ababa,
Ethiopia

Asia Pacific Centre for Women
in Development (APCWD),
c/o Asia Pacific Development Centre,
PO Box 2444,
Kuala Lumpur,
Malaysia

Canadian Research Institute
for the Advancement of Women,
151 Slater Street, Suite 415,
Ottawa,
Ontario KIP 5H3,
Canada

Center for the Study of Women and
Sex Roles,
CUNY Graduate School and University
Center,
33 West 42nd Street,
New York,
NY 10036,
United States of America

Centre National de la Recherche
Scientifique (CNRS),
Groupe d'Études des Rôles des Sexes,
de la Famille et du Développement
Humain,
82 rue Cardinet,
75017 Paris,
France

Centro Culturale Virginia Woolf,
Via del Governo Vecchio 39,
Rome,
Italy

Centro de Estudios Sobre la Mujer
en México,
Apartado Postal 61-192,
Mexico D.F.,
Mexico

Ewha Women's University,
Seoul 120,
Republic of Korea

Fundação Carlos Chagas,
Av. Prof. Francisco Morato 1565,
Jardim Guedala,
05513 São Paulo—SP,
Brazil

Higher Institute of Culture for Women,
El Zamalik,
Cairo,
Egypt

Institute for Women's Studies
in the Arab World,
PO Box 11-4080,
Beirut University College,
Beirut,
Lebanon

International Center for Research
on Women,
1010 16th St NW, 3rd floor,
Washington,
DC 20036,
United States of America

International Institute for Research
and Training for Women,
c/o United Nations,
Room DC-1026,
New York,
NY 10017,
United States of America

Multinational Research and Training
Center for Women,
Av. Ipolito Irigoyen 188,
2do Piso,
Córdoba,
Argentina

Research Unit on Women's Studies,
SNDT Women's University,
1 Nathibai Thackersey Road,
Bombay 400 020,
India

Society for Research on Women
in New Zealand,
PO Box 13-078,

Johnsonville,
New Zealand

Women and Development Unit,
University of the West Indies,
Extra-mural Department,
Cave Hill Campus,
Barbados

Women's Research Association,
52-54 Namchong-dong,
Chung-ku,

Seoul,
Republic of Korea

Women's Studies in Communication,
ORWAC,
Department of Speech Communication,
California State University,
5151 State University Drive,
Los Angeles,
CA 90032,
United States of America

Appendix 6

Format for media analysis

The analysis sheets that appear on the following pages were developed by the Swedish Broadcasting Corporation as part of their 'Equality Project' 1978 (cf. *Schema for Programme Analysis—Sex Roles in Television Fiction*). The format as it stands is intended to be used by researchers as well as by those completely unfamiliar with data-gathering techniques. It is meant to provoke thought and discussion as well as to provide concrete data, and can easily be used in groups or as part of a workshop session. The analysis sheet gives information on four different aspects of fictional content: (a) number of women and men appearing; (b) attributes of women and men: activities and occupations, interests, personal characteristics; (c) relationships between the characters; and (d) conclusions about women and men supported by the story, either explicitly or (more) often implicitly.

For those who have never used this kind of tool, it may take some time and practice before feeling at ease with the analysis sheet. Particularly if the analysis is being made directly from a broadcast transmission (rather than from a taped recording) it is advisable to take the questions gradually, concentrating for the first attempt on dealing with the first two pages. Leave the rest to be filled in after you have watched the entire programme, but read through the schema before you start to watch so that you know the kind of information you should be looking out for. Use a separate analysis sheet for each programme that you study.

The format reprinted here has been devised for the analysis of television programmes. However, it could quite easily be adapted for study of the fictional content of other media, such as radio or magazines.

'Our purpose with the analysis sheet is twofold. *First, we are concerned to stimulate discussion and action*. The analysis sheet is, we hope, so well thought out that it can be used by *any* group that is concerned to study how norms and values relating to "male" and "female" appear in the supply of television. *Second, we are concerned to document* the male and female images incorporated in the supply of fiction programmes over a specific period, in order to be able to make a comparison backwards in time and see if anything has changed.

'The purpose of tracing norms and values in the supply is to make ourselves aware of them. Once they are visible, something can be done about them. It is possible actively to seek and stimulate the production of programmes with a different view of humanity.' Swedish Broadcasting Corporation Audience and Programme Research Department

PROGRAMME_____

1. - DRAMATIS PERSONAE?

 List all the characters of relevance to the plot. Note their approximate age, marital status and occupation, if indicated. Mark the principal characters with "X".

Characters	Age	Marital status	Occupation	"X" for principal characters

Male:

1. _____ ☐
2. _____ ☐
3. _____ ☐
4. _____ ☐
5. _____ ☐
6. _____ ☐
7. _____ ☐
8. _____ ☐

Female:

1. _____ ☐
2. _____ ☐
3. _____ ☐
4. _____ ☐
5. _____ ☐
6. _____ ☐
7. _____ ☐
8. _____ ☐

	N Male	N Female
OCCUPATION:		
No occupation mentioned..........	____	____
Have no occupation...............	____	____
"House-person"....................	____	____
Occupation:		
Kind of work not specified.....	____	____
Female-dominated field.........	____	____
Mixed..........................	____	____
Male-dominated field...........	____	____

SUMMARY

of preceding page: Check the box under each heading that best describes the programme.

- Among the characters ☐ more men ☐ more women ☐ roughly as many
 there are than women than men men as women

- Among the principal ☐ - " - ☐ - " - ☐ - " -
 characters there are

- Age: ☐ On average the men are older than the women
 ☐ On average the women are older than the men
 ☐ Men and women are of roughly the same age (on average)

- Marital status: ☐ Specified to same extent among men and women
 ☐ More clearly specified with respect to men
 ☐ More clearly specified with respect to women

- Occupation: ☐ Men and women have jobs to the same extent
 ☐ More men have jobs
 ☐ More women have jobs

- Among the characters with jobs, the occupations specified show the following pattern:
 ☐ "Men's work" for men and "women's work" for women
 ☐ Other. Describe: _____

2. - HOW ARE THE CHARACTERS RELATED?

 Indicate <u>known</u> relationships between the characters on the matrix on the
 following page.

Instructions:

 First, enter the characters' names on the lines to the left of the matrix and
 in the columns at the top of the matrix. Each cell of the matrix will thus
 indicate the relationship between two characters.

 Consider the characters one by one. Male 1 and Male 2 - are they in any way
 related? If so, how? Use the symbols indicated on the following page. Proceed
 to consider Male 1 and Male 3 - are they related? Etc, etc.

NOTE: Two persons may have multiple relationships (e.g. both hierarchical and
 amorous).

M - Married, cohabiting
F - Family, "blood ties"
A - Amorous relations
C - Other "couple" relations ("dates", escorts, etc.)
R - Rivals
HF - {Hierarchical relations/authority
 Formal relations/business, institutional
E - Enemies
Fr - Friends, "buddies", "side-kicks"
Ac - Acquaintances
U_f - Unrequited love (on the part of woman)
U_m - Unrequited love (on the part of man)

```
┌─────────────────────────────────────────────────────────────────────┐
│  SUMMARY                                                            │
│                                                                     │
│                                              No type of relationship│
│  - Most male-male relationships are of the type   predominates      │
│    ☐F   ☐A, C, R   ☐HF   ☐E   ☐Fr   ☐Ac          ☐                 │
│                                                                     │
│  - Most female-female relationships are of the type                 │
│    ☐F   ☐A, C, R   ☐HF   ☐E   ☐Fr   ☐Ac          ☐                 │
│                                                                     │
│  - Most male-female relationships are of the type                   │
│    ☐M.F ☐A, C, R  ☐HF   ☐E   ☐Fr   ☐Ac  ☐U_f, U_m  ☐               │
│                                                                     │
│  - Most relationships occur                                         │
│    ☐between men      ☐between women      ☐between men and women    │
└─────────────────────────────────────────────────────────────────────┘
```

THE FOLLOWING QUESTIONS APPLY TO PRINCIPAL CHARACTERS ONLY

3. - RANK THE PRINCIPAL CHARACTERS ACCORDING TO THEIR IMPORTANCE (CENTRALITY) IN THE PROGRAMME

 1._____ 2._____ 3._____
 4._____ 5._____ 6._____
 7._____ 8._____ 9._____

Comments (?):

4. - WHAT DO THE PRINCIPAL CHARACTERS DO?

What are the principal characters occupied with in the programme? Briefly describe their main activity, e.g. conversing, entertaining, household chores, beauty care, attending the theatre, etc.

Males: Name Activity

1. _____ _____

2. _____ _____

3. _____ _____

4. _____ _____

5. _____ _____

6. _____ _____

Female:

1. _____ _____

2. _____ _____

3. _____ _____

4. _____ _____

5. _____ _____

6. _____ _____

Comments: Do these activities reflect common sex-role patterns? How?

5. - CHARACTER DELINEATION

Describe each of the principal characters using words from the following list.

Appearance, outward manner:

ordinary, plain
elegant
athletic
proper, prim
unassuming
flamboyant, provocative
beautiful, handsome
ugly
clumsy, blunt
dainty, dapper
ridiculous
charming
pert
"world-wise"
sexy
repulsive
pretty
crude, "tough"

Temperament, feelings:

happy, cheerful
sorrowful
aggressive
friendly
cold
warm
extroverted, out-going
introverted, "private"
calm, secure
anxious, insecure
angry
nagging
dour
realistic
romantic
indifferent

Capacity, strength:

strong
weak, delicate
patient, long-suffering
impatient
knowledgeable, intelligent
ignorant
purposeful, methodical
impulsive
stupid
wise
unsure
self-confident
active
passive
scatter-brained, whimsical
sensible

Relations to others:

dominant
submissive
dependent on others
independent, self-reliant
loyal
egoistic, egocentric
helpful
disloyal
ruthless
empathetic (able to "live oneself into" another persons's situation)

Motives:

kind-hearted, altruistic
evil, malicious
ambitious
idealistic
dutiful, conscientious
adventurous
helpless, seeking help
dictated by social role
guided by feelings
responding to external forces or coercion
conventional
rebellious, obstinate

199

Males:

1. _____ _____

2. _____ _____

3. _____ _____

4. _____ _____

5. _____ _____

6. _____ _____

Females:

1. _____ _____

2. _____ _____

3. _____ _____

4. _____ _____

5. _____ _____

6. _____ _____

Comments: Do the characterizations reflect common sex-role patterns? In what respect?

SUMMARY		
	M	F
- Number of characters "faintly delineated" (=difficult to describe)	___	___
- Number of characters vividly and richly delineated	___	___
- Number of "one-dimensional" (stereotyped, flat) characters	___	___
- Number of characters delineated according to standard sex-role patterns	___	___

6. - GOALS AND MOTIVES

What do the principal characters want to achieve? Describe their goals briefly on the basis of what they say and do.

Males:

1. _____ _____

2. _____ _____

3. _____ _____

4. _____ _____

5. _____ _____

6. _____ _____

Females:

1. _____ _____

2. _____ _____

3. _____ _____

4. _____ _____

5. _____ _____

6. _____ _____

7. - HOW DO THE PRINCIPAL CHARACTERS BEHAVE?

 Once we have identified the principal characters' goals (or what they seem to be striving for) we can characterize how they go about pursuing those goals.

 One and the same character may, of course, <u>both</u> be the victim of circumstances <u>and</u> take the initiative to carry the plot forward. Therefore, please note the actions/events you have in mind in answering the following questions.

A. - Which of the characters act(s) on his/her <u>own initiative</u>, thus carrying the plot forward? How?

B. - Do any of these characters <u>succeed</u> in their strivings? Do they achieve their goals? Who succeeds with what?

C. - Do any of the characters <u>fail</u> in their strivings? How? Who fails to do what?

D. - Which of the characters is/are mainly <u>influenced by</u> the course of events or others' actions? Who is affected? How?

E. - Which of the characters find(s) it hardest to exert his/her will, to assert his/her views?

F. - Which of the characters find(s) it easiest to exert his/her will, to assert his/her views?

8. - WHAT IS DEPICTED AS 'FITTING' AND WHAT INAPPROPRIATE FOR MEN AND WOMEN, RESPECTIVELY?

 Now let us try to summarize the values regarding men's and women's behaviour that are implicit in the story.

A. - What is depicted as "fitting", pleasant or attractive, something to be emulated?

 For men? _____

 For women? _____

B. - What is depicted as inappropriate, unpleasant or repugnant, something to be avoided?

 For men? _____

 For women? _____

CONCLUSIONS about the world depicted in the programme (the "moral of the story"):

- Men are/must/should/want to/can _____

- Women are/must/should/want to/can _____

- General goals for the figures in this world are _____

9. - CHECK-LIST

Studies of sex-role patterns in television fiction show that men and women are often portrayed according to traditional stereotypes. How do these results correspond to the patterns apparent in this programme?

	The following patterns are common:	Corresponds (by and large)	Does not correspond
WHO? (Q. 1)	- More men than women are involved in the plot	☐	☐
	- More men than women among the principal characters	☐	☐
	- The men are older than the women (on average)	☐	☐
	- Women's marital status is more clearly specified than men's	☐	☐
	- A larger proportion of men have occupations	☐	☐
	- Among those with jobs, men do "men's work" and women do "women's work"	☐	☐
RELATION- SHIPS (Q. 2)	- Most interpersonal relationships are between men	☐	☐
	- Most relationships between men are hierarchical and/or formal (HF)	☐	☐
	- Most relationships between women are familial (F)	☐	☐
	- Few friendships (Fr) are depicted	☐	☐
	- Most friendships - to the extent they are depicted - occur between men	☐	☐
RANK (Q. 3)	- Men are more central to the plot than women	☐	☐
ACTIVITY (Q. 4)	- Men are engaged in activities related to their occupations more often than women	☐	☐
	- Men are engaged in leisure activities/ hobbies more often than women	☐	☐
	- Women are more often depicted in the home, where they are occupied with household chores, child care, clothing and/or beauty care	☐	☐

		Corresponds (by and large)	Does not correspond
THE PRINCIPALS (Q. 5)	- More women than men are "faintly delineated" (difficult to describe)	☐	☐
	- More men than women are vividly and richly delineated	☐	☐
	- Appearance is a central component in the delineation of female characters: Most women are depicted as attractive (beautiful, dainty, charming, pert, sexy, pretty) Appearance is of secondary importance among male characters	☐	☐
	- Women express their feelings more than men ("Feminine" descriptors: romantic, angry, anxious, insecure, nagging. "Masculine" descriptors: aggressive, cold, extroverted, realistic)	☐	☐
	- Men are depicted as being more capable than women ("Feminine" descriptors: unsure, weak, delicate, ignorant, passive. "Masculine" descriptors: strong, knowledgeable, intelligent, purposeful, methodical, wise, self-confident, active)	☐	☐
	- Men are depicted as independent, self-reliant individuals, and women as un-self-reliant, dependent ("Feminine" descriptors: submissive, dependent, empathetic "Masculine" descriptors: dominant, independent, loyal)	☐	☐
	- Men actively _pursue_ ambitions - fame, adventure, ideals - whereas women are _driven by_ (the victims of) feelings, their helplessness	☐	☐
GOALS (Q. 6)	- Women, to a greater extent than men, pursue limited, limited/short-term/egoistic goals	☐	☐
	- Men, to a greater extent than women, pursue broad/long-term/social-altruistic goals	☐	☐
BEHAVIOUR (Q. 7)	- Men, to a greater extent than women, take the initiative and carry the plot forward	☐	☐
	- Men are more often successful than women	☐	☐
	- When women take the initiative, they often suffer setbacks or fail	☐	☐
	- Women are more often the victims of "fate" or circumstances than men	☐	☐
	- Men assert their views, and exert their will	☐	☐

			Corresponds (by and large)	Does not correspond
..BEHAVIOUR (Q. 7)		— Men are – to a greater extent than women – more vividly and richly delineated, which means that they are <u>both</u> affected by events/ circumstances <u>and</u> carry the plot forward with greater or lesser success	☐	☐
STEREOTYPES VALUES (Q. 8)		— Women are depicted as primarily interested in the "private sphere" (romance, family, "hearth and home")	☐	☐
		— Men are depicted as primarily interested in the "social sphere" (the world outside the family and the home)	☐	☐
		— Women <u>should be</u> mainly interested in the home and the family (with careers and public affairs subordinate interests, if at all)	☐	☐
		— Men <u>should be</u> mainly interested in their careers and public affairs (with the home and family subordinate interests, if at all)	☐	☐
OTHER OBSERVATIONS		— _____	☐	☐
		— _____	☐	☐
		— _____	☐	☐
		— _____	☐	☐
		— _____	☐	☐

NOTE: One cannot make an assessment of the programme simply by tallying the number of "X's" in the respective columns. Some points are more important and should be given heavier weight than others. But this summary should offer a good basis for your answer to the final question:

10.- IS THIS A GOOD PROGRAMME WITH RESPECT TO THE EQUALITY OF THE SEXES?

☐ Yes, because _____

☐ No, because _____

<u>If "No"</u>: Does the programme work against equality passively or actively?

☐ Passively ☐ Actively

References

The references include both published and unpublished material relating to women and communication, basic sources for the compilation of Parts I to IV of this book, and selected additional reference data for further inquiry.

AARON, DOROTHY. 1975. *About Face: Towards a Positive Image of Women in Advertising*. Toronto, Ontario Status of Women Council.
AAUW. (AMERICAN ASSOCIATION OF UNIVERSITY WOMEN). 1974. *The Image of Women in Television*. Washington, D.C., American Association of University Women. Survey by Sacramento branch. (Mimeo.)
ABBAM, KATE. 1975. *Ghanaian Women in the Mass Media*. Unpublished paper written for International Women's Year. (Mimeo.)
ABC. (AUSTRALIAN BROADCASTING COMMISSION). 1977. *Women in the ABC. Report of the Task Force on Equal Opportunity for Women*. Sydney, Australian Broadcasting Commission. (Mimeo.)
ABDEL-RAHMAN, Awatef. 1978. *Image of the Egyptian Woman in the Mass Media*. Cairo, University of Cairo. (Mimeo.)
ABRAHAMSSON, ULLA B. 1979a. *Equality of the Sexes in Swedish Educational Television? Images of Men and Women in Two Weeks' Programming*. Stockholm, Swedish Broadcasting Corporation. (Mimeo.)
——. 1979b. *Sex Roles in Televised Fiction: A Swedish Frame of Reference*. Stockholm, Swedish Broadcasting Corporation. (Mimeo.)
ABS. (ASSOCIATION OF BROADCASTING STAFF). 1975. *The Future Employment of Women in the BBC. Evidence submitted to the Annan Committee on the Future of Broadcasting*. London, British Broadcasting Corporation. (Mimeo.)
ACCAD, ÉVELYNE. 1978. *Veil of Shame: The Role of Women in the Contemporary Fiction of North Africa and the Arab World*. Sherbrooke, Quebec, Éditions Naaman.
ACEVEDO, MARTA. 1979. *Pásele, pásele, aqui no le cuesta nada... aprender, un enfoque integrador de una posibilidad en comunicación*. Mexico, Radio Educación. (Mimeo.)
ACTT. (ASSOCIATION OF CINEMATOGRAPH, TELEVISION AND ALLIED TECHNICIANS). 1975. *Patterns of Discrimination Against Women in the Film and Television Industries*. London, ACTT.
ADAMSKI, FRANCISZEK. 1968. Press Readers—Studies to Date and Research Needs. *Polish Sociological Bulletin*, Vol. 1, No. 17, p. 97-105.
AFFIRM. (ALLIANCE FOR FAIR IMAGES AND REPRESENTATION IN THE MEDIA). 1979. *Women's Media Action Bulletin*, No. 2, July.
AFLATUNI, HOMA. 1978. *Images of Women on Television—Rahe Zendegi*. Tehran, Iran Communications and Development Institute. (Mimeo.)
AFRICA. 1977. Africa Literature Centre. *Africa*, April.
AID. (AGENCY FOR INTERNATIONAL DEVELOPMENT). 1978. *Educational Media for Women*.

References

LAC Regional Project Paper. Washington, D.C., Agency for International Development. (Mimeo.)

AIJPF. (Association Internationale des Journalistes de la Presse Féminine et Familiale). 1978. *How the Press Treats Women. Reports from Canada, France, Great Britain, Hungary, Italy, Netherlands and Switzerland*. Brussels, Association International des Journalistes de la Presse Féminine et Familiale.

Albertson, Lesley; Cutler, Terrence. 1976. Delphi and the Image of the Future. *Futures*, October, p. 397-404.

Alexander, Sandra. 1979. *Stop Organising, Be Creative. Report of the Organisation of Training Courses for Women in Film and Television*. Sydney, Australian Film and Television School.

Al-Hadeedy, Muna. 1977. *Image of Women in the Egyptian Cinema*. Cairo, University of Cairo. (Mimeo.)

Andersen, Lisso Orvad; Korsgaard, Elsebeth. 1978. *Massmedia og Likestilling*. Oslo, Nordiska Ministerrådets Sekretariat.

Anderson, Kristin. 1975. *A Report of Television and Radio Programming for Women and Children in the Middle East*. New York, Ford Foundation. (Mimeo.)

Andrassy, Maria. 1980. *Hungarian Women Today: in Film Documents—in Documentary Films*. Paris, Unesco. (Mimeo.)

Andren, Gunnar; Ericsson, Lars; Ohlsson, Ragnar; Taannsjo, Torbjorn. 1978. *Rhetoric and Ideology in Advertising*. Stockholm, Liberforlag.

Andren, Gunnar; Nowak, Kjell. 1978. *Gender Structures in Swedish Magazine Advertising 1950-1975*. Stockholm, University of Stockholm. (Mimeo.)

Anu, Mini; Joshi, Shashi. 1979. Old Poison in New Bottles. *Manushi*, No. 2, March/April, p. 51-4.

Arbeitsgruppe Frauenmaul. 1979. *Ich Hab' Dir Keinen Rosengarten Versprochen: das Bild der Frau in Fier Osterreichischen Tageszeitungen—eine Dokumentation*. Vienna, Frischfleisch & Lowenmaul.

Arizpe, Lourdes. 1977. Women in the Informal Sector: the Case of Mexico City. *Signs*, Vol. 3, No. 1.

Assadi, Ali. 1978. *Images of Women on Television—Talkho Shirin*. Tehran, Iran, Communications and Development Institute. (Mimeo.)

Atsumi, Ikuko. 1980. Interview. *Feminist International*, No. 2, p. 88-91. Tokyo, The Feminist Japan.

Aw, Eugenie. 1979. *The Impact of Audio Visual Media on the Socio-Cultural Behaviour of Women in Senegal*. Paris, Unesco. (CC/CD/MED.) (Mimeo.)

——. 1980. Des femmes—des intérêts. *Afrique Nouvelle*, 11 June, p. 18-19.

Bacarreza Rodriguez, Ximena. 1974. *Análisis de contenido de la revista femenina Paloma*. Santiago de Chile, Universidad Católica de Chile. (Mimeo.)

Baehr, Helen. 1980a. 'The Liberated Woman' in Television Drama. *Women's Studies International Quarterly*, Vol. 3, No. 1, p. 29-40.

——. 1980b. Out of Focus. *The Guardian*, 6 May.

Bakkar, Marjorie. 1979. The Image of Women in the Press. *National Council of Women (South Africa) News*, Vol. 44, No. 7, p. 3-7.

Barcus, Earle. 1971. *Saturday Children's Television*. Boston, University of Boston, School of Public Communication. (Mimeo.)

Barr, Pat. 1977. Newspapers. In: J. King and M. Stott (eds.), *Is this Your Life? Images of Women in the Media*, p. 67-81. London, Virago/Quartet.

Barreno, Maria Isabel. 1976. *A imagem de mulher na imprensa*. Lisbon, Comissão da Condição Femenina.

Barreto, Marien. 1978. La imagen de la mujer en las telenovelas. *La imagen de la mujer en los medios de comunicación*, p. 29-34. San Juan, Comisión para el mejoramiento de los derechos de la mujer.

Barrett, Michele. 1979. Representation and Cultural Production. In: Barrett, Corrigan, Kuhn and Wolfe (eds.), *Ideology and Cultural Production*, p. 9-24. London, Croom Helm.

Barrett, Michele; Corrigan, Philip; Kuhn, Annette; Wolff, Janet (eds.). 1979. *Ideology and Cultural Production*. London, Croom Helm.

Barrett, Nancy. 1973. Have Swedish Women Achieved Equality? *Challenge*, November/December.

BARTHES, ROLAND. 1973. *Mythologies*. London, Paladin.
BASCH, F. 1974. *Relative Creatures: Victorian Women in Society and the Novel 1837-1867*. London, Allen Lane.
BBC. (BRITISH BROADCASTING CORPORATION). 1965. *Listeners' Opinions of Woman's Hour. Audience Research Report*. London, British Broadcasting Corporation. (Mimeo. Restricted.)
——. 1972. *Listeners' Attitudes Towards Woman's Hour. Audience Research Report*. London, British Broadcasting Corporation. (Mimeo. Restricted.)
——. 1973. *Women in the BBC. Statement from Personnel Department*. London, British Broadcasting Corporation. May. (Mimeo. Internal document.)
BEASLEY, MAURINE; SILVER, SHEILA. 1977. *Women in Media: a Documentary Source Book*. Washington, D.C., Women's Institute for Freedom of the Press.
BELKAOUI, AHMED; BELKAOUI, JANICE. 1976. A Comparative Analysis of the Roles Portrayed by Women in Print Advertisements: 1958, 1970, 1972. *Journal of Marketing Research*, Vol. 13, p. 168-72.
BELTRAN, LUIS R. 1978. TV Etchings in the Minds of Latin Americans: Conservatism, Materialism and Conformism. *Gazette*, Vol. XXIV, No. 1, p. 61-83.
BENOIT, N.; MORIN, E.; PAILLARD, B. 1973. *La femme majeure. Nouvelle féminité, nouveau féminisme*. Paris, Seuil.
BERAUD, SUSAN. 1975. Sex Role Images in French Children's Books. *Journal of Marriage and the Family*, Vol. 37, p. 194-207.
BERG, ANNE MARIE; KALLERUD, BITTEN; MELBY, KARL. 1979. *Reklame og Kjønn: en Utredning om Kjønnsundertrykkende Reklame*. Oslo, Forbruker og Administrasjonsdepartementet. (Mimeo. Restricted.)
BERG, KAREN. 1969. School Books and Roles of the Sexes. *Hertha*, No. 5, p. 45-53.
BERMAN, MARSHA et al. 1977. *De Waardering van Vrouwen voor Vrouwenfilms*. Amsterdam, University of Amsterdam. (Mimeo.)
BESHA, R. M. 1979. *Women's Image in the Tanzanian Mass Media: Mass Media and Entertainment*. (Paper presented at BRALUP Workshop on Women's Studies and Development, University of Dar es Salaam.) Dar es Salaam, Bureau of Resource Assessment and Land Use Planning. (Mimeo.)
BLOCK, EVA. 1979. *Kvinnor i Dagspressens Ledarspalter*. Lund, University of Lund. (Mimeo.)
BOSANAC, GORDANA; POCEK MATIC, MIRJANA. 1973. Problem Kommunikacije Seksualiteta u Masovnom Mediji. *Zena*, Nos. 1-2, p. 11-28.
BOSERUP, ESTER. 1970. *Women's Role in Economic Development*. New York, St Martin's Press.
BOULDING, E.; NUSS, S.; CARLSON, D.; GREENSTEIN, M. (eds.). 1976. *Handbook of International Data on Women*. New York, Sage.
BOWMAN, W. 1974. *Distaff Journalists: Women as a Minority Group in the News Media*. Chicago, University of Illinois. (Mimeo.)
BRADY, KATE. 1980. From Fantasy to Reality: Magazines for Women. *Feminist International*. Tokyo, The Feminist Japan, No. 2. p. 5-8.
Broadcasting Yearbook, 1979. Washington, D.C., Broadcasting Publications.
BROWN, L. 1971. *Television: The Business Behind the Box*. New York, Harcourt-Brace.
BROWN, VIRGINIA. 1979. *The Effect of TV Commercials on Women's Achievement Aspirations*. Delaware, University of Delaware. (Mimeo.)
BRUNSDEN, CHARLOTTE. 1978. It is Well Known that by Nature Women are Inclined to be Rather Personal. In: Women's Studies Group (eds.), *Women Take Issue: Aspects of Women's Subordination*, p. 35-78. London and Birmingham, Hutchinson and University of Birmingham.
BRYCESON, DEBORAH F. 1979. *Notes on the Educational Potential of Mass Media vis-à-vis Women's Roles in Tanzanian Society*. (Paper presented at BRALUP Workshop on Women's Studies and Development, University of Dar es Salaam.) Dar es Salaam, Bureau of Resource Assessment and Land Use Planning.
BURNIE, JOAN. 1980. The Truth About Women in Television. *Cosmopolitan*, May, p. 148-9, 252, 254.
BUSBY, LINDA J. 1974. Defining the Sex Role Standard in Network Children's Programs. *Journalism Quarterly*, Vol. 51, No. 4, p. 690-6.

References

——. 1975. Sex Role Research on the Mass Media. *Journal of Communication*, Vol. 25, No. 4, p. 107-31.

——. 1980. *The Impact of Sex Role Acquisition: Mass Media Research*. Ames, Iowa, Iowa State University. (Mimeo.)

BUSBY, LINDA J.; STORM, SUSAN. 1977. *The Use of Mass Media as Tools of Socialisation: International Perspectives*. (Paper presented to the Speech Communication National Meeting, 1-5 December.) Ames, Iowa, Iowa State University. (Mimeo.)

BUTCHER, HELEN et al. 1974. *Images of Women in the Media*. Occasional Paper No. 32. Birmingham, University of Birmingham, Centre for Contemporary Cultural Studies. (Mimeo.)

BUTLER, MATILDA; PAISLEY, WILLIAM. 1980. *Women and the Mass Media*. New York, Human Sciences Press.

BUVINIC, MAYRA. 1976. *Women and World Development: an Annotated Bibliography*. Washington, D.C., Overseas Development Council.

BUVINIC, MAYRA; YOUSSEF, NADIA. 1978. *Woman-Headed Households: the Ignored Factor in Development Planning*. Washington, D.C., International Center for Research on Women.

BYRNE. EILEEN. 1978. *Women and Education*, London, Tavistock Publications.

CANTAROW, ELLEN et al. 1971. I am Furious (Female). In: Michele Hoffnung Garskof (ed.), *Roles Women Play: Readings Toward Women's Liberation*. Belmont, Calif., Brooks/Cole.

CANTOR, MURIEL. 1971. *The Hollywood TV Producer*. New York, Basic Books.

——. 1972. Comparison of Tasks and Roles of Males and Females in Commercials Aired by WRC-TV During a Composite Week. *Women in the Wasteland Fight Back*, p. 12-51. Washington, D.C., National Organization of Women.

CAPITAL RADIO. 1973. *Capital Radio Programme Plans, IBA*. London, Capital Radio. (Mimeo.)

CARISSE, C.; DUMAZEDIER, J. 1975. *Les femmes innovatrices*. Paris, Seuil.

CASANAVE, MICHELE. 1976. Public Radio Women's Programming 1.4% of Total. *Media Report to Women*, Vol. 4, No. 10, p. 7.

CBC. (CANADIAN BROADCASTING CORPORATION). 1975. *Women in the CBC*. Ottawa, Canadian Broadcasting Corporation. (Report of the CBC Task Force on the Status of Women.)

——. 1979. *The Portrayal of Women in CBC Programs*. Ottawa, Canadian Broadcasting Corporation. (Mimeo. Seminar transcript.)

CECIL, M. 1974. *Heroines in Love, 1750-1974*. London, Michael Joseph.

CEULEMANS, MIEKE; FAUCONNIER, GUIDO. 1979. *Mass Media: the Image, Role and Social Conditions of Women*. Paris, Unesco. (Reports and Papers on Mass Communication No. 84.)

CHABBRA, RAMI. 1980. *Women and the Media: What Strategies for Change?* New York, United Nations. Perspective Paper for UN/Unesco Seminar on Women and the Media. (Mimeo.)

CHANEY, ELSA. 1979. *Supermadre: Women in Politics in Latin America*. Austin, Texas, University of Texas Press. (Latin American Monographs No. 50.)

CHANG, W. H. 1975. Characteristics and Self-Perceptions of Women's Page Editors. *Journalism Quarterly*, Vol. 52, No. 1, p. 61-5.

CHELES-MILLER, PAMELA. 1975. Reactions to Marital Roles in Commercials. *Journal of Advertising Research*, Vol. 15, No. 4, p. 45-9.

CHEONG, CHIJA KIM. 1977. Korean Women's Access to Education and Employment in the Mass Media. In: Yu and Chu (eds.), *Women and Media in Asia*, p. 78-83. Hong Kong, Centre for Communication Studies, Chinese University of Hong Kong.

CHICAGO WOMEN IN PUBLISHING. 1978. *Equality in Print: a Guide for Editors and Publishers*. Chicago, Chicago Women in Publishing.

CHONG, WONG SOON. 1977. Access to Education and Employment in Mass Communications in Singapore. In: Yu and Chu (eds.), *Women and Media in Asia*, p. 104-8. Hong Kong, Centre for Communications Studies, Chinese University of Hong Kong.

CHULAY, CORNELL; FRANCIS, SARA. 1974. *The Image of the Female Child on Saturday Morning Television Commercials*. (Paper presented at the Annual Convention of the International Communication Association, New Orleans, La.)

CIBC. (COUNCIL ON INTERRACIAL BOOKS FOR CHILDREN). 1975. Children's Books

from the New China. *Racist and Sexist Images in Children's Books*. New York, Council on Interracial Books for Children, p. 30-4.

CLARKE, LORENNE; LANGE, LYNDA (eds.). 1979. *The Sexism of Social and Political Theory*. Toronto, University of Toronto Press.

CLARKE, P.; ESPOSITO, V. 1966. A Study of Occupational Advice for Women in Magazines. *Journalism Quarterly*, Vol. 43, p. 477-85.

COLLE, ROYAL; FERNANDEZ DE COLLE, SUSANA. 1977. *The Communication Factor in Health and Nutrition Programs: a Case Study from Guatemala*. Geneva, World Health Organization.

COLOMINA DE RIVERA, MARTA. 1968. *El huésped alienante: Un estudio sobre audiencia y efectos de las radio-telenovelas en Venezuela*. Maracaibo, Centro Audio-Visual.

——. 1976. *La celestina mecanica: Estudio sobre La mitologia de lo femenino; La mujer y su manipulación a traves de la industria cultural*. Caracas, Monte Avila Editores.

COMISSAO DA CONDICAO FEMININA. 1979. *Recomendacao sobre normas relativas ao exercício da publicidade no que se refere a imagem da mulher*. Lisbon, Comissão do Condição Feminina.

CONEY, SANDRA. 1977. These Films are About the Way Women Feel. *Broadsheet*, September.

COSETENG, ALICIA. 1977. Opportunities for Training Women for Careers in Asia/Teaching Opportunities. In: Yu and Chu (eds.), *Women and Media in Asia*. p. 213-19. Hong Kong, Centre for Communication Studies, Chinese University of Hong Kong.

COURTNEY, ALICE; LOCKERETZ, SARAH. 1971. A Woman's Place: an Analysis of the Roles Portrayed by Women in Magazine Advertisements. *Journal of Marketing Research*, Vol. 8, p. 92-5.

COURTNEY, ALICE; WHIPPLE, THOMAS. 1974. Women in TV Commercials. *Journal of Communication*, Vol. 24, p. 110-18.

——. 1978. *Canadian Perspectives on Sex Stereotyping in Advertising*. Ottawa, Advisory Council on the Status of Women.

CPB. (CORPORATION FOR PUBLIC BROADCASTING). 1978. *Equal Opportunity: Efforts and Accomplishments*. Report to Congress. Washington, D.C., Corporation for Public Broadcasting. (Mimeo.)

CROASDELL, CELIA. 1975. Women in the BBC. *Broadcasting*, February, p. 30–2.

CROLL, ELISABETH. 1978. *Feminism and Socialism in China*. London, Routledge & Kegan Paul.

CUEVAS, ESMERALDA ARBOLEDA. 1980. *Influence of the Mass Communication Media on Attitudes Towards the Roles of Women and Men in Present Day Society. Report to the United Nations Economic and Social Council*. New York, Economic and Social Council. (E/CN.6/627/Rev. 1). (Mimeo.)

CULLEY, J.; BENNET, R. 1976. Selling Women, Selling Blacks. *Journal of Communication*, Vol. 26, No. 4, p. 160-74.

CUTHBERT, MARLENE. 1979. *The Impact of Audio-Visual Media on the Socio-cultural Behaviour of Women in Jamaica*. Paris, Unesco. (CC/CD/MED.)

DALSTON STUDY GROUP. 1976. Was the Patriarchy Conference Patriarchal? *Papers on Patriarchy*. Brighton, Women's Publishing Collective.

DARDIGNA, A. M. 1975. *Femmes—femmes sur papier glace*. Paris, F. Maspero.

DAWITT, T. 1977. Media et femmes rurales en Afrique. *Assignment Children*, No. 38. Geneva, Unicef.

DE CLARICINI, S. 1965. Women's Weeklies in Italy. *Gazette*, Vol XI, No. 1, p 43-56.

DE MARMORA, DIANA. 1979. Cosmopolitan o el mensaje como instrumento de alienación. *Que leen los adolescentes?* p. 47-85. Bogotá, Corporación Centro Regional de Población.

DES FEMMES EN MOUVEMENT. 1980. En Chine: La réalité d'une contre-révolution bureaucratique. *Des femmes en mouvement hebdo*, No. 34, 27 June, p. 24-31.

DISPENZA, J. 1975. *Advertising and the American Woman*. Dayton, Ohio, Pflaum Publishing.

DNP. (DEPARTAMENTO NACIONAL DE PLANEACIÓN). 1977. *Plan nacional de alimentación y nutrición*. Bogotá, Departamento Nacional de Planeación. (Mimeo.)

DOHRMAN, R. 1975. A Gender Profile of Children's Educational TV. *Journal of Communication*, Vol. 25, No. 4, p. 56-65.

References

DOWNING, M. 1974. Heroine of the Daytime Serial. *Journal of Communication*. Vol. 24, p. 130-7.

DRIVER, CHRISTINA. 1976. Women in the BBC. *Broadcast*, October, p. 163-4.

ECE. (ECONOMIC COMMISSION FOR EUROPE). 1979. *The Economic Role of Women in the ECE Region*. Paris, Economic Commission for Europe. (ECE/SEM.5/2.)

EDGAR, PATRICIA. 1971. *Sex Type Socialisation and Television Family Comedy Programs*. La Trobe University School of Education Technical Report, No. 2. Bundoora, Australia, La Trobe University.

EDGAR, PATRICIA; MCPHEE, HILARY. 1974. *Media She*. Melbourne, Heinemann.

Effe. 1980. Nuova Effe: Perche? *Effe*, Vol. VIII, Nos. 5-6, p. 2.

EMBREE, ALICE. 1970. Media Images I: Madison Avenue Brainwashing—the Facts. In: Robin Morgan (ed.), *Sisterhood is Powerful*. New York, Vintage Books.

ENGELS, FREDERICK. 1972. *The Origins of the Family, Private Property and the State*. New York, Pathfinder Press.

EPSTEIN, CYNTHIA. 1978. The Women's Movement and the Women's Pages: Separate, Unequal and Unspectacular. In: Tuchman et al. (eds.), *Hearth and Home: Images of Women in the Mass Media*, p. 216-21. New York, Oxford University Press.

EQUAL STATUS COUNCIL OF NORWAY. 1980. *Towards Equality Between Men and Women. National Plan of Action: A Proposal*. Oslo, Equal Status Council of Norway.

ETIENNE, MONA. 1980. Women and Men, Cloth and Colonisation: The Transformation of Production-Distribution Relations Among the Baule (Ivory Coast). In: Etienne and Leacock (eds.), *Women and Colonisation: Anthropological Perspectives*, p. 214-38. New York, Praeger.

ETIENNE, MONA; LEACOCK, ELEANOR (eds.). 1980. *Women and Colonisation: Anthropological Perspectives*. New York, Praeger.

EWEN, STUART. 1976. *Captains of Consciousness*. New York, McGraw-Hill.

FARLEY, ELLEN; KNOEDELSEDER, WILLIAM. 1978. Rub-a-dub-dub, Three Networks in a Tub: the Future is Now in TV's Titillation Sweepstakes. *Washington Post*, 19 February.

FATT, ARTHUR C. 1967. Article in *Journal of Marketing*, Vol. XXXI, p. 60-2.

FELL, LIZ. 1980. *Challenging the Established Media Structure*. Perspective Paper for UN/Unesco Seminar on Women and the Media, New York. New York, United Nations. (Mimeo.)

FEMINIST THEORY AND ACTIVISM COMMITTEE. 1980. *What is Feminism?* (Paper circulated at non-governmental Forum, Copenhagen, WCUNDW, 14-24 July, by Feminist Theory and Activism Committee of the International Feminist Networking Section.) (Mimeo.)

FINER COMMITTEE. 1974. *Report of the Committee on One-Parent Families*. (Chairman Sir Maurice Finer.) Vol. 2. London, HMSO. (Cmnd. 5629-1.)

FLERX, VICKI; FIDLER, DOROTHY; ROGERS, RONALD. 1976. Sex Role Stereotypes: Developmental Aspects and Early Intervention. *Child Development*, Vol. 47, No. 4, p. 998-1007.

FLICK, MARIAN. 1977. *Political Socialisation: the Social Functions of Sex Roles in Advertisements. Design of a Comparative Study of the Netherlands and Norway*. Bergen, University of Bergen. (Working Papers, Sex Roles in Advertisements No. 2.) (Mimeo.)

——. 1978. *Mass Media Research and its Implications for Norwegian Policy Formation*, Bergen, University of Bergen. (Working Papers, Sex Roles in Advertisements, No. 7.) (Mimeo.)

FLORA, CORNELIA BUTLER. 1973. The Passive Female and Social Change: a Cross-Cultural Comparison of Women's Magazine Fiction. In: Ann Pescatello (ed.), *Female and Male in Latin America*, p. 59-85. Pittsburgh, Pa., University of Pittsburgh Press.

——. 1980. Women in Latin American Fotonovelas: from Cinderella to Mata Hari. *Women's Studies International Quarterly*, Vol. 3, No. 1, p. 95-104.

FOOTE, CONE AND BELDING MARKETING INFORMATION SERVICE. 1972. *A Report of the Way Women View their Portrayal in Today's Television and Magazine Advertising*. New York, Foote, Cone & Belding.

FOUGEYROLLAS, PIERRE. 1967. *Television and the Social Education of Women*. Paris, Unesco. (Reports and Papers on Mass Communication, No. 50.).

FRANK, MIRIAM. 1978. Feminist Publications in West Germany Today. *New German Critique*, Vol. 13, p. 181-94.
FRANZWA, HELEN. 1975. Working Women in Fact and Fiction. In: A. Welsl (ed.), *Mass Media and Society*, p. 398-402. Palo Alto, Calif., Mayfield.
FRIEDAN, BETTY. 1971. *The Feminine Mystique*. London, Victor Gollancz.
FROBEL, FOLKER; HEINRICHS, JURGEN; KREYE, OTTO. 1978. The World Market for Labor and the World Market for Industrial Sites. *Journal of Economic Issues*, Vol. XII, No. 4.
GALLAGHER, MARGARET. 1979. *The Portrayal and Participation of Women in the Mass Media*. Paris, Unesco. (CC.79/WS/130.) (Mimeo.)
——. 1980a. *Women and Cultural Industries*. Paris, Unesco. (CC.80/CONF.629/Col.9.) (Mimeo.)
——. 1980b. *Images of Women in the Mass Media*. International Commission for the Study of Communication Problems, No. 59 bis. Paris, Unesco. (Mimeo.)
GANS, HERBERT. 1979. *Deciding What's News: a Study of CBC Evening News, NBC Nightly News, Newsweek and Time*. New York, Pantheon.
GENG, VERONICA. 1976. Requiem for the Women's Movement: Empty Voices in Crowded Rooms. *Harpers Magazine*, November, p. 49-68.
GERONA-ADKINS, RITA M. 1979. *Review and Appraisal of Progress Made and Obstacles Encountered at the National Level in Asia and the Pacific in Attaining the Minimum Objectives set Forth in Paragraph 46 of the World Plan of Action and of Objectives of the Asian Plan of Action*. Bangkok, Economic and Social Commission for Asia and the Pacific. (Mimeo.)
GHORAYEB, ROSE. 1979. *Women and the Mass Media in the Lebanon*. Beirut, Institute for Women's Studies in the Arab World. (Mimeo.)
GITTINGS, JOHN. 1980. From Gang of Four to Three-Piece Suite. *The Guardian Weekly*, 27 April, p. 8.
GLAZER SCHUSTER, ILSA. 1979. *New Women of Lusaka*. Palo Alto, Calif., Mayfield.
GOLDING, PETER. 1978. The International Media and the Political Economy of Publishing. *Library Trends*, Vol. 26, No. 4.
GOLDING, PETER; MURDOCK, GRAHAM. 1979. Ideology and the Mass Media. In: Barrett, Corrigan, Kuhn and Wolfe (eds.), *Ideology and Cultural Production*, p. 198-224. London, Croom Helm.
GOONATILAKE, HEMA. 1980. Women in Creative Arts and Mass Media. In: *Status of Women in Sri Lanka*, p. 95-188. Colombo, University of Colombo.
GORE, M. S. 1980. *The SITE Experience*. Reports and Papers on Mass Communication. Paris, Unesco.
GOREN, DINA. 1978. *Image and the Mass Media in Israel*. Jerusalem, Hebrew University of Jerusalem. (Mimeo.)
GRAMSCI, ANTONIO. 1971. *Prison Notebooks: Selections*. London, Lawrence & Wishart.
GRENDI, VERENA. 1979. *Die Frau in den Massenmedien*. Bern, University of Bern. (Mimeo.)
GRIFFITH, R.; MAYER, A. 1957. *The Movies*. New York, Bonanza Books.
GUENIN, Z. B. 1975. Women's Pages in American Newspapers: Missing Out on Contemporary Content. *Journalism Quarterly*, Vol. 52, p. 66-9.
HABIB, MIRIAM. 1975. *Women and the Media in Pakistan*. Paper presented at International Women's Year Seminar, Islamabad. (Mimeo.)
——. 1980. *Women in the Communications Workforce: a Profile of Lahore*. Perspective Paper for UN/Unesco Seminar on Women and the Media. New York, United Nations. (Mimeo.)
HALL, S. 1977. African Women on Film. *Africa Report*, Vol. 22, No. 1, p. 15-17.
HALL, TONY. 1980a. 'I Get a Strong Feeling the Conference is Being Politicised'. *Forum 80*, 23 July, p. 1.
——. 1980b. A Redefinition of Journalism by IPS. *Forum 80*, 30 July, p. 6.
HALLORAN, JAMES (ed.).1970. *The Effects of Television*. London, Panther.
HARMS, JOAN. 1978. *Yleisradion Selonteko Yk: N Kansainvalisen Naisten Vuosikymmen Suomen Ohjelmaan*. Helsinki, Finnish Broadcasting Company. (Mimeo.)
HARRISON, RACHEL. 1978. Shirley: Relations of Reproduction and the Ideology of Romance. In: Women's Studies Group (eds.), *Women Take Issue: Aspects of Women's*

Subordination, p. 176-95. London and Birmingham, Hutchinson and University of Birmingham.
HASKELL, MOLLIE. 1973. *From Reverence to Rape: the Treatment of Women in the Movies.* New York, Holt, Rinehart & Winston.
HEMMINGS, SUE. 1979. Out of the Background. *Spare Rib*, No. 47, October, p. 6-8.
HMSO. (HER MAJESTY'S STATIONERY OFFICE). 1974. *Women and Work: a Statistical Survey.* London, HMSO.
——. ANNAN COMMITTEE. 1977. *Report of the Committee on the Future of Broadcasting.* (Chairman, Lord Annan.) London, HMSO. (Cmnd. 6753.)
HOBSON, DOROTHY. 1978. Housewives: Isolation as Oppression. In: Women's Studies Group (eds.), *Women Take Issue: Aspects of Women's Subordination*, p. 79-95. London and Birmingham, Hutchinson and University of Birmingham.
HOROWITZ, MARYANNE CLINE. 1976. Aristotle and Woman. *Journal of the History of Biology*, Vol. 9, No. 2, p. 183-213.
HRM (HUMAN RESOURCES MANAGEMENT). 1978. *Medios de Comunicación para la integración de la mujer latino américana de escasos recursos.* Washington, D.C., Human Resources Management Inc. (Mimeo.)
HUSSEY, GEMMA. 1978. Women Reject the TV Stereotype. *Irish Broadcasting Review*, p. 8-12.
IABC (INTERNATIONAL ASSOCIATION OF BUSINESS COMMUNICATORS). 1977. *Without Bias: a Guidebook for Nondiscriminatory Communication.* California, International Association of Business Communicators.
IDE, SACHIKO. 1978. Language, Women and the Mass Media in Japan. *Feminist Japan*, Vol. 1, No. 4, p. 22-4.
ILO (INTERNATIONAL LABOUR ORGANISATION). 1975. *Equality of Opportunity for Women.* Geneva, ILO.
INDEPENDENT COMMISSION ON INTERNATIONAL DEVELOPMENT ISSUES. 1980. *North-South: a Programme for Survival.* Report of the Commission. Chairman Willy Brandt. London, Pan Books.
INDIAN COUNCIL FOR SOCIAL SCIENCE RESEARCH. 1975. *Status of Women in India: Synopsis of the Report of the National Committee on the Status of Women.* New Delhi, Allied Publishers Private Ltd.
INDIAN FEDERATION OF UNIVERSITY WOMEN'S ASSOCIATION. 1977. *A Teacher-Training Course on Sexism in the Classroom. Report to UNICEF.* Geneva, Unicef. (Mimeo.)
INTERNATIONAL FEDERATION OF UNIVERSITY WOMEN (IFUW). 1978. *Newsletter*, No. 38, July.
IPS (INTERPRESS SERVICE). 1980. *An International Women's Information and Communication Network: A Contribution to the Debate on Women and the New International Information Order.* New York, United Nations. (Background Paper for UN/Unesco Seminar on Women and the Media.) (WCUNDW/Sem. 1/3.) (Mimeo.)
ISBER, CAROLINE; CANTOR, MURIEL. 1975. *Report of the Task Force on Women in Public Broadcasting.* Washington, D.C., Corporation for Public Broadcasting.
ISIS COLLECTIVE. 1976. Women in the Daily Press. *ISIS International Bulletin*, No. 2, p. 1-11.
——. 1980. The Feminist Press in Western Europe. *ISIS International Bulletin*, No. 16.
ITZCOVICH, MABEL. 1979. Putting Women on the Front Page. *Unesco Features*, No. 742.
IWAO, SUMIKO. 1977. Access to Education and Employment for Women in Japan. In: Yu and Chu (eds.), *Women and Media in Asia*, p. 71-7. Hong Kong, Centre for Communications Studies, Chinese University of Hong Kong.
JAPANESE MINISTRY OF LABOUR. 1977. *The Status of Women in Japan.* Tokyo, Women and Minors' Bureau.
JOHNSTON, C. 1975a. *Notes on Women's Cinema.* London, Society for Education in Film and Television.
——. 1975b. Feminist Politics and Film History. *Screen*, Vol. 16, No. 3, p. 115-24.
JONES, MAGGIE. 1980. Work in the USSR Slavery. *Forum 80*, 28 July, p. 3.
JURNEY, DOROTHY. 1978. *The Strength and Shortcomings of the Press.* (Paper presented at Carolina Symposium, University of North Carolina.) (Mimeo.)
KANDEL, LILIANE. 1979. Sous la plage, les medias. *Les temps modernes*, Vol. 34, p. 1157-73.
KAPLAN, DIANE. 1978. *Women Radio Announcers: Sex-typed out of Competition.* Pittsburgh, Pa., University of Pennsylvania. (Mimeo.)

KARPF, ANNE. 1980. Women and Radio. *Women's Studies International Quarterly*, Vol. 3, No. 1, p. 41-54.

KATZMAN, N. 1972. Television Soap Operas: What's Been Going On Anyway? *Public Opinion Quarterly*, Vol. 36, No. 2, p. 200-12.

KAY, K.; PEARY, G. (eds.). 1977. *Women and the Cinema: a Critical Anthology*. New York, Dutton.

KELMAN, HERBERT. 1958. Compliance, Identification and Internalisation: Three Processes of Attitude Change. *Journal of Conflict Resolution*, Vol. 2, p. 51-60.

KEY, WILSON B. *Media Sexploitation*. New York, Signet.

KHAN, SALMA. 1980. *Women in Bangladesh*. Dacca, Planning Commission, Government of Bangladesh/Unicef. (Mimeo.)

KING, JOSEPHINE; STOTT, MARY (eds.). 1977. *Is This Your Life? Images of Women in the Media*. London, Virago/Quartet.

KISHWAR, MADHU. 1979. Family Planning or Birth Control. *Manushi*, No. 1, January, p. 24-6.

KOERBER, CARMEL. 1977. Television. In: King and Stott (eds.), *Is This Your Life? Images of Women in the Media*, p. 123-42. London, Virago/Quartet.

KRIPPENDORF, Sultana. 1977. *Women's Education in Bangladesh: Needs and Issues*. Part II. Dacca, Foundation for Research on Educational Planning and Development.

KUCHENHOFF, E. 1977. Die Darstellung der Frau im Fernsehen. In: M. Furian (ed.), *Kinder und Jugendliche im Spannungsfeld der Massenmedien*. Stuttgart, Bonz Verlag.

KYARUZI, AGNES. 1979. *Women's Images in the Tanzanian Mass Media: Newspapers*. Dar es Salaam, Bureau of Resource Assessment and Land Use Planning. (Paper presented at BRALUP Workshop on Women's Studies and Development, University of Dar es Salaam.)

LAINE, P. 1974. *La femme et ses images*. Paris, Stock.

LAKOFF, ROBIN. 1975. *Language and Woman's Place*. New York, Harper & Row.

LAPIDUS, GAIL WARSHOFSKY. 1978. *Women in Soviet Society*. Berkley, Calif., University of California Press.

LEACOCK, ELEANOR. 1978. Women's Status in Egalitarian Society: Implications for Social Evolution. *Current Anthropology*, Vol. 19, No. 2, p. 247-75.

LEDERER, G. 1968. *Gynophobia, ou la peur des femmes*. Paris, Éditions Payot.

LEGARE, ANNE. 1979. *L'impact des moyens de communication de masse dans le domaine de l'audiovisuel sur le comportement socioculturel des femmes: le cas de l'émission 'Femme d'aujourd'hui'*. Paris, Unesco. (CC/CD/MED.) (Mimeo.)

LEIJON, ANNA-GRETA. 1976. Sexual Equality in the Labour Market. *Women Workers and Society*. Geneva, ILO.

LEINFELLER, CHRISTINE. 1979. *Das Bild Der Frau im Osterreichischen Fernsehen*. Vienna. (Mimeo.)

LESSER, GERALD. 1974. *Children and Television: Lessons from Sesame Street*. New York, Random House.

LEWARTOWSKA, S. 1975. Women's and Family Newspapers and Magazines. *Zeszyty Prasoznawcze*, Vol. 16, p. 65-70.

LIGIA CHANG, A. 1977. *Programas de formación profesional para la mujer trabajadora*. Costa Rica, CINTERFOR.

LIGIA CHANG, A.; DUCCI, MARIA ANGELICA. 1977. *Realidad del empleo y la formación profésional de la mujer en América Latina*. Montevideo, CINTERFOR. (Studies and Monographs No. 24.)

LILLI, LAURA. 1976. La stampa femminile. In: V. Castrinovo and N. Tranfaglia (eds.), *La stampa italiana del neocapitalismo*, p. 251-312. Bari, Editori Laterza.

LONE, SALIM. 1980. Feminists, Worlds Apart. *Washington Post*, 14 June, p. A17.

LOPATE, CAROL. 1976. Daytime Television: You'll Never Want to Leave Home. *Feminist Studies*, Vol. 3, No. 3/4, p. 69-82.

LOVENHEIM, BARBARA. 1978. Admen Woo the Working Woman. *New York Times*, 18 June.

LOWRY, SUZANNE. 1980. The Big Clap-Out. *The Observer*, 3 August, p. 34.

LUGENBEEL, B. D. 1975. Defining Story Patterns in *Good Housekeeping*. *Journalism Quarterly*, Vol. 52, No. 3, p. 548-50.

LUNDEEN, BRUCE; LUNDEEN, ALISA. 1977. *The Potential of Locally Produced Materials and Small Media in Community Development*. Washington, D.C., AID. (Mimeo.)

MACCOBY, ELEANOR; JACKLIN, CAROL. 1974. *The Psychology of Sex Differences.* Palo Alto, Calif., Stanford University Press.

MADDISON, JOHN. 1974. *Radio and Television in Literacy.* Paris, Unesco. (Reports and Papers on Mass Communication, No. 62.)

MALAKHOVSKAYA, NATALIA. 1980. La famiglia maternale (trans.), *Effe*, Vol. VIII, No. 1-2, p. 6-7.

MANUSHI COLLECTIVE. 1980. The Media Game: Modernising Oppression. *Manushi*, No. 5, May/June, p. 37-46.

MARACEK, Jeanne; PILIAVIN, J.; FITZSIMMONS, E.; KROGH, E.; LEADER, E.; TRUDELL, B. 1978. Women as TV Experts: the Voice of Authority? *Journal of Communication*, Vol. 28, p. 159-68.

MARGULIES, LEE. 1978. FCC Taking Another Look at TV. *Los Angeles Times*, 12 October.

MARQUES DE MELO, JOSE. 1971. Las telenovelas em São Paulo: Estudio do público receptor. *Communicação social: teoria e pesquisa.* 2nd ed., p. 247-54. Brazil, Vozes.

MARQUEZ, F. T. 1975. The Relationship of Advertising and Culture in the Philippines. *Journalism Quarterly*, Vol. 52, No. 3, p. 436-42.

MARZOLF, MARION. 1977. *Up From the Footnote: a History of Women Journalists.* New York, Hastings House.

MARX, KARL. 1974. *Capital*, Vol. I. London, Lawrence & Wishart.

MATTELART, MICHELE. 1976. Chile: the Feminine Version of the Coup d'État. In: June Nash and H. I. Safa (eds.), *Sex and Class in Latin America.* New York, Praeger.

——. 1977. *La cultura de la opresión femenina.* Mexico City, Era, Serei Popular.

——. 1978. Reflections on Modernity: a Way of Reading Women's Magazines. *Two Worlds*, Vol. 1, No. 3, p. 5-13.

MATSUI, Y. 1978. Contempt for Women and Asians in the Japanese Press. *Feminist Japan*, Vol. 1, No. 4, p. 12-14.

MATTERU. May 1980. *The Image of Woman in Tanzanian Oral Literature.* Dar es Salaam, Bureau of Resource Assessment and Land Use Planning. (Paper presented at BRALUP Workshop on Women's Studies and Development, University of Dar es Salaam.)

MATTHEWS, TONY. 1978. *Parosi: A BBC Contribution to Language Learning in the Asian Community.* London, BBC Publications.

MCCAFFREY, KATHLEEN. 1979. *Images of Women in the Literature of Selected Developing Countries: Ghana, Senegal, Haiti, Jamaica.* Washington, D.C., Agency for International Development. (Mimeo.)

——. 1980. Images of Women in West African Literature and Film: A Struggle Against Dual Colonisation. *International Journal of Women's Studies*, Vol. 3, No. 1, p. 76-88.

MCDONALD, OONAGH. 1979. Europe: What We've Got and What We Want. *Cosmopolitan*, May.

MCGRAW-HILL. n.d. *Guidelines for Equal Treatment of the Sexes in McGraw-Hill Book Publications.* New York, McGraw-Hill.

MCNEIL, JEAN. 1975. Feminism, Femininity and the Television Series: a Content Analysis. *Journal of Broadcasting*, Vol. 19, No. 3, p. 259-71.

MCROBBIE, ANGELA. 1978. Working Class Girls and the Culture of Femininity. In: Women's Studies Group (ed.), *Women Take Issue: Aspects of Women's Subordination*, p. 96-108. London and Birmingham, Hutchinson and University of Birmingham.

MAZRUI, ALI. 1975. *The Political Sociology of the English Language: An African Perspective.* The Hague, Mouton.

Media Report to Women. 1978. Settlement with the New York Times. *Media Report to Women*, special issue, 31 December.

MELLEN, JOAN. 1973. *Women and their Sexuality in the New Film.* New York, Horizon Press.

——. 1976. *The Waves at Genji's Door. Japan Through its Cinema.* New York, Pantheon.

MERRITT, SHAYNE; GROSS, HARRIET. 1978. Women's Page/Lifestyle Editors: Does Sex Make a Difference? *Journalism Quarterly*, Vol. 55.

MICHEL, ANDRÉ (ed.). 1977. *Femmes, sexisme et sociétés.* Paris, Presses Universitaires de France.

MICHEL, ANDRÉ (ed.). 1979. *Le féminisme.* Paris, Presses Universitaires de France.
MIKHAIL, MONA N. 1979. *Images of Arab Women.* Washington, D.C., Three Centuries Press Inc.
MILES, B. 1975. *Channeling Children. Sex Stereotyping in Prime Time TV.* Princeton, N.J., Women on Words and Images.
MILLER, C.; SWIFT, K. 1977. *Words and Women.* London, Gollancz.
MILLER, S. H. 1976. Changes in Women's Lifestyle Sections. *Journalism Quarterly,* Vol. 53, No. 4, p. 641-7.
MILLETT, KATE. 1970. *Sexual Politics.* New York, Doubleday.
MILLUM, TREVOR. 1975. *Images of Woman. Advertising in Women's Magazines.* London, Chatto & Windus.
MINISTERIO DE CULTURA. 1978. *Presentación de la campaña publicitaria sobre la mujer.* Madrid, Ministerio de Cultura. (Mimeo.)
MIYAZAKI, TOSHIKO. 1978. *Housewives and Daytime Serials.* Leiden, University of Leiden. (Mimeo.)
MOHAMMADI, ALI. 1978. *Woman Today—Female Images in a Contemporary Iranian Magazine.* Tehran, Farabi University. (Mimeo.)
MOSS, MANORAMA. 1978. What Extension Educators and the Mass Media Can and Can't Do—a Nutrition Education Project in India. *Development Communication Report,* July.
MUNERATO, ELICE; DARCY DE OLIVEIRA, MARIA HELENA. 1979. *Las musas da matine.* São Paulo, Fundaçao Carlos Chagas. (Mimeo.)
MURDOCK, GRAHAM; GOLDING, PETER. 1977. Capitalism, Communication and Class Relations. In: James Curran et al. (eds.), *Mass Communication and Society.* London, Edward Arnold.
MURUMATSU, YASUKO. 1977. *The Image of Women in Japanese Television Dramas.* Tokyo, NHK. (Mimeo.)
MWENDA, DEBORAH. 1979. *Women's Image in the Tanzanian Mass Media: Radio.* Dar es Salaam, Bureau of Resource Assessment and Land Use Planning. (Paper presented at BRALUP Workshop on Women's Studies and Development, University of Dar es Salaam.)
NATIONAL ACTION COMMITTEE ON THE STATUS OF WOMEN. 1978. *The Portrayal of Women in CBC Television.* A Brief to the Canadian Television and Telecommunications Commission. Ottawa, National Action Committee on the Status of Women. (Mimeo.)
NATIONAL COMMISSION ON THE ROLE OF FILIPINO WOMEN. 1978a. *The Image of Filipino Women in Newspaper Advertising.* Manila, NCRFW. (Mimeo.)
——. 1978b. *Stereotyping of Women in Prime Time Television Commercials.* Manila, NCRFW. (Mimeo.)
——. 1978c. *Image and Reality Among Filipino Women: A Comparative Study of the Values Portrayed by the Female Lead Characters in Tagalog Films and the Values Held by Female College Students.* Manila, NCRFW. (Mimeo.)
NATIONAL COMMITTEE ON EQUALITY BETWEEN MEN AND WOMEN. 1979. *Step by Step.* Stockholm, Liberforlag.
NATIONAL UNION OF JOURNALISTS EQUALITY WORKING PARTY. 1977. *Images of Women: Guidelines for Promoting Equality Through Journalism.* London, NUJ.
NEWKIRK, C. R. 1977. Female Roles in Three Non-fiction Women's Magazines. *Journalism Quarterly,* Vol. 54, No. 4, p. 779-82.
NEWLAND, KATHLEEN. 1979. *The Sisterhood of Man.* New York, W. W. Norton/Worldwatch Institute.
NFCB (NATIONAL FEDERATION OF COMMUNITY BROADCASTERS). 1978. *Annual Report.* Washington, D.C., NFCB.
NORDENSTRENG, KAARLE; VARIS, TAPIO. 1974. *Television Traffic—a One-Way Street?* Paris, Unesco. (Reports and Papers on Mass Communication, No. 70.)
NORTHCOTT, H. C. 1975. Trends in TV Portrayals of Blacks and Women. *Journalism Quarterly,* Vol. 52, No. 4, p. 741-4.
NORTHRUP, BOWEN. 1977. Moscow's Medicine. *Wall Street Journal,* 23 May.
NOW (NATIONAL ORGANIZATION OF WOMEN). 1972. *Women in the Wasteland Fight Back.* Washington, D.C., NOW.

References

NUITA, YOKO. 1979. *Impact of Audio-Visual Media on Socio-Cultural Behaviour of Women in Japan.* Paris, Unesco. (CC/CD/MED.) (Mimeo.)
NUJ (NATIONAL UNION OF JOURNALISTS). 1978. *Annual General Report.* London, NUJ.
OBBO, CHRISTINE. 1980. *African Women: Their Struggle for Economic Independence.* London, Zed Press.
O'DONNELL, W. J.; O'DONNELL, K. J. 1978. Update: Sex Role Messages in TV Commercials. *Journal of Communication,* Vol. 28, No. 1, p. 156-8.
O'KELLY, C. 1974. Sexism in Children's Television. *Journalism Quarterly,* Vol. 5, No. 4, p. 722-4.
OKWENJE, ELIZABETH et al. 1977. *Reading, Listening and Viewing Habits of Women.* (Paper presented at Women and Media Consultation, Kitwe, Zambia.) (Mimeo.)
OLIVERA, MERCEDES. 1978/79. The Oppression of Women in the Capitalist System. *Two Worlds,* Vol. 1, No. 3, p. 14-18.
ORWANT, JACK; CANTOR, MURIEL. 1977. How Sex Stereotyping Affects News Preferences. *Journalism Quarterly,* Vol. 54, p. 99-108.
PALA, ACHOLA O. 1977. Definitions of Women and Development: an African Perspective. In: Ximena Bunster et al (eds.), *Women and National Development: the Complexities of Change.* Chicago, University of Chicago Press.
PATHAK, ELA. 1977. *The Image of the Woman in Indian Hindi and Gujarati Films.* Ahmedabad, The Woman's Group. (Mimeo.)
——. 1979. *The Relevance of the Image of the Woman Reflected in the Women's Sections of the Dailies Printed in Ahmedabad.* Ahmedabad, The Women's Group. (Mimeo.)
PAULSON, JOY. 1976. Women in Media. In: J. Lebra et al. (eds.), *Women in Changing Japan.* Colorado, Westview Press.
PENDERYN, DIC. 1978. Twenty-one Women, Three Men and One Baby. *Film and Television Technician,* June.
PINEDA BONILLA, MARÍA JESUS. 1974. *La publicidad y la mujer: su influencia en el sector laboral de Lima.* Lima, Pontificia Universidad Catolica del Perú. (Mimeo.)
PINGREE, SUZANNE; HAWKINS, ROBERT. 1978. *Television Use and Effects among West Australian Children.* Australia, Murdoch University. (Mimeo.)
——. 1979. *American Programmes on Australian Television: the Cultivation Effect in Australia.* University of Wisconsin-Madison. (Mimeo.)
PRB (POPULATION REFERENCE BUREAU). 1977. *Interchange,* March.
PREALC (PROGRAMA REGIONAL DE EMPLEO PARA AMERICA LATINA Y EL CARIBE). 1978. *Participación femenina en la actividad económica América Latina (analisis estadístico).* (Working Paper 161.)
PRESS INSTITUTE OF INDIA. 1975. *Report of the Seminar on the Role of the Mass Media in Changing Social Attitudes and Practices Towards Women.* Indian Institute of Mass Communication, Indian Council of Social Science Research. (Mimeo.)
QUARTIM DE MORÃES, MARIA. 1979. *Papeis femininas e transmissae de ideologias.* São Paulo, Fundação Carlos Chagas. (Mimeo.)
QUIROZ, T. M.; LARRAIN, B. E. 1978. *Imagen de la mujer que proyectan los medios de comunicación de masas en Costa Rica.* Universidad de Costa Rica. (Mimeo.)
RAICES, M. 1976. *Male and Female Roles in OECA Programming.* Toronto, Ontario Educational Communications Authority.
RASKIN, A. H. 1977. Women are Still Absent from Labour's Top Ranks. *New York Times,* 5 June.
RAY, L. 1972. The American Women in Mass Media: How Much Emancipation and What does it Mean? In: C. Safilios-Rothschild (ed.), *Towards a Sociology of Women,* p. 41-62. Lexington, Mass./Toronto, Xerox College Publishing.
RICKEL, A.; GRANT, L. 1979. Sex Role Stereotypes in the Mass Media and Schools: Five Consistent Themes. *International Journal of Women's Studies,* Vol. 2, No. 2, p. 164-79.
RIHANI, MAY. 1978. *Development as if Women Mattered: an Annotated Bibliography with a Third World Focus.* Washington, D.C., Overseas Development Council.
RIOS DE BETANCOURT, ETHEL. 1977. *La influencia de los medios de comunicación, la educación, la literatura y el arte en la visión de la mujer.* (Paper presented at the Conference of Puerto Rican Women.) (Mimeo.)

ROMAO, ISABEL; BAGINHA, FERNANDO. 1979. *Feminino-masculino, factos e imagens*. Lisbon, Comissão de Condição Feminina.
ROSALDO, M.; LAMPHERE, L. (eds.). 1974. *Women, Culture and Society*. Palo Alto, Calif., Stanford University Press.
ROSEN, M. 1973. *Popcorn Venus: Women, Movies and the American Dream*. New York, Coward, McCann & Geoghehan.
ROSENHAN, MOLLIE. 1977. Images of Male and Female in Soviet Children's Readers. In: D. Atkinson et al. (eds.), *Women in Russia*. Palo Alto, Calif., Stanford University Press.
ROSS, MILEVA. 1977. Radio. In: King and Stott (eds.), *Is This Your Life? Images of Women in the Media*, p. 9-36. London, Virago/Quartet.
ROWBOTHAM, SHEILA. 1973. *Woman's Consciousness, Man's World*. London, Penguin.
ROWLEY, JOHN. 1980. Conference Personality 2. *Forum 80*, 17 July, p. 2.
SAFILIOS-ROTHSCHILD, C. 1968. 'Good' and 'Bad' Girls in Modern Greek Movies. *Journal of Marriage and the Family*, Vol. 30, No. 3, p. 527-31.
SALAZAR DE GARCIA, GLORIA. 1979. *Women's Pastoral Project: a Progress Report*. San Jose, CELEP. (Mimeo.)
SANTA CRUZ, ADRIANA; ERAZO, VIVIANA. 1980. *Compropolitan: el orden transnacional y su modelo feminino*. Mexico City, Editorial Nueva Imagen.
SARTI, CYNTHIA; QUARTIM DE MORÃES, MARIA. 1979. *A mulher nas revistas femininas*. São Paulo, Fundação Carlos Chagas. (Mimeo.)
SCOTT, HILDA. 1974. *Does Socialism Liberate Women?* Boston, Beacon Press.
SCREEN ACTORS GUILD. 1974. SAG Documents Use of Women and Minorities in Prime-time TV Shows. Press Release, 31 October. Hollywood, Calif., Screen Actors Guild.
SEARS, SALLIE. 1979. *Psycho-Sexual Imperatives: Their Role in Identity Formation*. New York, Human Sciences Press.
SEMENOV, V. S. 1973. Obszory Braka i Ljukvi v Molodeznyh Zurnolev. *Molodez. Obrazovanie, Vospitanie, Professional' naja Dejatel'nost'*, p. 164-70. Leningrad.
SEPSTRUP, PREBEN. 1978. *En Undersagelse af Mandes og Kvindebilledet i den Danske Magasin og Dagspresseannoncering*. (Report to Danish Consumer Ombudsman.) Copenhagen. (Mimeo.)
SHARPE, SUE. 1972. The Role of the Nuclear Family in the Oppression of Women. *New Edinburgh Review*, Summer.
——. 1976. Reflections from the Media. *'Just Like a Girl': How Girls Learn to be Women*, p. 91-120. Harmondsworth, Middlesex, Penguin.
SIGNORIELLI, NANCY; GERBNER, GEORGE. 1978. *Women in Public Broadcasting: a Progress Report*. Pittsburgh, Pa., University of Pennsylvania. (Mimeo.)
SMITH, DWAYNE; MATRE, MARC. 1975. Social Norms and Sex Roles in Romance and Adventure Magazines. *Journalism Quarterly*, Vol. 52, No. 2, p. 309-15.
SMITH, ROGER. 1978. *Images and Equality: Women and the National Press*. Guildford, University of Essex. (Mimeo.)
SMITH, S. 1975. *Women who Make Movies*. New York, Hopkinson & Blake.
SMYTHE, DALLAS. 1954. Reality as Presented by Television. *Public Opinion Quarterly*, Vol. 18, p. 143-56.
——. 1977. Communications: Blindspot of Western Marxism. *Canadian Journal of Political and Social Theory*, Vol. 1, No. 3.
SOKOLOWSKA, MAGDALENA. 1976. The Woman Image in the Awareness of Contemporary Polish Society. *Polish Sociological Bulletin*, Vol. 3, No. 35, p. 41-50.
Spare Rib. 1980. Interview: Natalia. *Spare Rib*, No. 98, September, p. 16-17, 39.
SREBERNY-MOHAMMADI, ANNABELLE. 1978. *At the Periphery: Women, Communications in Iran*. (Paper presented to Research Committee on Sex Roles in Society, 9th World Congress of Sociology. Uppsala, Sweden.) (Mimeo.)
STANLEY, JOYCE; LUNDEEN, ALISA. 1978. *Audio-Cassette Listening Forums: a Participatory Women's Development Project*. Washington, D.C., Agency for International Development. (Mimeo.)
STRAINCHAMPS, E. (ed.). 1974. *Rooms with No View. A Woman's Guide to the Man's World of the Media*. New York, Harper & Row.
SULEIMAN, MICHAEL. 1974. Changing Attitudes Toward Women in Egypt: the Role

of Fiction in Women's Magazines. (Paper presented at Middle Studies Association Meeting.) (Mimeo.)
SURGEON GENERAL'S SCIENTIFIC ADVISORY COMMITTEE ON TELEVISION AND SOCIAL BEHAVIOUR. 1972. *Television and Social Behaviour*, Vols. I to V. Washington, D.C., Government Printing Office.
SVERIGES RADIO. 1978. *Saklighet, Opartiskhet... Jamstelldhet? Slutrapport fran Sveriges Radios Jamstalldhetsprojekt*. Stockholm, Sveriges Radio. (Mimeo.)
TAGNEY, JOY. 1979. Giving the Girls a Share of the Market. *The Guardian*, 20 February.
TAMMES, DIANE. 1980. Camerawoman Obscura: a 'Personal' Account. *Women's Studies International Quarterly*, Vol. 3, No. 1, p. 59-62.
TASK FORCE ON MINORITIES IN PUBLIC BROADCASTING. 1978. *A Formula for Change*. Washington, D.C., Corporation for Public Broadcasting.
TASK FORCE ON WOMEN AND ADVERTISING. 1977. *Women and Advertising: Today's Messages—Yesterday's Images*. Toronto, Canadian Advertising Advisory Board.
TAVARES DA SILVA, REGINA; DOMINGUEZ, CRISTINA; LEMOS, CONCEICAE. 1979. *A imagem da mulher na publicidade*. Lisbon, Comissão de Condição Feminina. Cadernos condição feminina, No. 10.)
TEDESCO, NANCY. 1975. *Men and Women in Television Drama. The Use of Two Multivariate Techniques for Isolating Dimensions of Characterisation*. Pittsburgh, Pa., University of Pennsylvania. (Mimeo.)
THORNE, B.; HENLEY, N. (eds.). 1975. *Language and Sex: Difference and Dominance*. Rowley, Mass., Newbury House.
TOEPLITZ, JERZY. 1980. Inquiry on Participation of Women in Radio, Television and Film in Four Countries: Australia, Canada, United Kingdom and United States. Part I in *Women in the Media*. Paris, Unesco.
TRODD, FELICITY. 1972. Women in the Trade Unions. In: M. Wandor (ed.), *The Body Politic*, p. 153. London, Stage 1.
TSUDA, A. 1975. *Mediation of Sex Roles: the Case of Norwegian Television*. Oslo, University of Oslo. (Mimeo.)
TUCHMAN, Gaye. 1974. Assembling a Television Talk Show. In: Tuchman (ed.), *The TV Establishment: Programming for Power and Profit*. Englewood Cliffs, N.J., Prentice-Hall.
——. 1978. *Making News: a Study in the Construction of Reality*. New York, The Free Press.
——. 1979. Women's Depiction in the Mass Media. *Signs*, Vol. 4, No. 3, p. 528-42.
TUCHMAN, GAYE; DANIELS, ARLENE K.; BENET, JAMES (eds.). 1978. *Hearth and Home: Images of Women in the Mass Media*. New York, Oxford University Press.
TUNSTALL, JEREMY. 1970. *Media Sociology: A Reader*. London, Constable.
——. 1971. *Journalists at Work*. London, Constable.
——. 1977. *The Media are American*. London, Constable.
TUROW, J. 1974. Advising and Ordering: Daytime, Prime Time. *Journal of Communication*, Vol. 24, No. 2, p. 138-41.
UNESCO. 1975. *Report on the Relationship Between Educational Opportunities and Employment Opportunites for Women*. Paris, Unesco. (Mimeo.)
——. 1980. *Women in the Media*. Paris, Unesco.
UNICEF. 1975. *Facts About Females and Education*. United States Committee for Unicef. Geneva, Unicef.
——. n.d. *Situación de la mujer en América Latina y el Caribe y su impacto en la infancia*. Geneva, Unicef. (Unicef/TARO-7911.)
UNITED METHODIST CHURCH. 1976. *Sex Role Stereotyping in Prime Time Television*. New York, United Methodist Church.
UNITED STATES COMMISSION ON CIVIL RIGHTS. 1977. *Window Dressing on the Set: Women and Minorities in Television*. Washington, D.C., United States Commission on Civil Rights.
——. 1979. *Window Dressing on the Set: An Update*. Washington, D.C., United States Commission on Civil Rights.
VAERNO, GRETHE. 1978. Getting into Male-Run Media. *Development Forum*, July.
VALENTINE, PENNY. 1979. Women in TV–Feminists in Control? *Time Out*, No. 473, May.
VAN BRIESEN, CHRISTINE. 1979. *Europa: Medien und Frau*. Munich, Freier Deutscher Autorenverband.

References

VAN GELDER, LINDSY. 1974. Women's Pages: You Can't Make News Out of a Silk Purse. *Ms.*, November, p. 112-16.
VENKATESAN, M; LOSCO, J. 1975. Women in Magazine Ads: 1959-1971. *Journal of Advertising Research*, Vol. 15, p. 49-54.
VON WELSER, URSULA. 1976. *Bereicht zur Lage der Weiblichen Mitarbeiter den WDR.* Report presented to Westdeutschen Rundfunk.
WAGNER, LOUIS; BANOS, J. B. 1973. A Woman's Place: a Follow-up Analysis of the Roles Portrayed by Women in Magazine Advertisements. *Journal of Marketing Research*, Vol. 10, p. 213-14.
WASSENAAR, I. 1976. *Vrouwenbladen. Spiegels van een Mannenmaatschappij.* Amsterdam, Wetenschappelijke Uitgeverij.
WBAI-FM. 1979. Radio is a Feminist Issue. *Broadcast*, 3 December.
WCUNDW (WORLD CONFERENCE OF THE UN DECADE FOR WOMEN). 1980a. *Programme of Action for Second Half of the United Nations Decade for Women: Equality, Development and Peace.* New York, United Nations. (A/CONF.94/22.)
——. 1980b. *Review and Evaluation of Progress Achieved in the Implementation of the World Plan of Action: Employment.* New York, United Nations (A/CONF. 94/8/ Rev. 1.)
——. 1980c. *Review and Evaluation of Progress Achieved in the Implementation of the World Plan of Action: Education.* New York, United Nations. (A/CONF. 94/10.)
——. 1980d. *International Seminar on Women and the Media.* United Nations Headquarters, New York, 20-23 May 1980. Conference Background Paper. New York, United Nations. (A/CONF. 94/BP/10.)
——. 1980e. *National Report Submitted by Portugal.* New York, United Nations. (A/CONF. 94/NR/22.)
——. 1980f. *National Report Submitted by Indonesia.* New York, United Nations, (A/CONF. 94/NR/13.)
——. 1980g. *National Report Submitted by Jamaica.* New York, United Nations. (A/CONF. 94/NR/7/Rev. 1.)
——. 1980h. *Review and Evaluation of Progress and Obstacles Encountered at the National Level in Attaining the Objectives of the World Plan of Action.* New York, United Nations. (A/CONF. 94/30.)
WEA (WORKERS' EDUCATIONAL ASSOCIATION). 1977. *Women in Focus: Six Video Tapes about Women.* West of Scotland District WEA. (Mimeo.)
WEIBEL, K. 1977. *Mirror, Mirror, Images of Women Reflected in Popular Culture.* New York, Anchor.
WERNER, ANITA. 1975a. Kvinner i Massemedien. *Samtiden*, Vol. 84, No. 10, p. 599-612.
——. 1975b. The Effects of Television on Children and Adolescents: A Case of Sex and Class Socialisation. *Journal of Communication*, Vol. 25, No. 4, p. 45-51.
WHITE, CYNTHIA. 1970. *Women's Magazines 1963-1968: a Sociological Study.* London, Michael Joseph.
WHITE, D. M. 1950. The Gatekeeper: a Case Study in the Selection of News. *Journalism Quarterly*, Vol. 27, p. 383-90.
WIESAR, NORA JACQUES. 1980. Ancient Song, New Melody in Latin America: Women and Film. In: Beverly Lindsay (ed.), *Comparative Perspectives of Third World Women.* New York, Praeger.
WILLIAMS, RAYMOND. 1968. *Communications.* London, Penguin.
WOMEN IN MEDIA. 1976. *The Packaging of Women.* London, Women in Media.
WOMEN MEDIA WORKERS. 1978. *New Journalist*, January. Special issue on media presentation of women.
WOMEN'S ADVISORY COUNCIL. 1976. *WNBC Monitoring Findings.* New York, WAC.
WOMEN'S STUDIES GROUP (eds.). 1978. *Women Take Issue: Aspects of Women's Subordination*, London and Birmingham, Hutchinson, in association with the Centre for Contemporary Cultural Studies, University of Birmingham.
WOOLF, VIRGINIA. 1975. *A Room of One's Own.* London, Penguin.
YADAVA, J. S. 1976. *Exposure of Women to Mass Media.* New Delhi, Indian Institute of Mass Communication. (Mimeo.)
YING, DIANE. 1977. Access to Education and Employment in Mass Media for Women in the Republic of China. In: Yu and Chu (eds.), *Women and Media in Asia*, p. 109-15. Hong Kong, Centre for Communication Studies, Chinese University of Hong Kong.
YU, TIMOTHY; CHU, LEONARD (eds.). 1977. *Women and Media in Asia.* Hong Kong, Centre for Communication Studies, Chinese University of Hong Kong.

HQ 1221 .G24 1981 c.1

FEB 20 '90
FEB 1 4 1992

CC. 80/D-137/A